PHOTOGRAPHING SHADOW AND LIGHT

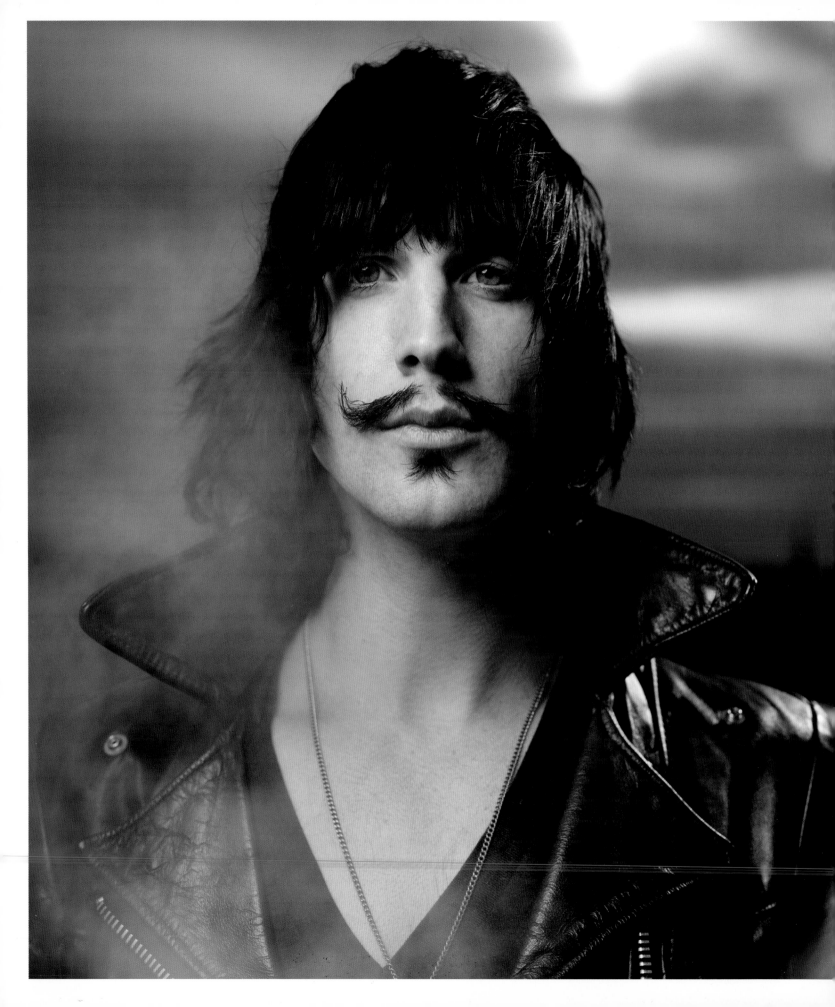

PHOTOGRAPHING
SHADOW AND LIGHT

INSIDE THE DRAMATIC LIGHTING TECHNIQUES AND CREATIVE VISION
OF PORTRAIT PHOTOGRAPHER JOEY L.

JOEY L.

WITH JEFF KENT
FOREWORD BY DAVID HOBBY

AMPHOTO BOOKS

an imprint of the Crown Publishing Group / New York

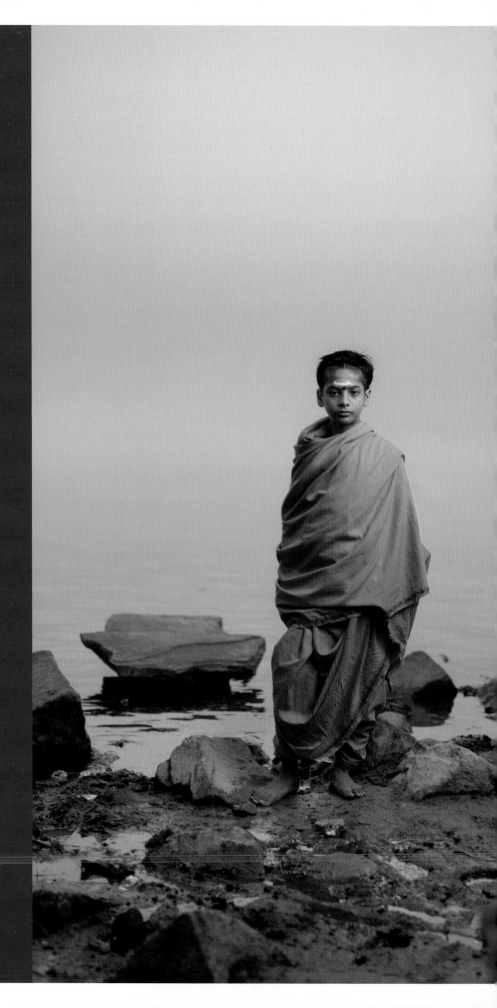

Published in the United States by Amphoto Books,
an imprint of the Crown Publishing Group, a
division of Random House, Inc., New York.
www.crownpublishing.com
www.amphotobooks.com

AMPHOTO BOOKS and the Amphoto Books
logo are trademarks of Random House, Inc.

A foreword is included herein by David Hobby.

Library of Congress Cataloging-in-Publication
Data

L., Joey (Lawrence)
Photographing Shadow and Light: inside the
dramatic lighting techniques and creative vision
of portrait photographer joey l. / Joey L. with Jeff
Kent.
 p. cm.
 Includes bibliographical references and index.

1. Cinematography—Lighting. 2. Portrait
photography—Lighting. I. Kent, Jeff, 1974- II.
Title.
 TR891.L16 2011
 777'.52—dc23
 2011046721

ISBN 978-0-8174-0014-9
eISBN 978-0-8174-0015-6

Printed in China

Design by Kara Plikaitis
Cover design by Kara Plikaitis

10 9 8 7 6 5 4 3 2 1

First Edition

This book is dedicated to my mom and dad,
who put up with my crap for years.

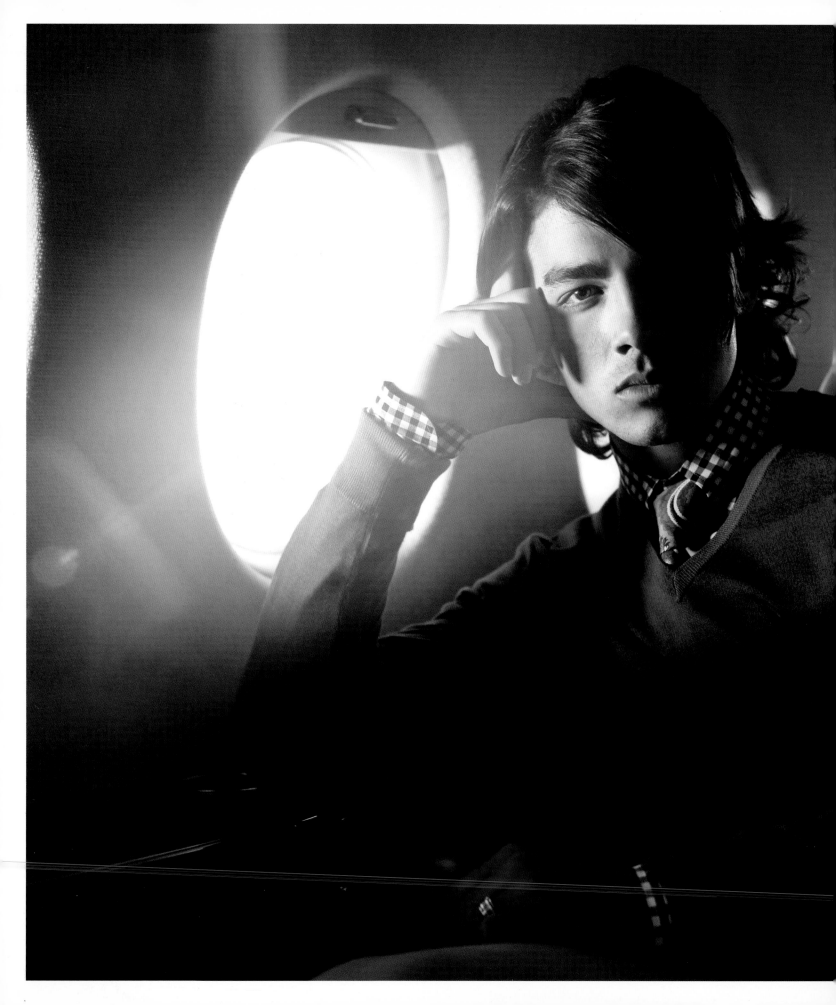

CONTENTS

FINE ART PORTRAITS

MUSIC PORTRAITS

COMMERCIAL PORTRAITS

FOREWORD BY DAVID HOBBY

When I began writing the foreword for this book, I decided to avoid the obvious focus on Joey Lawrence's age. But as it turns out, I was wrong. We are going to talk about his age.

Not in the Mozart-wrote-a-symphony-at-age-five sense, but more in the context of who Joey is and how this body of work was created so early in his career. For those who don't know, Joey made the photos in this book before or at the age of twenty-one.

To me, the most interesting part of this is not the fact *that* he was twenty-one, but the fact of *when* he was twenty-one. Joey's development as an artist has happened since the turn of the millennium. He has never known a world without computers or Photoshop. He is a digital native, and that has had a profound effect on his photography and photographic path. Further, the combination of when he was born and his early success places him at the vanguard of an emerging group of Generation Z photographers.

Members of Generation Z are thought of as having been born in the early to mid-1990s. Although Joey was born in 1989, he understood at a very young age exactly how the new digital environment had changed everything about photography. So in many ways, Joey is a few years ahead of his time. And, in a broader sense, he is what's coming. This book is an example of how the world's most successful photographers will be thinking five or ten years hence.

Previous generations of photographers grew up in an era when it was assumed that you could get a steady job with a great company and be set for life. For many photographers, myself included, that meant something like working your way up to a great metro daily newspaper. Once there, no worries. Just don't screw up and you'll be fine.

Clearly, that time has passed.

For photographers of my generation, our dependable business model has been crushed like a bug. For younger photographers, the digital transition has been a liberation. In fact, the most successful photographers of the future will have more in common with a Silicon Valley garage start-up than with the track of their photographic forebears. Forward-thinking photographers are already becoming entrepreneurs, mostly in the sense that they create their

own ecosystems. They don't need printing presses, distribution, or the validation of a large company of any kind.

Joey was born around the same time as the Internet and has grown up alongside it. He is highly motivated and exhaustively self-taught, learning at a blistering pace far beyond that of the typical photography school. Just as important, he is both confident and creatively fearless—a result, I think, of his education outside a hierarchical environment.

When you grow up receiving the validation of your teachers, you learn to depend on that validation. When you grow up on your own, you learn to trust your instincts. Joey's education happened with a camera in one hand and an Internet-connected computer in the other. He learned Photoshop the same way his thirteen-year-old peers were learning to beat Halo: perfectly willing to die a thousand deaths en route to his goal. Photographers of Joey's generation are different. Their education, motivations, shooting styles, business models—all different.

It helps that Joey was born to exceptionally supportive parents. They not only gave him the freedom to learn and explore photography, but encouraged him to take creative chances and pursue more ambitious gigs. I'd like to think that when my own kids hit seventeen in a few years, I'll be just as supportive.

It was right around 2007 when I first met Joey. He was in the midst of transitioning between his parental and professional environments. Five years doesn't sound like very long ago, but in digital native years it can be a lifetime. Joey was already shooting a steady stream of professional jobs. He had an agent in New York and another in London. On top of that, he was nearing completion of his first digital commercial product: a tutorial explaining pretty much everything he had learned to date about photography and postproduction.

Think about that for a moment. At seventeen years old, Joey already understood that he needed neither a publisher nor a distributor to be successful as a photographer. He just

needed to create a digital product and put it out there. It would live or die via online word of mouth. Digital natives think differently.

The digital products were just a node in his ecosystem, but they gave him the ability to fund his photography. The symbiosis worked. He has done two more digital products since. Create and ship. Hone and iterate. Think like a digital start-up.

It was at this point that I started following Joey's career, and we kept in touch. Word soon trickled out that he had been hired to shoot the posters for the upcoming *Twilight* movie. As the first adaptation of Stephenie Meyer's book series, the movie was all but guaranteed to be a blockbuster. And they were going to let an eighteen-year-old photographer shoot the poster. It was unheard of.

A year later, in December 2008, I stepped out of the subway in London and saw his photos on the *Twilight* posters. They were everywhere—double-decker buses, kiosks, billboards—*everywhere*. I remember having difficulty processing that in my head. I took some shots and emailed them to Joey along with my congratulations.

What I would find out later was that he had seriously considered turning down the *Twilight* job. He didn't feel that it fit the compass point of his career. Ultimately, his main draw for doing the posters was that the paycheck would fuel more ambitious personal projects. It would allow him to travel to India to photograph holy men without commercial backing. And the photos from that project would impress future art directors enough to garner yet more high-end commercial assignments. Lather, rinse, and repeat.

Still technically in high school (he was taking leaves to shoot commercial jobs and personal projects), Joey was already learning not just how to create his own ecosystem, but how to scale it to the point where it was creating its own weather.

Now, four years later, at a time when many people his age are holding freshly minted college diplomas and searching for jobs, Joey is largely in control of his path. He is choosy about what he shoots. He creates jobs and projects out of thin air by crafting imaginative treatments and proposals—and supplementing them with the body of work to back them up.

Rather than take a subpar job, Joey will search out creative partners for collaborative personal projects that suit them both. This is the kind of privilege formerly afforded only to successful photographers later in their careers. But Joey saw this as the shortcut to creative freedom—and success—before he was old enough to drive.

I remember seeing the images in this book as a stream over the last five years as Joey created them. I have never been one to critique photos (or, truth be told, to accept the critiques of others), but seeing all of these images together, you start to get a better sense of the photographer who made them.

What I see in these pictures gels perfectly with the person I have come to know. Joey has a deep and passionate curiosity about people. Whether his subject is a cultural icon with an eight-figure salary or a penniless indigenous person, the curiosity is equally sincere. His interaction with people is as genuine as it is fearless. And that shows in his photos.

Joey is as comfortable working with cutting-edge digital technology as he is adapting the look of an Old Master painter from the 1600s. As he shoots, he affects the air of a goofy college kid, even as he is thinking, seeing, calculating, and executing his photography. Outwardly, Joey is happy-go-lucky. On the inside, he's as intense as anyone I have ever met. More so, I believe, than he feels he is allowed to show. But in reading the book you'll quickly see that he *always* does his homework and is generally the most well-researched person in the room when it comes time to make photos.

Speaking of reading the book, the difference in voice between the words and photos will feel like a paradox. The words are those of a young adult—a passionate, well-researched young adult, but a young adult all the same. The photos, however, are those of a confident, motivated professional with more experience than many photographers twice his age.

Joey Lawrence is young, technologically literate, ambitious, and already playing the long game. He is the future of photography. Get used to it. We are now in a world where talent, creativity, fearlessness, agility, and persistence all work together to trump seniority.

This is what's next, and it's exciting.

David Hobby is the creator of Strobist.com.

INTRODUCTION

My interest in photography and cinematography began when I was seven, back in my hometown of Lindsay, Ontario. I used to make little home movies with a Hi 8 camera, filming scenes of my friends running around the neighborhood, being chased by dinosaurs. I used toys as props, staged scenes, and edited everything together on a VCR into minimovies.

In my early teens, I started photographing personal projects, including self-portraits and images of homeless people on the streets of Toronto. Then I began photographing local rock bands in my town. I built my own website and an online portfolio, which led to some interest outside of Lindsay, including from an electronic musician in Amsterdam, who came across my work and then contacted me about photographing him for some promotional material. Slowly but surely, I started picking up bigger band photo shoots. By the time I was sixteen, my work drew the attention of some band managers who hired me to photograph their clients and then started acting as my first photo agents. I began traveling with a few different bands, photographing them on location all over North America; I was spending much more time shooting than going to school. Luckily, my parents were extremely supportive from the start. Rather than telling me to put down the camera and do my homework, they encouraged me to follow my dream, in spite of the growing difficulty of keeping up with my schoolwork. They knew that I was doing what I was supposed to do.

All this time I had a goal, which was to move beyond music photography and progress into more substantial commercial shooting. So I started working toward a more commercial-friendly portfolio by photographing the bands in situations that would appeal to commercial clients. In addition to the standard album cover poses and group shots that my clients needed, I'd work in individual portraits, more creative setups, and sets of images that looked like ad campaigns. The bands were happy to oblige—they got more creative pictures for their press kits, and I got to expand my portfolio. While shooting promotional images for the band Silverstein, for example, I experimented by treating it more like an advertising gig for a commercial client. The image on page 15 looks more like a commercial portrait, lit with four different light sources.

My early on-set photography was a far cry from the productions I'm managing now.

Initially, these images appealed to several different entertainment clients—television and film art directors, mostly—who appreciated the hybrid style that mixed music industry imagery with commercial portraiture. I started working with a proper photo agent, and by the time I was eighteen, I was landing substantial commercial and editorial photo assignments with clients ranging from *Forbes* to the History channel, to the producers of the movie *Twilight*. From there, my career has continued to develop into larger-scale, mainstream advertising jobs for major clients throughout North America, Europe, and the Middle East.

Running a parallel track to my commercial photography career has been an evolving series of fine art projects on diverse cultures around the world. I've made multiple trips to remote regions of Ethiopia, Indonesia, India, and other distant lands to live among and photograph people whose cultures and belief systems are a complete departure from the mind-sets driving my commercial imagery. My fine art portrait projects aren't done for commercial gain; they are personal, exploratory, and essential to my development as an artist. Many of the techniques that I use during these scaled-down, highly portable sessions form the basis for my commercial portrait lighting techniques. These images are a great way for me to fine-tune my approach to lighting and posing in ways that ultimately inform everything I do as a photographer.

People always ask about my "big break," that project or image that propelled my career to a higher level. I don't think there is one. I don't believe that photographers ever get to a place where they shoot one great job and then are set forever. Instead, this field requires perpetual self-education and personal development. That's how I learned photography and how I will continue to evolve as an artist. I've spent countless hours reading books on technique, studying old texts on classic artistic methods, visiting photography forums, and examining not only the images of esteemed photographers but also the paintings of revered masters, such as the seventeenth-century Dutch portraitists.

You'll notice that I don't mention putting in classroom time or getting a formal education in photography. I have none. I've never gone to school for photography. I've never assisted a well-known photographer. I've never worked for an ad agency or production company or studio. Those aren't boasts. I don't consider myself superior to anyone else because I'm self-taught. And I'm not a rebel who completely rejects the value of a formal education. This is simply the path that worked for me. More relevant for the readers of this book, it's a path that led me to borrow, discover, and combine a variety of techniques, which I've blended into a distinct style that has been well received in the marketplace. I still learn something new on every shoot. The trick is to never stop educating yourself, whether it's in school, in professional seminars, or on your own.

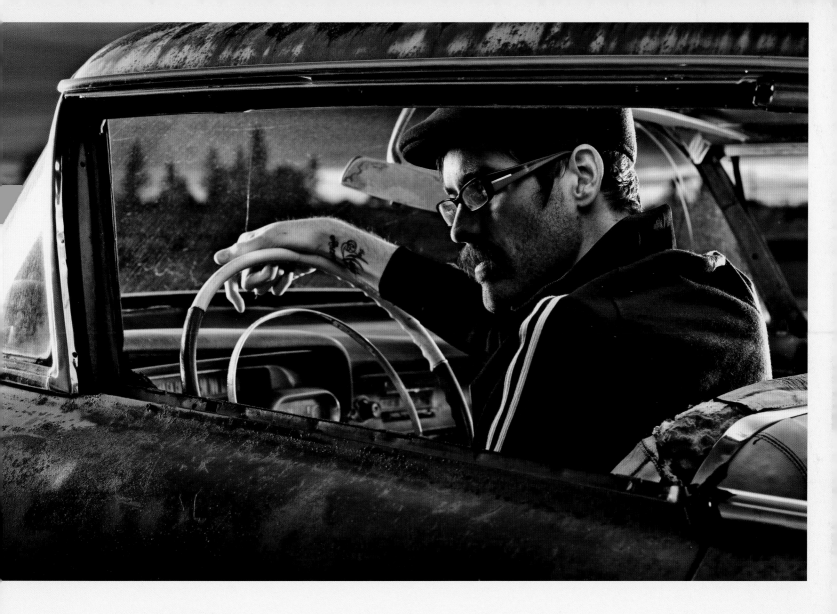

Though this was a shoot to create promotional materials for the band Silverstein, I treated it more like an advertising gig for a big commercial client. To light this scene, I applied four different light sources: The direct light from the setting sun flooded the car from the front windshield, lighting the front of the subject. My main light was a Speedotron flash head in a Chimera softbox, coming from the front of the car at a similar angle as the sun. Another Speedotron flash head shining from the back of the car acted as a backlight to separate his head from the background. And, finally, a little silver reflector positioned just below the frame and aimed up at the side of the car bounced the main light back onto the front of the car to bring out some detail.

1/200 sec. at f/8, ISO 50

Natural light from setting sun

Flash head with grid

Car

Silver reflector

Flash head in softbox

Me

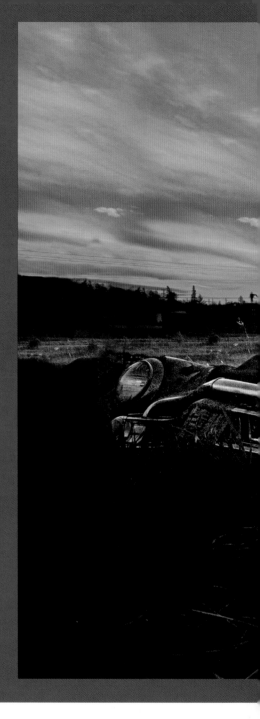

This portrait is a pure sunset shot, in which I silhouetted the members of Silverstein to create a dark, moody image. Because the image looks different from the typical group band shot, it helped to broaden the reach of my portfolio to appeal to more mainstream commercial clients.

1/200 sec. at f/11, ISO 100

Now, I'm not suggesting that you copy my style to find success—far from it. A photographer's most valuable asset is his or her personal vision. What I am suggesting is that the path to developing one's personal vision may take twists and turns, but experimentation and self-discovery are extremely valuable. Because I learned many of my methods independently, I may work in a way that doesn't make sense to some photographers. I may formulate more complicated lighting setups than are technically necessary for some situations. The result, though, is a look that is completely mine, that sets me apart. My clients and customers appreciate that I have a distinct point of view.

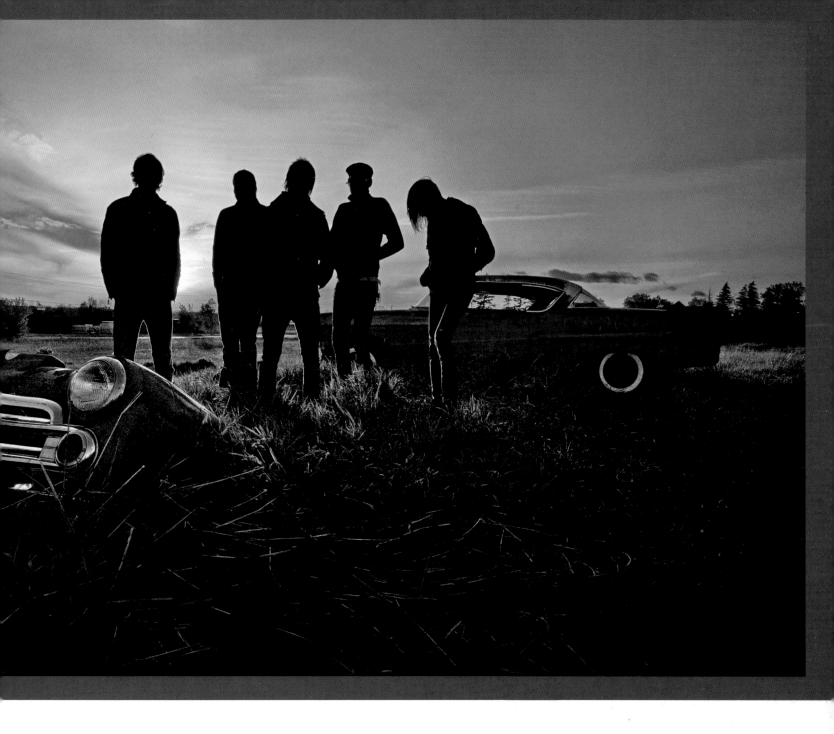

Every photographer should have a distinct point of view. The real trick is showing it, and having the courage to embrace it. Hopefully this book will contribute to your own journey to establish a personal vision. The lessons within are meant to be a guideline, not a step-by-step instruction manual. I suggest that you process my tips and techniques and then determine how they best apply to you. If you and I photograph the same thing with the same equipment and the same basic settings, we should, ideally, get different results, because we each see the world differently. We each view light differently and are captivated by different elements of a composition. Those differences are good, and they're why photography is such a fascinating art form.

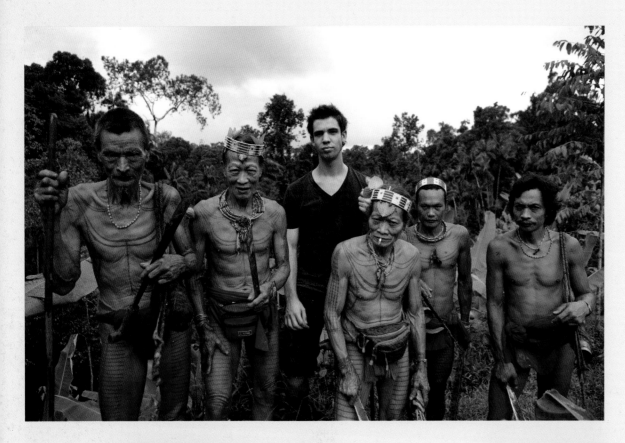

When on location with the Mentawai, in Indonesia, I established relationships with my subjects and built trust with others by enlisting them to help me with the portrait shoots.

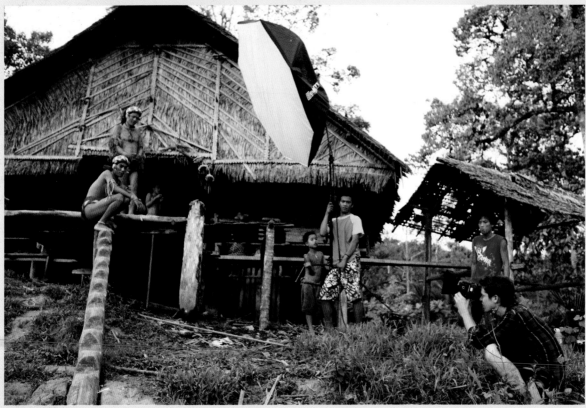

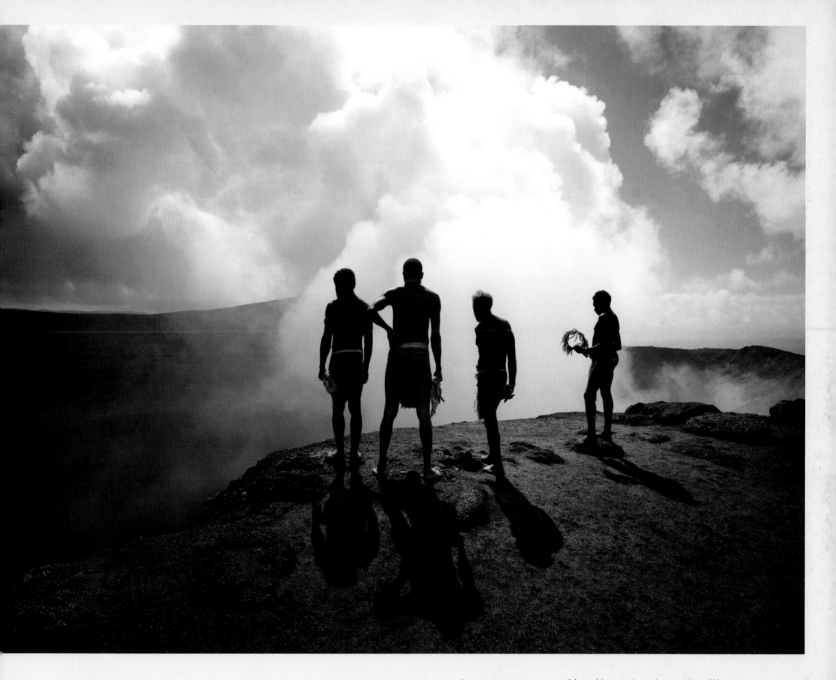

In many ways, my series on Mount Yasur is about the interplay of life and death. The people living around the volcano are vibrant, and the volcano itself is "alive" as an active geological force, but everything around the volcano is dead. The ground is covered in ash, the landscape is littered with dead plants and unforgiving rocks, even the air is laden with deadly sulfur. My images of the people ascending the volcano and looking over the edge are meant to have an atmospheric feel. I wanted to show their true feelings about the volcano, which include awe and terror.

1/125 sec. at f/3.2, ISO 50

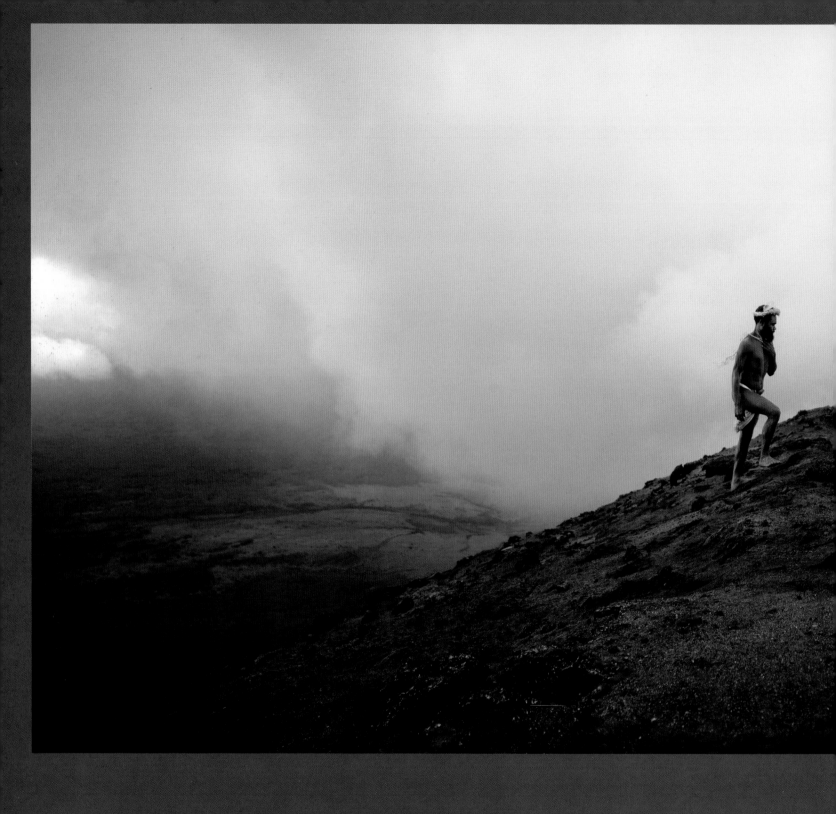

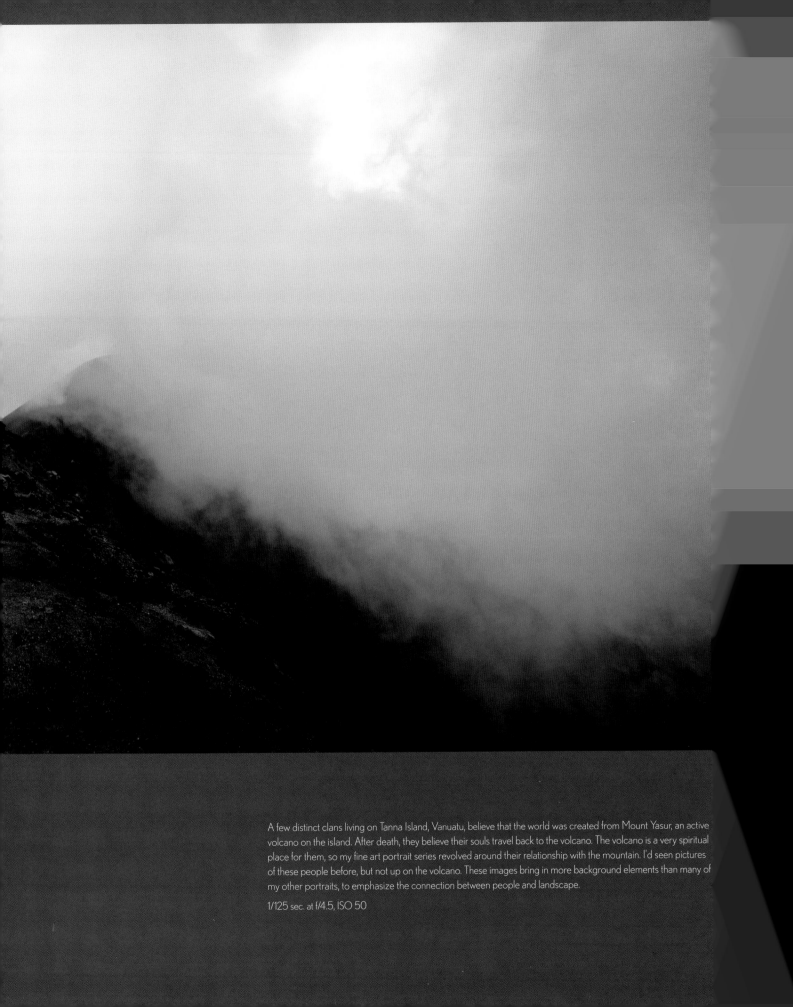

A few distinct clans living on Tanna Island, Vanuatu, believe that the world was created from Mount Yasur, an active volcano on the island. After death, they believe their souls travel back to the volcano. The volcano is a very spiritual place for them, so my fine art portrait series revolved around their relationship with the mountain. I'd seen pictures of these people before, but not up on the volcano. These images bring in more background elements than many of my other portraits, to emphasize the connection between people and landscape.

1/125 sec. at f/4.5, ISO 50

STYLE

I DEFINE MY STYLE AS "CINEMATIC PORTRAIT PHOTOGRAPHY." MY WORK COMBINES classic influences, such as that of the Dutch master painters, with references to contemporary themes from film and television. But I didn't come to this artistic identity overnight. It took a great deal of time and effort to home in on my unique personal vision, and then to develop the techniques to make it a reality. In many ways, I had to reject some of the current trends toward fast-click photography and slow myself down, examine the process, and concentrate on the fundamentals of what I was doing. This has been an ongoing endeavor. An artistic style is forever evolving and improving upon itself. I often look back on work I once thought was great and now see it as terrible. That is a healthy progression because I'm constantly trying to improve upon what I've done in the past.

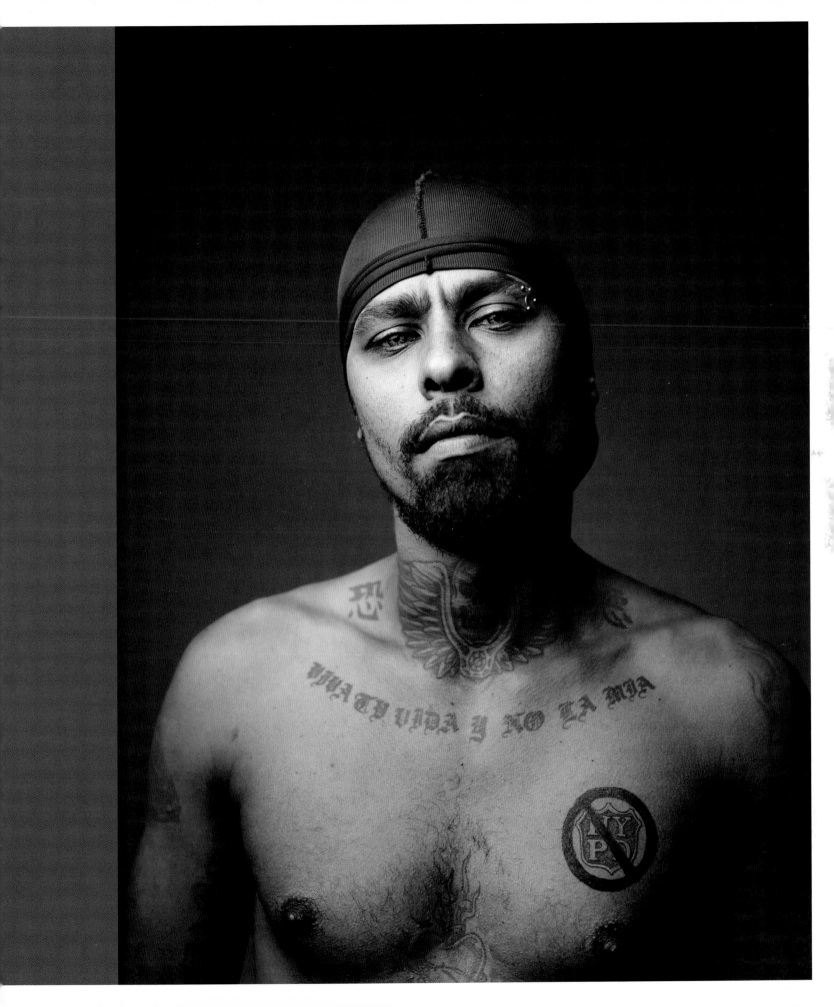

In the digital age, it's very easy to overlook your responsibility as a photographer. The technology available today is incredible. It has become so easy to take pictures. Digital cameras are affordable, ubiquitous, and easy to use. Social media make it a snap to share photos with people all over the world. It's an exciting time for those interested in producing and displaying images. However, just because it's easy to take and share pictures doesn't mean you always should. Real photography is a craft, an art form that requires close attention to details. In today's fast-paced world, when it comes to making images with any chance at longevity, it's important to slow it down and do it right. It's critical to understand photography principles and have a vision for your image first, before you think about photographing. It's about working toward a goal, aspiring toward something different. It's not about snapping off thousands of photos and hoping you get lucky with one of them.

Ultimately, the photographic process should result in an image that says something about the photographer as well as the subject. I believe strongly in this concept. As a photographer, you influence every scene that you photograph. It doesn't matter whether you're directing a major commercial shoot or capturing a photojournalistic image of a special moment; by being there you are affecting the scene. Your presence has an impact and that image should reflect your hand in some way.

What does this mean, exactly? I'm talking about putting your personal stamp on your photography. As a photographer, any image you create needs to come from you. It needs to have that little something extra that makes it unique and personal. When I was a kid, if we got 100 percent on a project in school, it was just an A. The only way to get an A+ was to go above and beyond, to add something special. I often think of what my father used to tell my brothers and me: "Do the job right the first time or don't do it at all." That is the approach I take with my photography. I never simply take a picture. I set up my shots. I think about them. And then I execute with as much care and precision as possible. I aim to get the image right in camera, and always add something extra, something that will make the image distinctly mine. Everything I create is a product of my personal vision. My success in this field has been built, in large part, on a dedication to that vision, as well as an ongoing effort to be consistent with my personal brand in the face of all other influences.

The three portraits shown on pages 23, 25, and 26 are from three different fine art portrait series in three different parts of the world, but show a consistent approach to lighting, posing, and composition. The images don't need to be identical, but a cohesive thread helps unify a body of work and provide a distinct identity for the photographer.

PAGE 23 AND PAGE 26 1/125 sec. at f/3.5, ISO 100; RIGHT 1/60 sec. at f/4, ISO 100;

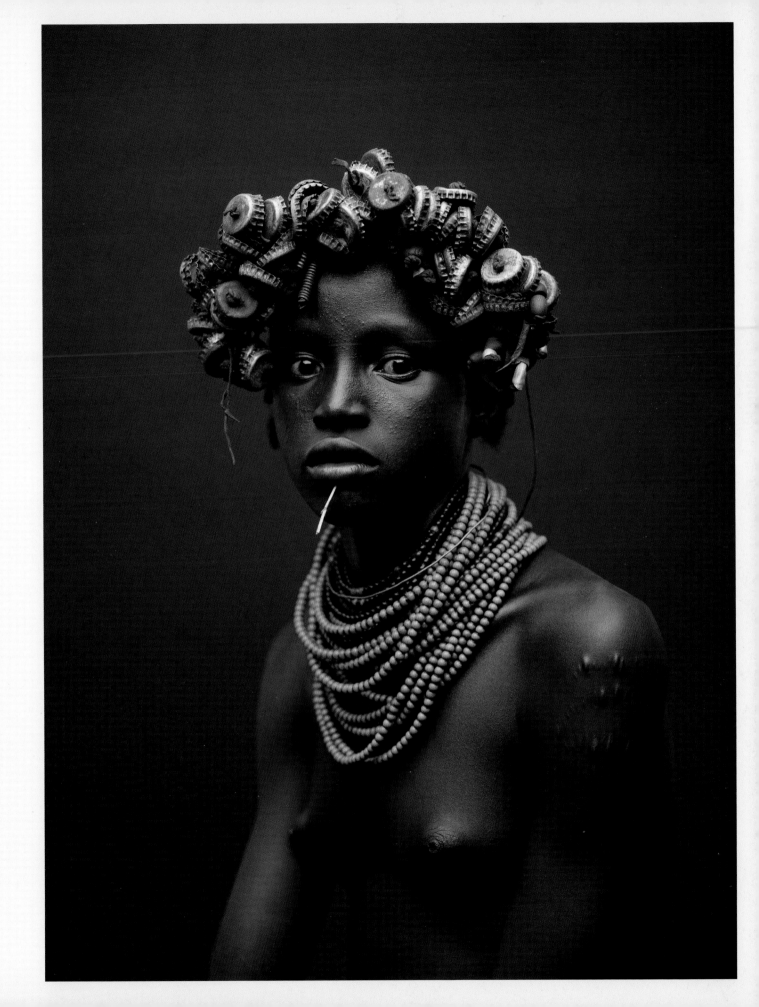

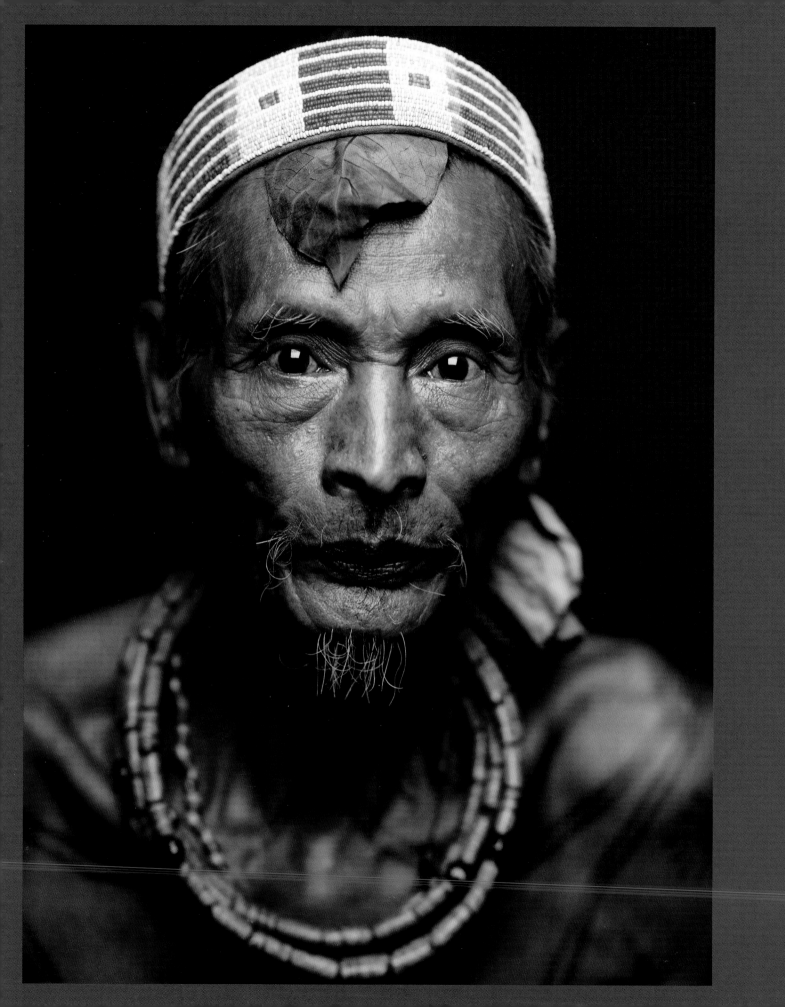

The most successful photographers I've known or studied have had a distinct point of view. As a result, their work is recognizable. That level of cohesiveness is what separates the great image creators from the leagues of people who just take pictures. It's also what makes you a marketable entity in the highly competitive professional market. I decided early on to focus on a particular style. I found out what I love and what I'm good at, and I worked at it as hard as I could. My style has evolved, but there is a unifying thread; when you look through my portfolio, it looks like it came from one hand. That cohesiveness put me in a niche market. I'm not good at everything, but I'm good at what I do. I focused. I didn't go after every single client; I concentrated on the ones that really mattered to me, the ones that make sense for my business and help me advance my career.

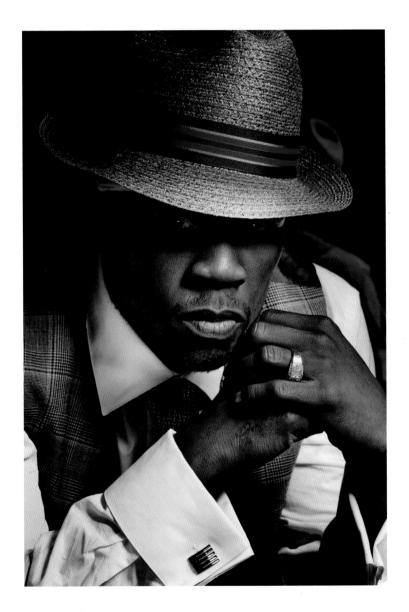

One of the hallmarks of my style is positioning the shaded side of the subject's face toward the camera, as in this commissioned portrait of 50 Cent.

1/200 sec. at f/16, ISO 200

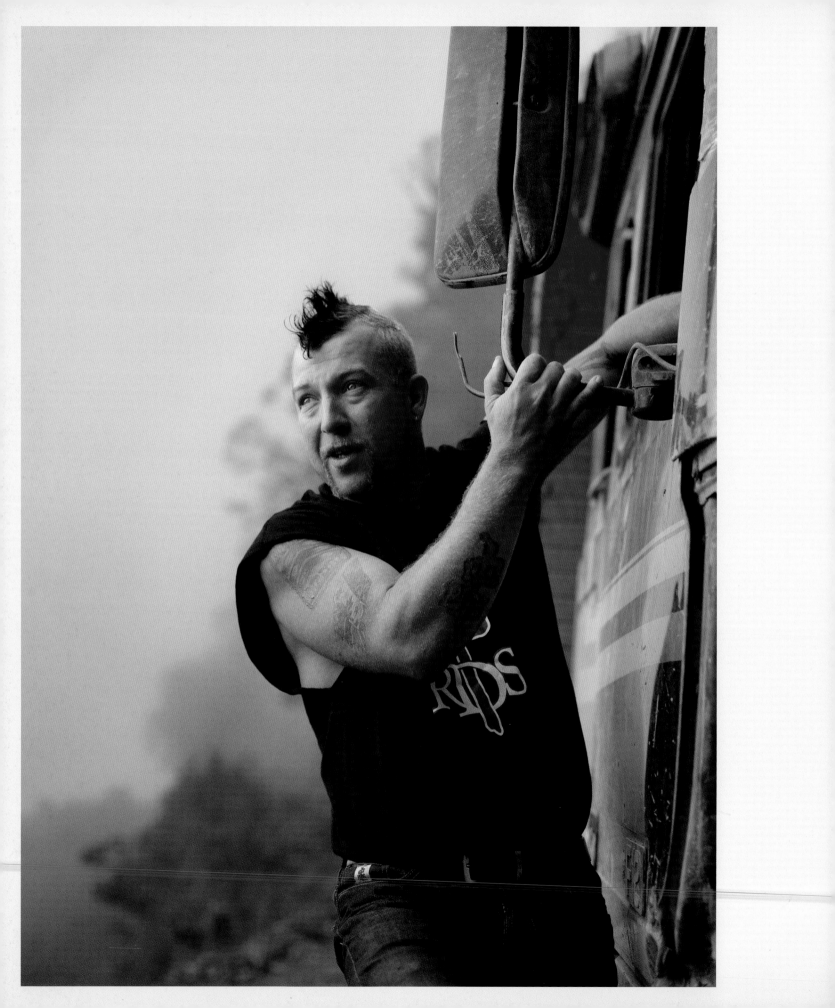

My personal vision is very much a product of the environment in which I was raised. I wouldn't make the same type of images if I was born at another time, or in another place. My style is heavily influenced by movies, television, and modern cinematography. I learn a lot from watching movies, especially in relation to lighting. When I see something interesting, I try to figure out how it was done. Similar to movie lighting, I often build sets for my commercial work that include a sweet spot of light for the subject to move within. These types of setups allow the subjects to move and interact more freely, and I can work with them on subtle tweaks to optimize the lighting effects without needing to reconfigure lights.

While my work has been heavily influenced by modern film and television—particularly the dramatic lighting setups and fluid, contemporary compositions—I also look to classic inspirations, such as the seventeenth-century portrait paintings of the Dutch masters. I love their compositions and lighting. The way they posed subjects and represented light has defined portrait styles for centuries. One of the most fascinating features of the Dutch masters' lighting is their technique of turning the shadow side of the subject's face toward the viewer. This produces a more dramatic look with a wide tonal range in the shadows. You'll notice a similar approach throughout my portraiture, particularly my fine art work.

This interplay of light and shadow is central to my photographic style. Somewhere between four-hundred-year-old painting techniques and cutting-edge cinematic lighting, I've crafted a style that emphasizes mood and atmosphere, where my treatment of shadows can be dramatic or subtle, depending on my objectives for the image. I underexpose my backgrounds to create a darker, moodier look with a smoothed-out, painterly effect, placing the emphasis on the subject. The colors, the tones, and the mood from the backgrounds feed into the colors, tones, and mood on the faces of my subjects. Above all, there is a carefully crafted harmony between all the elements in the image, so the final composition looks real but idealized. The lighting and other techniques shouldn't be so dramatic that they take over the image. There's drama, but just a touch; everything is integrated.

I like to think that there's cohesiveness across all of my work, from the fine art portrait series to the commercial images. However, within that context, the different images obviously vary quite a bit, depending on their purpose. My commercial work is very much about popular culture, and so it follows the signs of the times. My fine art portraits look modern but

This commissioned portrait for the History channel's *IRT: Deadliest Roads* is another example of my trademark style, with the shaded side of the subject's face positioned toward the camera.

1/100 sec at f/4, ISO 50

are more personal and have different uses. They are focused examinations of each subject. Doing commercial and fine art photography is like working in two separate worlds. It's like being a race-car driver by day and a cab driver by night—two completely different spheres; they just happen to both involve cars. In the same way, commercial and fine art photography are very different; they just happen to both involve cameras.

When you are making an advertisement, you want to orient it toward what people want or what they aspire to be. For example, Levi's jeans has a customer base that reaches well into middle age, but their advertising primarily shows younger people because they want to project the image of youth, as if putting on their jeans will make you feel young again. An advertisement is made with photography, but it's more than a photograph. There's always an overarching message related to a brand. So the image needs to work with that message and advance the objectives of the client. My style is important—after all, I get hired because the client is seeking a particular look—but the style must serve the ultimate purpose of the image, which is to sell something.

With fine art portraits, the purpose of the image is entirely different. Photographers who create fine art imagery aren't trying to sell a product or get people to aspire to a certain lifestyle. It is all about the photograph. Fine art images come together in a series to tell a unifying story as well, but ultimately it all comes back to the photograph.

I mention the differences between these two kinds of photography because it is so important for photographers to create for themselves as well as for their occupation. That's how you develop a style, by mixing on-demand creativity for clients with the complete artistic freedom of your personal photography. One informs the other, and ideally each sphere of your work will help you improve the other and grow as a total photographer. So yes, it's like being a race-car driver by day and a cab driver by night, but there are driving skills involved in doing both, and hopefully you can learn to be a better driver by blending the best of both worlds.

In this image from my series on the sadhus of Varanasi, India, I worked carefully with the ambient light and surrounding colors to produce a portrait that is as natural looking as possible. By reducing the power of my flash to add just a pop of light, I enhanced the subject subtly, without producing a dramatic impact on the rest of the composition.

1/125 sec. at f/4.5, ISO 50

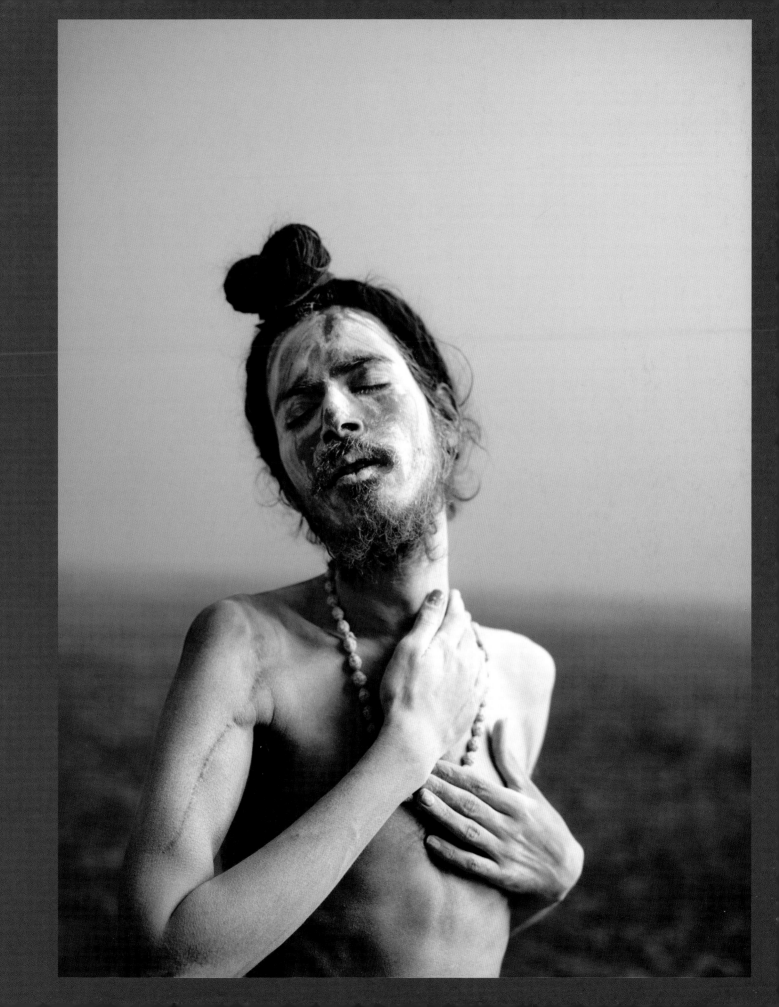

TECHNIQUE

TECHNIQUE IS IMPORTANT, AS IS A STRONG FOUNDATION OF PHOTOGRAPHIC AND artistic principles. But the technical elements aren't nearly as important as the direction of your photo. Whether you use one light or eight, your first thought should be how the picture will look—the mood, the feel, and the character. Keep the technicalities in the back of your mind so they don't get in the way of your artistic vision, and then apply those technical items as needed to bring your vision to life.

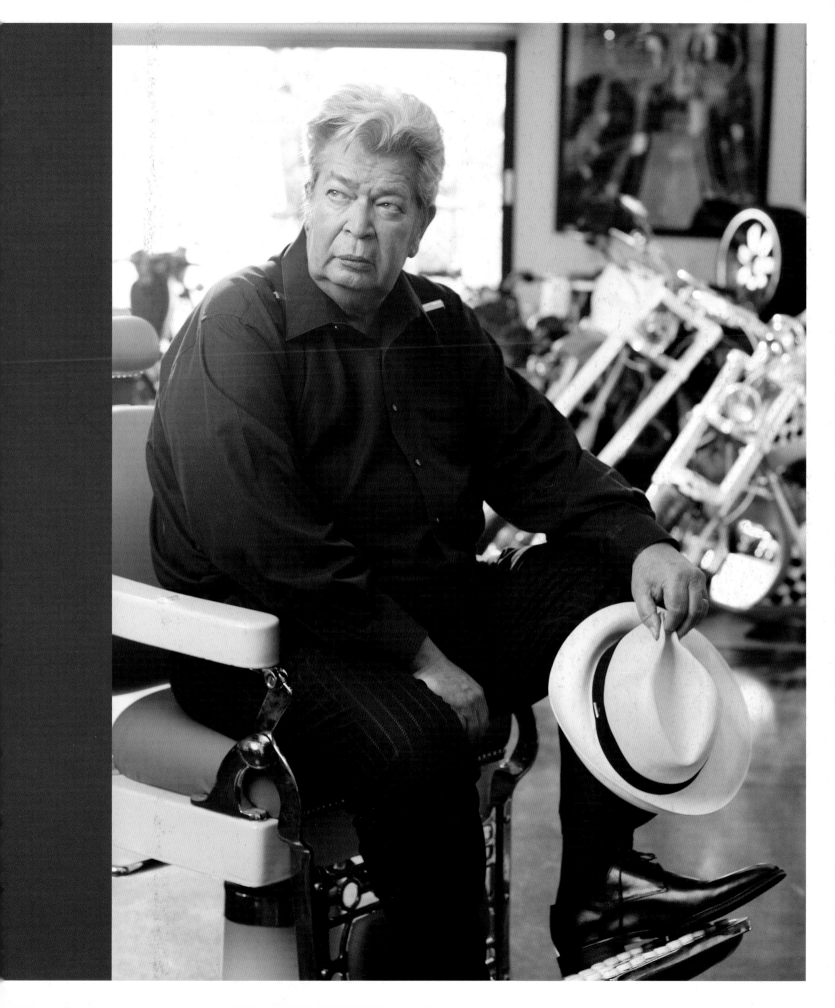

LIGHTING

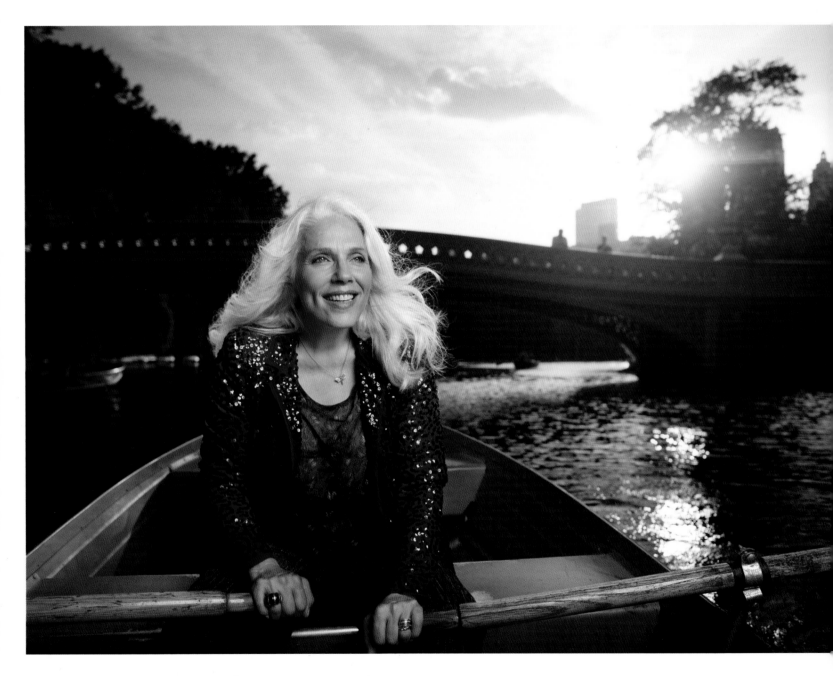

For this portfolio piece, shot to appeal to potential pharmaceutical clients, I started with the sun as a strong ambient light source that defined the look of the scene. With the sun backlighting my subject and providing a warm glow, I just needed to add some flash to the foreground to brighten the front of the subject. My assistant, Morgan, rowed a boat alongside the subject's boat, holding a flash head in a large Elinchrom Rotalux Softbox Octa beside her, above and to the right, just off frame. This light augments the natural light of the scene, providing a main light on the subject while the sunset provides a strong backlight. By rowing alongside the subject, my assistant, Morgan (see opposite) was able to hold the octabox at the right distance to provide appealing flashlight in the foreground while the light from the setting sun flared in the background.

1/125 sec. at f/6.3, ISO 50

MY LIGHTING THEORY IS BASED ON A STEP-BY-STEP, ADDITIVE PROCESS.

Once I have an initial vision of the direction of a photo in my mind, I set up one light at a time. I start with a blank scene and make an exposure without any artificial light to determine what I need to add. I always do test shots with a test subject. Then, using my test subject as the stand-in model, I set up one light, check the scene again, then maybe another, then maybe another, and so on. I don't add a bunch of lights at once because it can get confusing and I can't determine as clearly what each light is accomplishing in the image. Instead, I prefer to tweak each element in the composition individually so that I add only what's necessary to augment the scene, nothing more. That way the light serves the artistic vision for the image, instead of becoming the dominating feature of the image. In my early work, my lighting tended to dominate the photographs. The images were more about dramatic light and less about the "performance" or direction of the subject. Nowadays, I try to find a happy balance between great lighting and great expression from the subject.

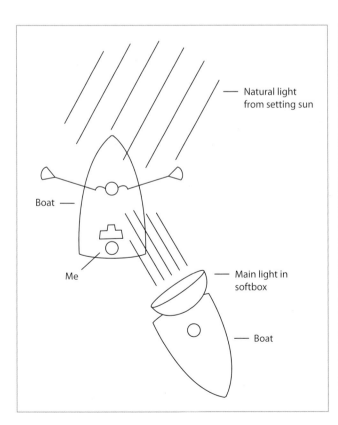

Natural light from setting sun

Boat

Me

Main light in softbox

Boat

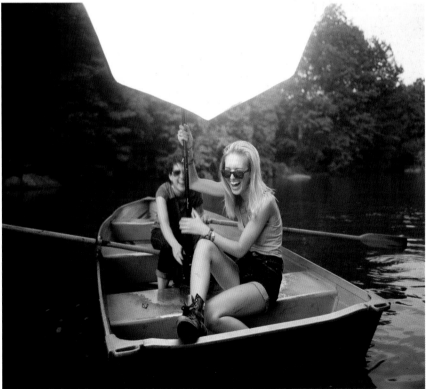

Understanding lighting fundamentals is essential to this process because it helps me use the existing light sources more effectively. The process begins with observing the light that is present in the scene and then treating that as the baseline for adding any additional elements. Let's say I'm in a city and the setting sun is reflecting off the glass windows of the skyscrapers. In this scenario, I probably have two light sources already in place: (1) the reflected light bouncing off the buildings can be my main light, illuminating the front of my subject; (2) the direct light from the setting sun can be my backlight, adding definition to the subject by lighting it from the rear and separating it from the background. With this baseline established, I just have to evaluate what else I need to tweak the scene.

When adding light, I always start with the main light, which should cover the subject's face or body, depending on the composition. I want this light to hit all of the subject(s) and create most of the impact. Usually, the main light is the only light I'll tweak during a photo shoot. Once all the supplemental lights have been established, they stay put. They provide an area of idealized light that I keep my subject within. However, I'll move the main light around, based on the position of my subject and the effects I want to create.

After establishing my main light and doing some test shots, I determine what else the image needs. Does it need a backlight or rim light? Backlight can be any kind of light coming from behind the subject, while rim light shines specifically along the edges of the subject, separating it from the background. If the image needs one of these lights, I add it, test, and reevaluate. Does the image also need some background lights to add definition to the background? If so, I add, test, and reevaluate. It goes on like this until I'm satisfied that I've created the perfect lighting "scene."

Throughout this process, I'm simply adding one light at a time to make the image look like the picture I've conceived in my head. That's why it's important to have a vision, so you have a guide for your work. However, you don't want to be too restricted by that vision, too determined to re-create your mind's image exactly. As I add light, I observe my scene carefully to see how the different elements react to each new light. I might discover something by accident, or stumble upon a look that I hadn't imagined. Some of my most successful images were the result of happy accidents that occurred while I was setting up a shot. So be flexible, because you never know what brilliant look you might create.

I like dark, moody images, so I often underexpose my backgrounds to get atmospheric shadows and blended, creamy shapes. However, you can't just underexpose a photograph and expect to create atmosphere. When you shoot shadowy images, there has to be a light creating the shadows. I typically shine the light on the side of the subject's face that's away from the

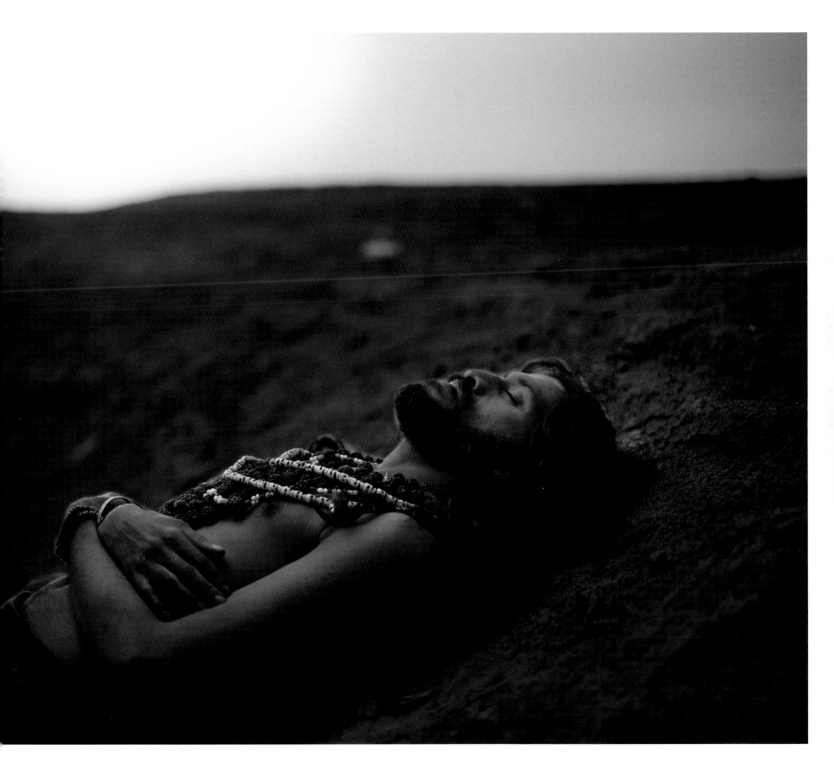

Here is an image from my series on the sadhus of Varanasi, India. As with the photo on page 31, my goal was to work with the ambient light and surrounding colors to create an authentic-looking portrait. Supplemental light is used with a light touch to subtly enhance the subject without overwhelming the subject's environment.

1/80 sec. at f/2.8, ISO 50

camera, creating interesting shadows on the side of the face closest to the camera. This approach is reminiscent of the technique used by the Dutch master portrait painters, which I described in the previous chapter. When you light straight on, the light can be very flat and you lose dimension in your subject's face. By lighting the far side of the face, you get moody shadows and create some drama—how much drama depends on the exact angle and power of the light, and the pose of your subject.

Sometimes when creating these dark, moody images, I lose the sparkle in my subject's eyes. The shadows, particularly on the camera side of the face that is shielded from the main light, can swallow up the eyes. In these cases, I use a catchlight to add just a pop of light to brighten up the eyes. I set the power low so it won't affect the rest of the image, but it puts a little twinkle in the eyes.

When modifying my light sources, I favor products that provide some variability in the light. Makers of softboxes and other lighting modifiers are always trying to create products that produce perfectly flat, even light. I don't like that kind of light. I prefer modifiers that have hot spots and feathered light falling away from those hot spots. When working with softboxes, I often remove the inner baffle, which is just another layer of diffusion material inside the softbox, intended to further spread out the light and avoid a hot spot in front of the bulb. I *want* that hot spot, and I use the brighter, concentrated area of light to my advantage, either directing it straight at my subject for a high-contrast, dramatically lit portrait or aiming it just off my subject for a softer, less contrast-y appearance. In many of my portraits, especially the environmental portraits for my fine art series, the focal point of my main light actually misses my subjects, so they are illuminated by the feathered light that falls off from that central hot spot.

Working this way means that the effect of the light changes remarkably when you move the softbox even just a few inches. Aim the softbox in one direction, and the light's hot spot might fall more directly on the subject, creating a stronger lighting effect and a higher-contrast portrait. Tilt it just an inch or two in another direction, and the hot spot might miss your subject completely so he or she is illuminated by only edge light, causing less contrast and more variable shadows. The difference is profound and often just a matter of twisting your wrist ever so slightly when positioning the light.

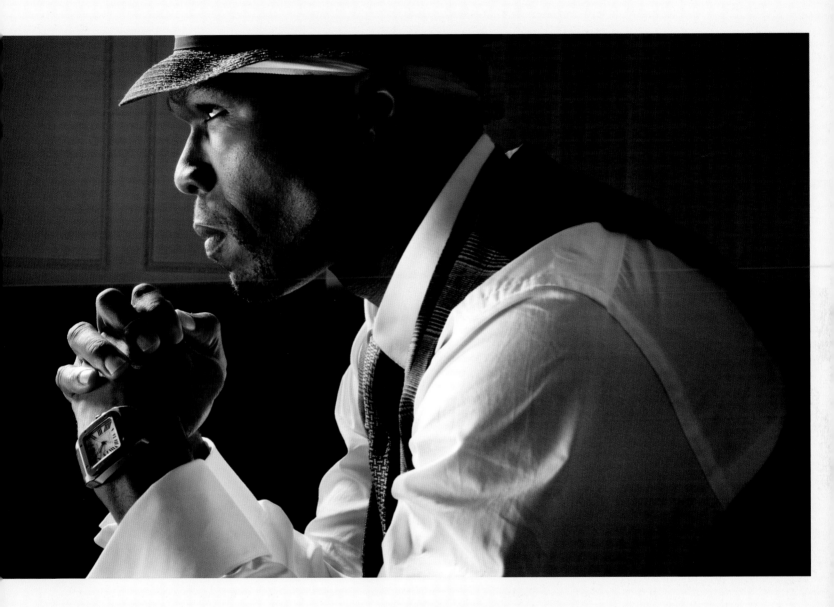

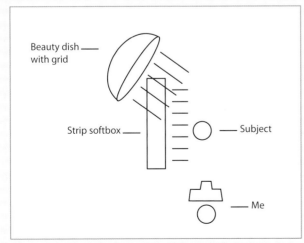

Beauty dish with grid

Strip softbox ——

Subject

Me

For this profile portrait of 50 Cent, shot for a *Vibe* magazine article, I used a Profoto Pro flash head modified by a silver beauty dish as my main light. Positioned above the subject and aimed down at him at a 45-degree angle, this light provides the main illumination of the subject. I focused the light with a 20-degree grid to create more directed light. Beneath 50 Cent's face, just below the frame, I had an assistant hold another flash head in a strip softbox, turned to low power and aimed up to provide a bit of fill and some sparkle in his eyes.

1/200 sec. at f/16, ISO 200

EXPOSURE

AS I'VE SAID EARLIER, I UNDEREXPOSE THE BACKGROUND TO EMPHASIZE
the subject and provide the dark, moody look that has become my signature. For commercial shoots, I'll often underexpose the background but keep the subject in proper exposure by illuminating him or her with multiple-light setups. The background goes darker while the subject is in perfect light.

For my one-light fine art portraits, I often use a combination of underexposing the background, applying a neutral density filter to a correctly exposed subject, and adding a single light on the subject. I discuss this technique in more detail in "The Cradle of Mankind" chapter, but the basics of the method involve metering my subject correctly, then metering for my lights, then applying a 2-stop neutral density filter on my camera lens, and finally turning my lights 2 f-stops higher to compensate for the filter. My subject remains properly exposed because of the higher-power artificial light, while the background, which has no artificial light, exposes 2 f-stops lower, giving a darker, more dramatic look. The technique also lets me shoot at a wider aperture, like f/2.8 or f/3.5, which keeps the background in soft focus for a creamy, painterly appearance.

While my subject remains in proper exposure because of a combination of powered-up flash and a neutral density filter on my camera lens, my intentional underexposure of the background turns it dark and moody.

1/50 sec. at f/4, ISO 100

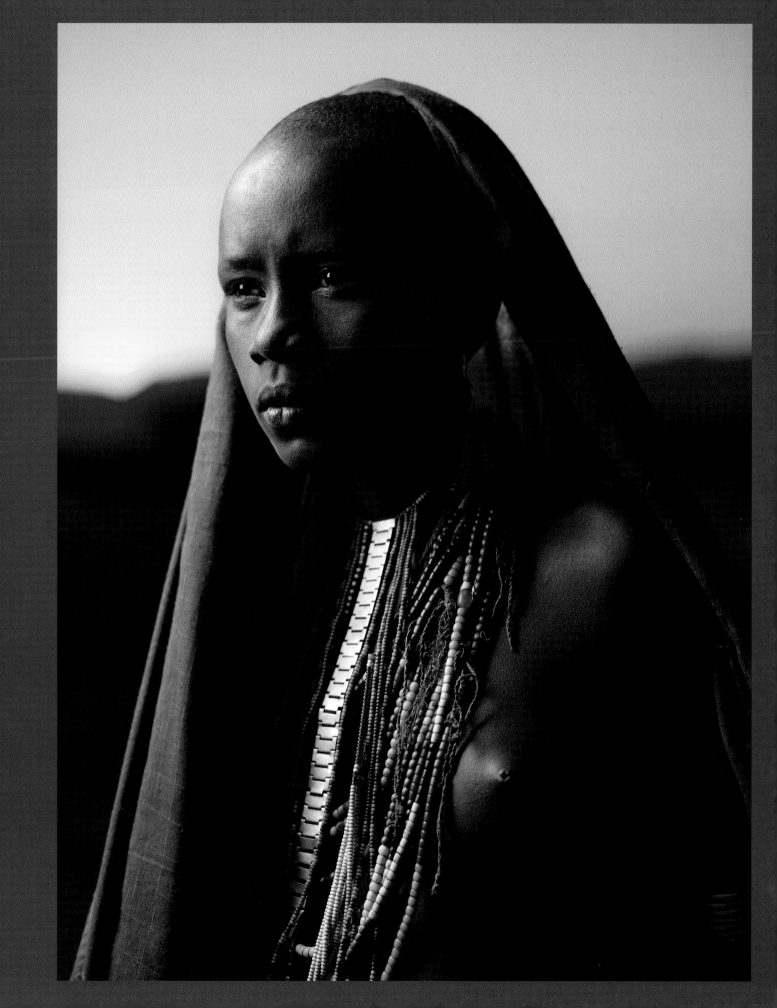

COMPOSITION

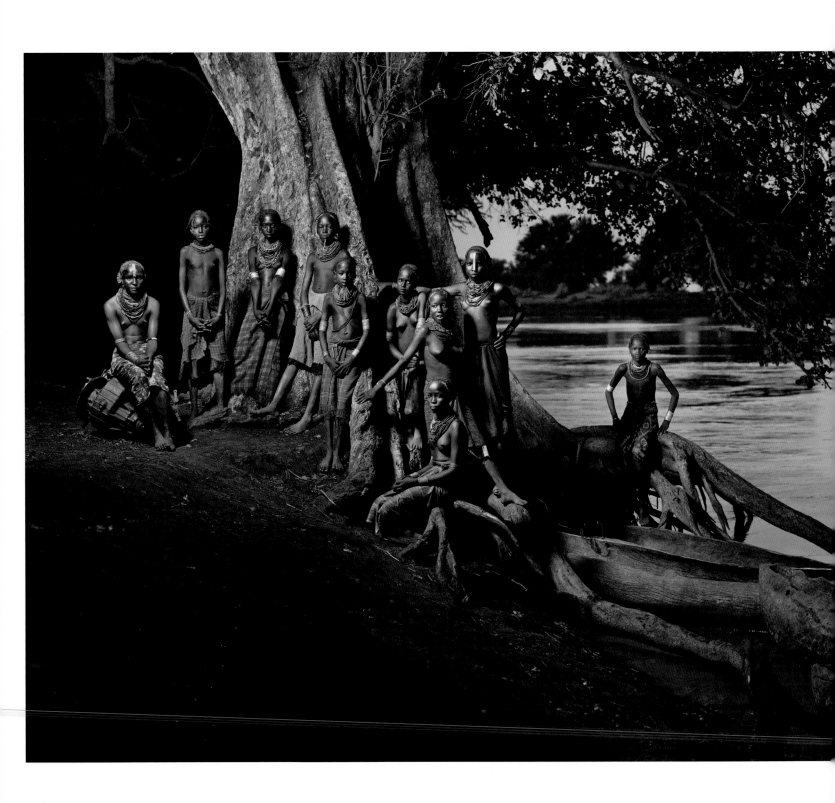

A LOT OF PHOTOGRAPHERS LIKE TO EMPHASIZE CERTAIN

facial features by cropping their images to conceal part of the head or face. I don't like this approach, though I use it now and then when the situation is right. I prefer compositions used by the old master portrait painters, which almost always kept the entire head in view. I arrange my single subjects centrally or to one side, often using the "rule of thirds" (composing the image with a 3×3 grid), and I balance the background elements to avoid distraction.

Group shots have a more complex composition since there needs to be a balance between the different people in the frame, as well as the background elements. The key is to consider all of the pieces of the image—the people, the natural elements in the frame, the light, the sky, anything that affects how the viewer's eye moves through the picture. All of these elements need to work in harmony so the image has a smooth flow. They don't need to be lined up evenly, or even neatly. There can be some variability in the composition. But the viewer's eye needs to proceed from one element to another without getting stuck or distracted by parts of the image that aren't the intended focus.

I had photographed all these young Ethiopian women of the Daasanach tribe individually, before we set up this group shot, so they understood the basic process prior to the creation of this more advanced composition. They put themselves in an interesting arrangement, and then I moved them a little to optimize the composition. The idea was not to make everything symmetrical or regimented, but to create a natural flow that the viewer's eye could follow across the image. The man in the bottom right corner, in the boat, was just sitting there watching the scene. He had no idea he was also in the picture.

1/100 at f/5, ISO 100

POSING

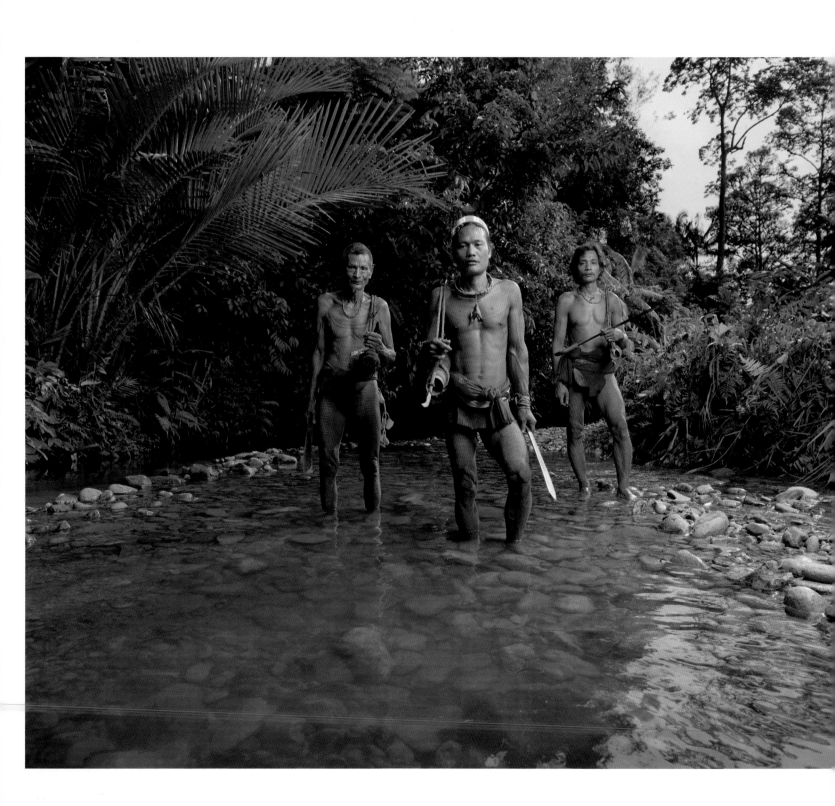

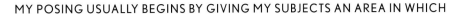

MY POSING USUALLY BEGINS BY GIVING MY SUBJECTS AN AREA IN WHICH

to stand and then seeing what they do in that space. I want to see what their natural tendencies are. I might offer small tips, such as "Look up more," or "Turn your head to the side," but I tend to enjoy people's natural poses the most.

For this reason, I love working with "real" people, especially people who haven't been inundated by imagery their whole life, such as the tribal people I photographed in Ethiopia and Indonesia. They aren't conditioned to commercial images, so they don't walk in front of the lens with any preconceived notions of how they should look. They tend to just stand there without any self-consciousness, and you don't have to break them of any bad posing habits born from watching too many modeling shows on TV—like puckering their lips or trying to make their jaw muscles "pop."

When working with people who aren't used to being photographed professionally, the first step is to help them feel comfortable and relaxed. If you can get these types of subjects to let their guard down a bit, you can create some intriguing, genuine portraits. I often start by giving my subjects a marker to move around within my lighting setup. I want them to try to be themselves. If they remain stiff, I might suggest that we take a break, and while I'm fiddling with my camera gear or attending to something else, I'll keep an eye on them. If they relax and settle into a natural-looking pose, I'll tell them to hold it, and I'll start working again from that starting place. If a subject persists in giving me a stiff stance and can't seem to settle into a natural pose, I ask him or her to put one foot behind the other and then shift weight to the back foot. That move changes the dimension of the body, adjusting the shoulders and posture.

With big groups, I use some of the same techniques, but obviously I'm faced with a major challenge if several members of the group are uncomfortable. Fortunately, groups have a built-in mechanism for relieving tension, which is the social connection of being on set together. I begin by putting everyone in my lighting sweet spot, then I add dimension by arranging some people in front and some in back, staggering them across the scene so they're not all standing in a straight line. Then I give it some time. I don't start photographing immediately because my subjects will still be stiff. I do something else that looks important for a few seconds. As the group members relax and start talking to each other, they unconsciously adjust themselves into postures that are natural for human interaction. They release the tension in their shoulders and turn toward each other to ease conversation. When they settle into those natural poses, I'll tell them to freeze. I might make small adjustments, like turning the shoulders of the subjects on the outside of the group toward the middle, which draws the viewer's eye toward the center of the composition. When I've made those tweaks and achieved the most natural poses I think I'm going to get, I start photographing.

These Mentawai men stood candidly in front of my camera, each of them shifting his weight to the back leg in a manner that I often suggest to my subjects. The pose makes the subject look relaxed and natural.

1/60 sec. at f/8, ISO 50

FINE
ART
PORTRAITS

My biggest passion is traveling the world, meeting interesting people and making portraits of unique individuals from different cultures. My fine art portrait series have taken me from the sidewalks of my neighborhood to the tribal lands of Ethiopia to the top of a volcano in Vanuatu.

While each of these series bears subtle artistic distinctions, my photographic fundamentals are the same. I travel with one light, a studio-quality flash head modified by a large octagonal softbox. I power the light with a battery pack, which my assistant and I lug with us wherever we shoot. My typical lighting approach involves holding the light above and to one side of the subject, aiming it down at about a 45-degree angle, and using the distinct light features of the octabox to produce moody, dramatic portraits. I typically under-expose my background and shoot with a shallow depth of field for a more painterly look. These shooting methods form the basis of my approach to all photography—personal and professional. However, exactly how I apply light, exposure, composition, and pose depends on each subject, each setting, and my objectives for that particular image.

THE CRADLE OF MANKIND

IN MANY WAYS, THE IMAGES FOR "THE CRADLE OF MANKIND"—AND THE PROCESS used to create them—provide a glimpse into my overall thinking as a portrait photographer. This was a personal project that I carried out with several tribes in the Omo River Valley, a remote region in southern Ethiopia. These photographs tell a story of trust, relationships, and respect, and the patient approach required to build those elements into a cohesive collection of imagery. These portraits are about unique peoples and their roles as participants in the modern world. They are stories. They are monographs. They are pieces of these endangered tribes' evolving histories.

Before visiting the tribes of the Omo Valley, I had been interested in the way the people had been depicted photographically. At the same time, I was inspired to tell their stories in a different way. Much of the photography captured in this part of world is photojournalistic or reportage. There are many images that show these tribes as if they were pieces of history. I saw a lot of pictures of people holding spears and dressed as they would have one hundred years ago. Yes, many of the tribes of the Omo Valley had been living an ancient lifestyle that hadn't changed in a significant way for thousands of years, but much of that has changed in the last fifty years or so. Today, these people are affected by the modern world more than ever before. When I went to the valley, people were carrying automatic weapons, wearing some Western clothing, and were in touch with the outside world. They are undoubtedly part of today's world, caught between the age-old customs of their past and the prospect of a new, more hectic future that's increasingly integrated with contemporary society. With that in mind, I wanted to bring the images into the modern era because, although these people might be wearing goatskins and sleeping in huts, they are living in the same world that I am.

This meant imbuing the images with a sense of dignity. These indigenous people have been exploited by governments and modern corporations over and over again. They are viewed as unsophisticated outcasts, and treated almost the way Native Americans were treated

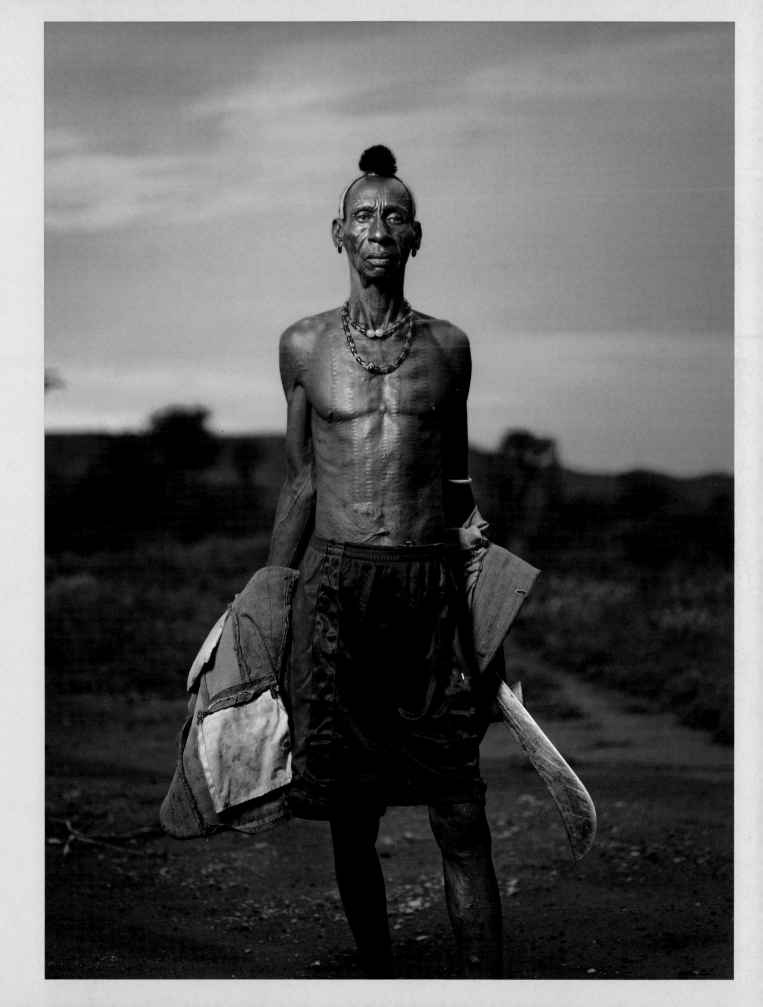

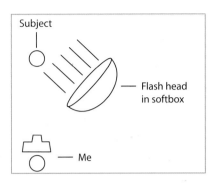

Subject

Flash head
in softbox

Me

when America was colonized—like backward, primitive people. However, they have a very organized belief system and society; it's just different from ours. So I wanted to give them a sense of dignity in the portraits.

This series includes a lot of classical posing with subjects looking off camera. Yet at the same time, the images are modern stylistically. I wanted to bring in elements of lighting and color that were different from the typical approach.

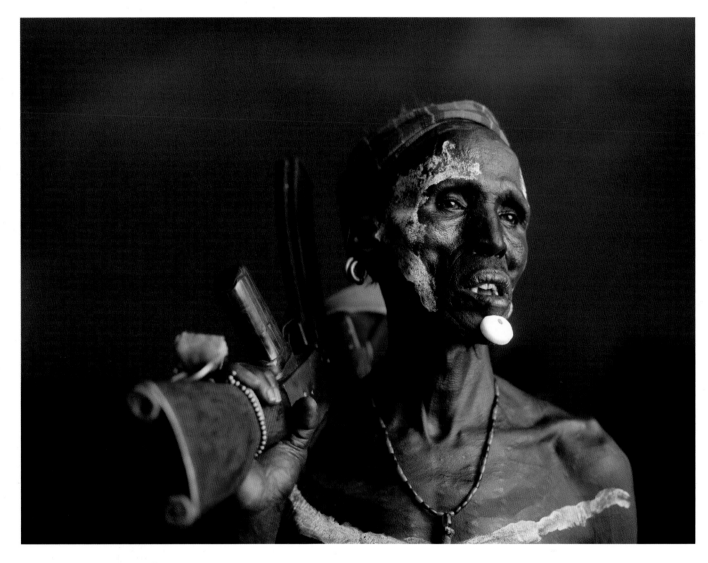

ABOVE An elder of the Karo tribe, Biwa is respected and well adorned as a warrior, carrying rows of scarification representing the enemies he's killed in battle. Posing with his automatic weapon, Biwa demonstrates the contrasts evident in the changing world of the Omo Valley as modern influences become more and more prevalent.

1/60 sec. at f/3.2, ISO 100

OPPOSITE The feathered headpiece of this elder of the Mursi tribe symbolizes a noble warrior who has earned a great deal of respect. I photographed him with the sun behind me, making it difficult for him to look in my direction. He had seen others looking at the lens, so he kept trying to do the same, squinting as he stared into the sun. I suggested that he turn his head to the side, and when he did, it provided the perfect look for this portrait.

1/60 sec. at f.4.5, ISO 100

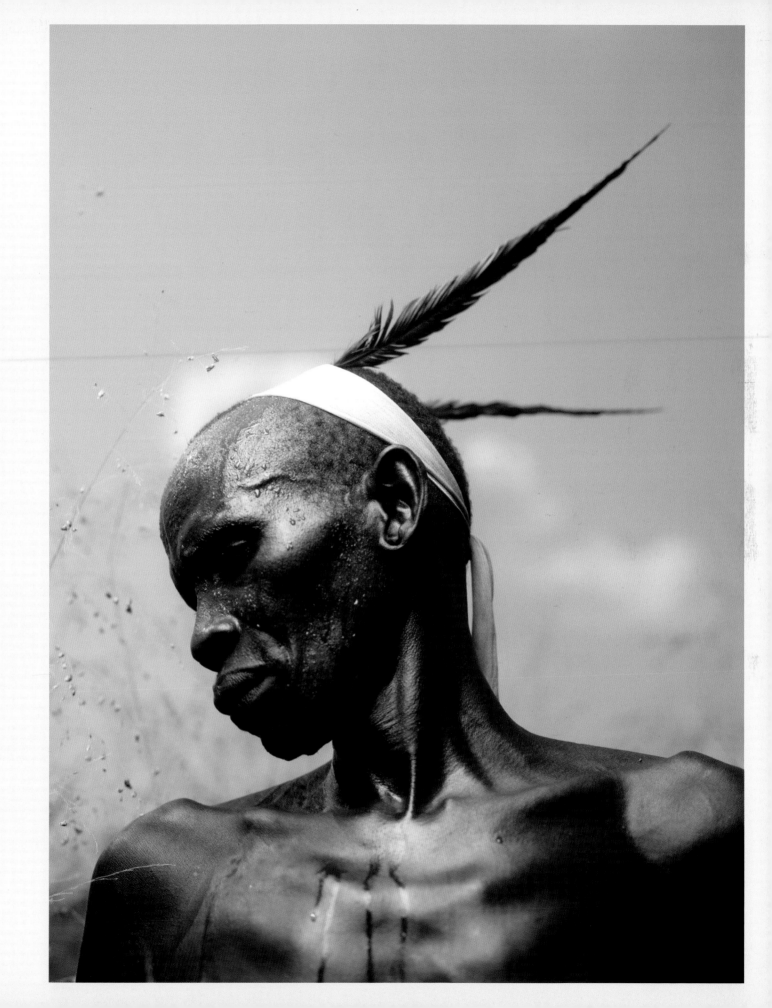

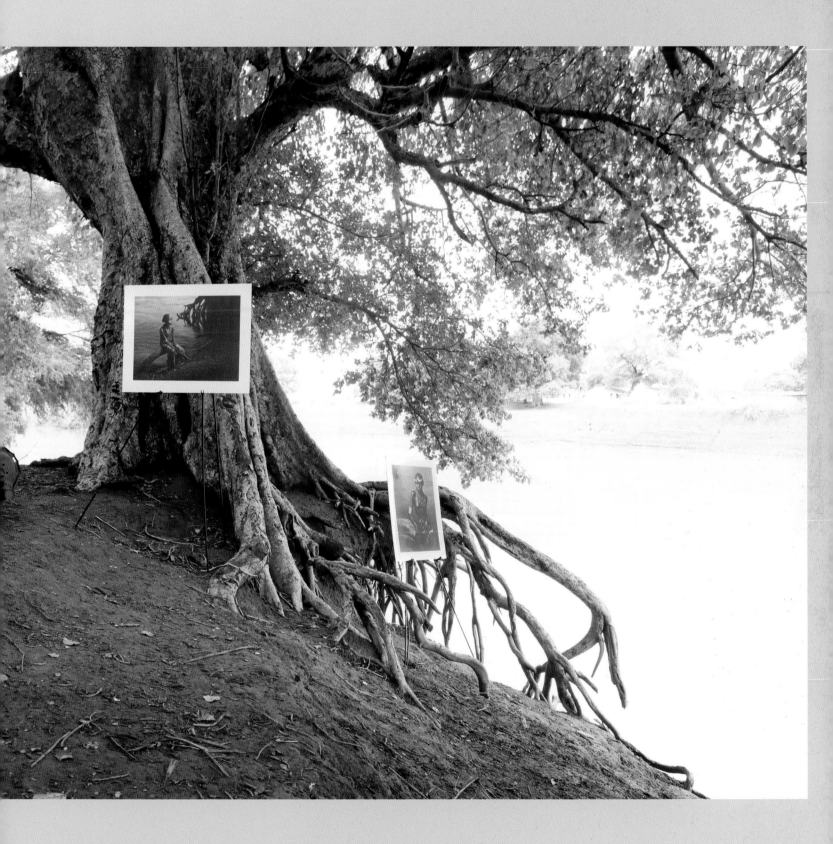

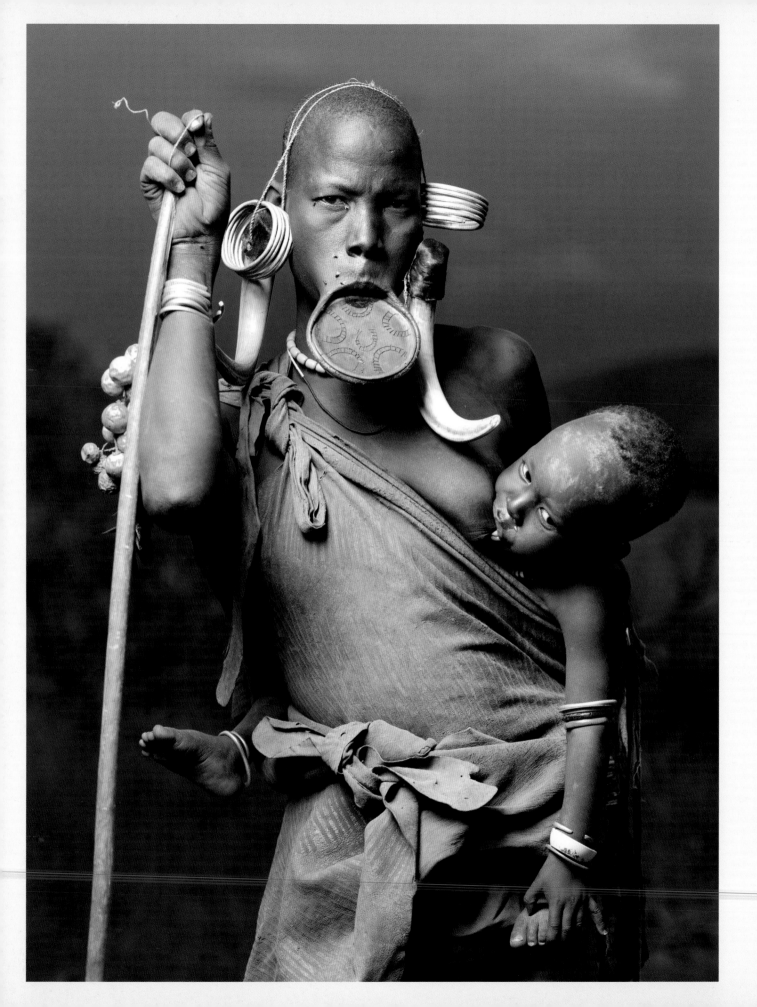

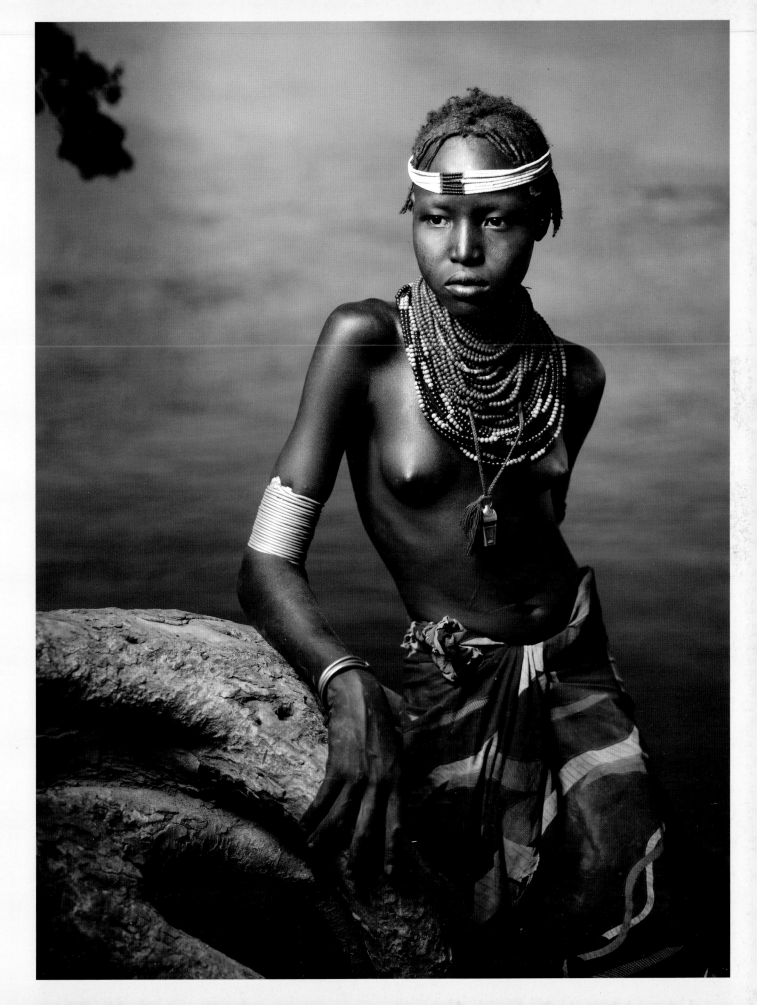

The people of the Omo Valley were usually quite easy to pose because they haven't been inundated by imagery their whole lives. They are unconditioned to commercial images—television, billboards, magazines. I simply set up my lighting, positioned my subject in an area of good light, and then asked him or her to stand there naturally. They didn't pose or make faces they thought were attractive or model-like. They just behaved naturally.

The group compositions took more time. For those images, I did more directing in terms of telling people where to stand and arranging the individuals so there was a natural flow. Usually, I assigned each person a space to stand or sit in, and then I'd see what that person did in the space naturally. Sometimes I told them to look up or down, or away from the camera, but most of the final posing came naturally from the subjects.

Compositionally, the group shots had more complexity. My goal was to find a balance based on what was in the frame—both people and natural elements in the surrounding scenery. This is a process that requires an intuitive sense of flow. How do the elements in the frame draw your eye from one to another? The compositional elements don't have to be symmetrical, but there should be a sequence that grabs your attention and adds interest to the overall image.

RIGHT When you don't have two lights, you can always use the sun as a second light. For this portrait of Rufo, the late-day sun was low in the sky and at the perfect angle to fit in the frame. I used her veil to diffuse the light, providing a greenish hue to the image as the sunlight filtered through the translucent fabric.

1/80 sec. at f/4, ISO 100

OPPOSITE During my third trip to the Omo Valley, I focused my work on a series of portraits conducted in front of a portable black background. My basic photographic fundamentals were the same, but the black backgrounds allowed me to bring even more attention to my unique and fascinating subjects.

1/100 sec. at f/4, ISO 100

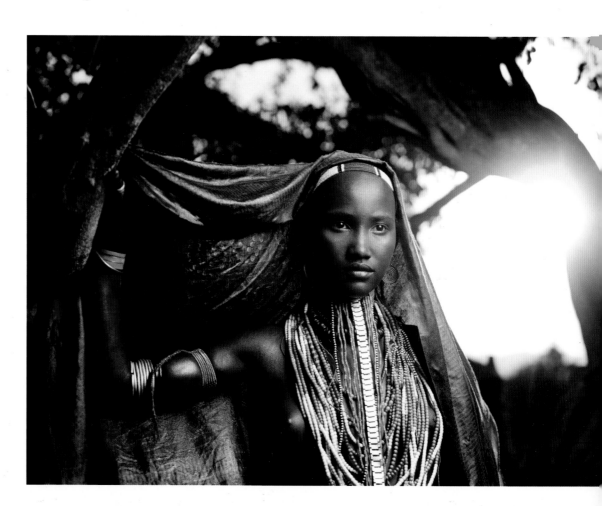

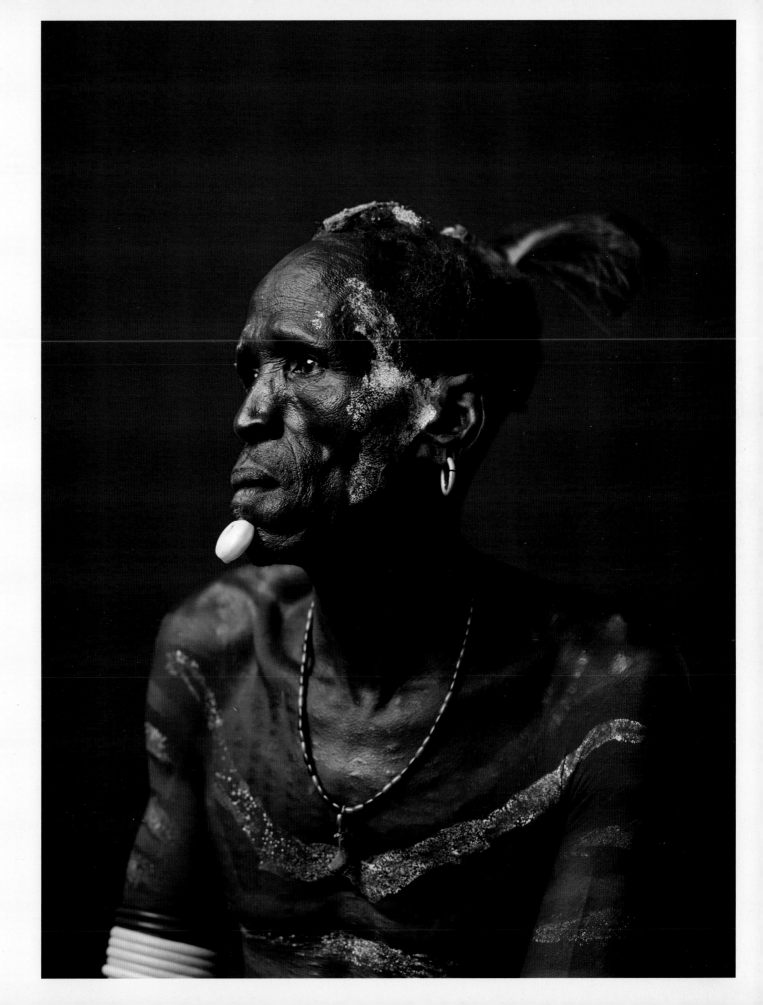

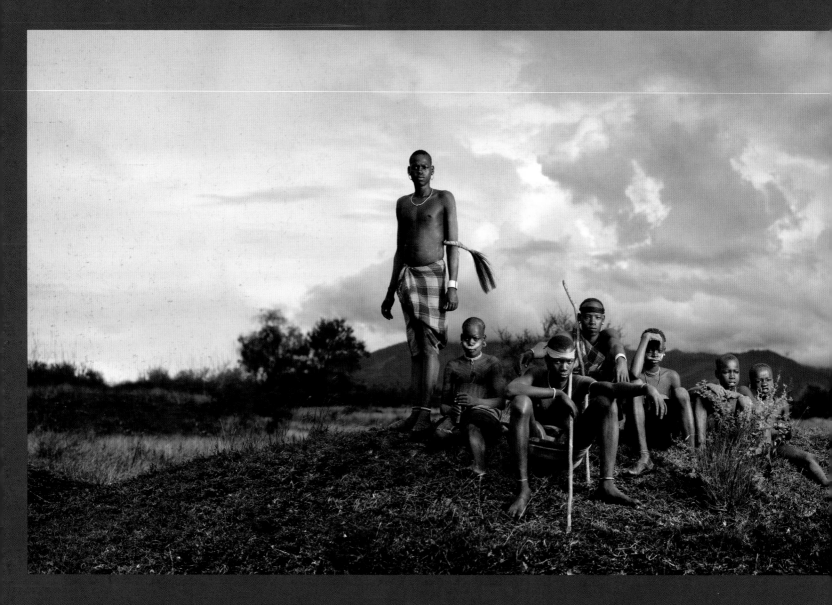

On our way to photograph another tribe, we encountered a funeral for a woman of the Bodi Me'en tribe. The Bodi Me'en have traditionally believed that there is an evil, cannibalistic spirit among them, so when they bury someone, they guard the body for a couple of months to protect it from the evil spirit that may try to steal the body. They have also feared being possessed by this spirit, so they come to the funeral armed and prepared to protect their dead and themselves. Over time the Bodi Me'en's fears have faded, and this has become more of a customary practice, but the superstition still exists among some of the more remote Bodi Me'en clans. As I was photographing the man on the right with the gun, other people came over to see what was going on. This composition just started to unfold, so I took a few steps back and captured the entire scene.

The storm clouds in the sky are typical of this time of year. I intentionally travel to Ethiopia in October or November, at the tail end of the rainy season. There isn't as much rain, but you still get these atmospheric storm clouds, which make great backdrops. The cloudy sky also offers a softer, flatter light that works well with my underexposure technique for an almost painterly appearance.

1/125 sec. at f/4, ISO 100

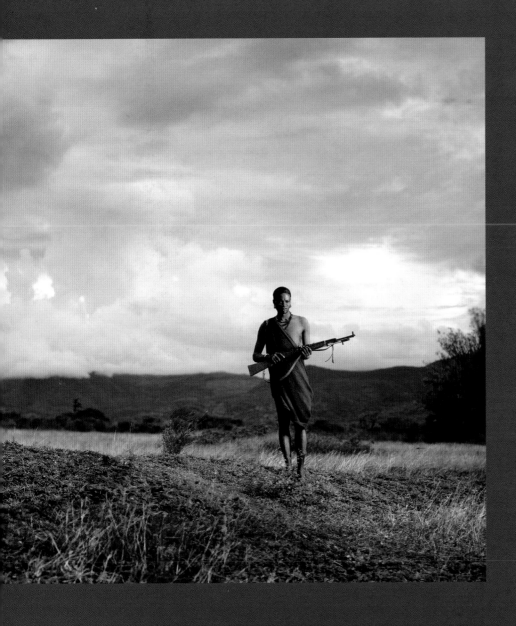

HALLOWEEN IN BROOKLYN

IN 2010, I TRIED DESPERATELY TO GET TO THE MAHA SHIVRATRI FESTIVAL, AN annual Hindu festival celebrating the god Shiva, in Varanasi, India. During the festival, devotees offer Bael leaves to the Lord Shiva, fast all day, and then hold an all-night vigil. Hindu holy men parade around with Rudraksha seeds around their neck as they march toward the Ganges River to take a sacred swim. Unfortunately, a delayed advertising shoot in Dubai forced me to miss the festival.

If I couldn't make it to India for Maha Shivratri, maybe there was an event closer to home that would prove similarly interesting. I started thinking about festivals in the United States and Canada that might appear strange to an outside observer. Halloween came to mind. Although I recognize that Halloween and Maha Shivratri are completely different, they both include elements that seem peculiar to people unfamiliar with the customs. As a photographer interested in people, it's a useful exercise to occasionally step outside of your normal thought process and observe the cultures and traditions around you from a different perspective. When you step back and look at the world as an outsider, you discover new things that were right in front of you all along. Become an observer. You don't have to travel halfway around the world to make engaging, atmospheric portraits of fascinating characters. Sometimes you only have to travel around the block.

I live in the Bushwick neighborhood of Brooklyn, a predominately Puerto Rican and Dominican area that is full of life. Although it's one of the most impoverished neighborhoods in New York, it boasts a rich cultural flavor. On Halloween, the kids' costumes are just as elaborate and creative as they are in any wealthy suburban neighborhood. Parents watch carefully over their children as they walk door to door seeking the next treat. It's Halloween in Brooklyn, and it happens only once a year. My goal with this series was to create timeless images of a popular contemporary tradition that would make viewers feel as if they were looking at photographs of a strange foreign ritual.

This image sums up the series in many ways. The child is in costume but is also wearing a Brooklyn hat, placing him in my setting unmistakably. The chocolate on his face speaks to the candy frenzy that occurs on Halloween. He is facing into the light, with the left side of his face falling into dramatic shadow. The shadow side of his face is still oriented toward the camera, but the head-on lighting illuminates his face clearly, showing the chocolate smudges. I had him position the brim of his hat away from the light, so it wouldn't produce extra shadows that would have obscured his face.

1/125 sec. at f/4, ISO 50

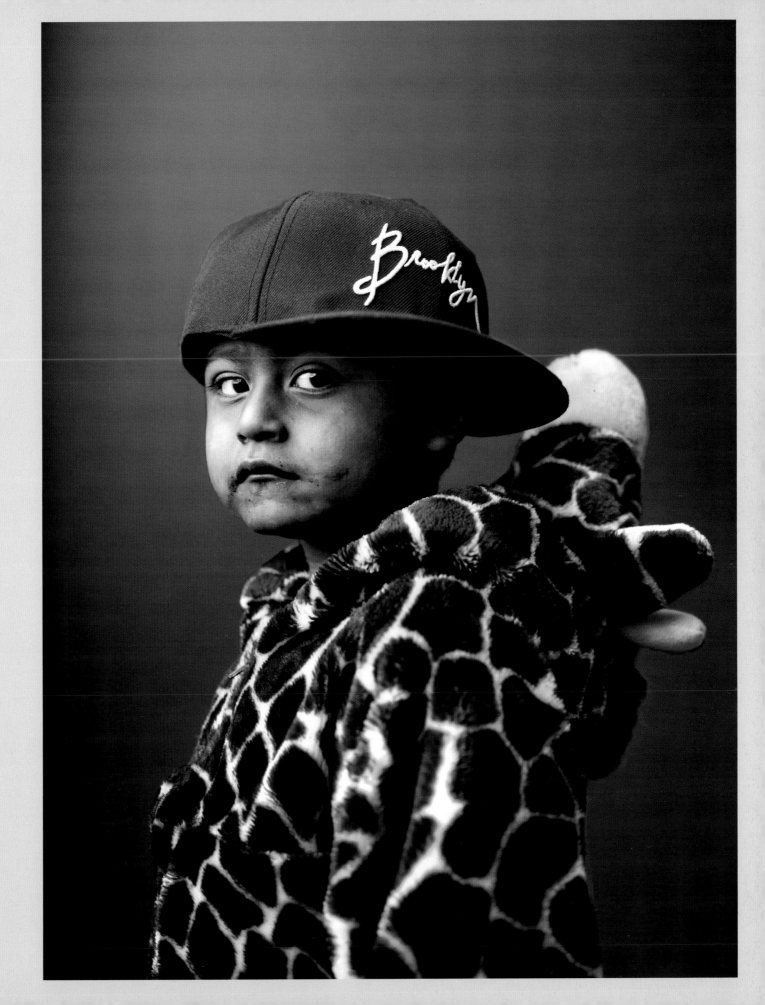

MY BROOKLYN CAMERA BAG

- **Camera:** Phase One 645 camera body with Phase One P 65+ back
- **Lens:** 80mm F2.8 lens
- **Light:** Profoto Pro flash head
- **Light modifier:** Elinchrom Rotalux Softbox Octa
- **Accessories:** Kata Hiker backpack to carry the battery pack; Photoflex Telescopic Litedisc Holder to hold up the background
- **Power source:** Profoto Pro-7b

MAKING IT HAPPEN

I wanted to photograph a series of portraits from the perspective of a foreigner looking in, as if I were making an ethnographic study of all the costumes. I chose to photograph most of my subjects on a black background to focus on the people and their costumes. In many cases, I purposely included the edges of the backdrop in the frame to play off of the "homemade" feel of the costumes. The backdrop separates the subject from the background, but by showing the edges, it suggests that they were photographed on location, outside, on the street. Throughout this series, I worked in environmental shots to place the subjects in Brooklyn, showing some of the sidewalk or the pathway of Maria Hernandez Park.

I used a portable lighting setup similar to my system for the Ethiopia series (Profoto Pro-7b battery pack, Profoto Pro flash head, Elinchrom Rotalux Softbox Octa). This system is mobile, and nothing touches the ground (my assistants held the Rotalux Octa and background and we carried the battery pack in a backpack), so I didn't need a permit—not that anyone

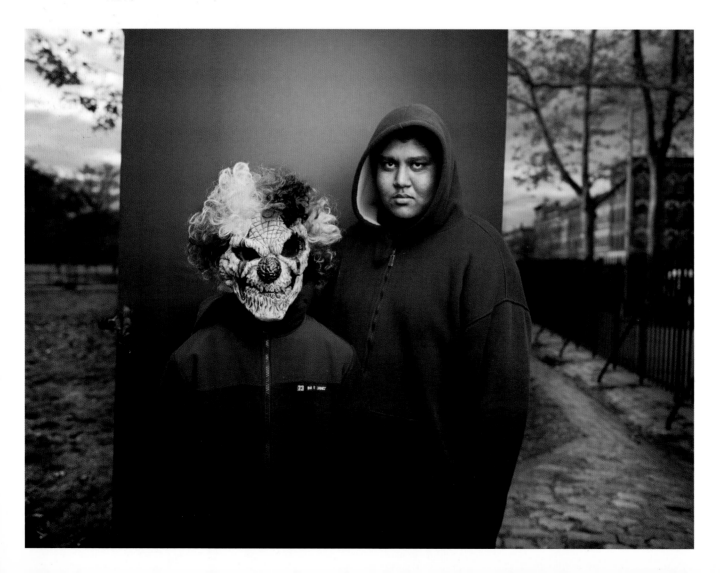

would have cared in Bushwick anyway. The only rule was to be courteous and move out of people's way as they passed on the sidewalk. I had every subject, or the legal guardian of every subject, sign a model release. This covered me for future use of the images and provided a contact address to mail my subjects prints of their portraits.

My background was a simple piece of black foamcore, purchased for twenty dollars from a paint store. I rigged a Photoflex Telescopic Litedisc Holder to the back with an absurd amount of gaffer's tape so that an assistant could hold it. One assistant would stand behind the subject and hold the background upright while keeping herself hidden behind it. My other assistant would hold the light above the subject to camera right or left, aimed down roughly at a 45-degree angle. Both assistants had their hands full, as October 31 was extremely windy that year. There were more than a few occasions when I thought one of them would fly away!

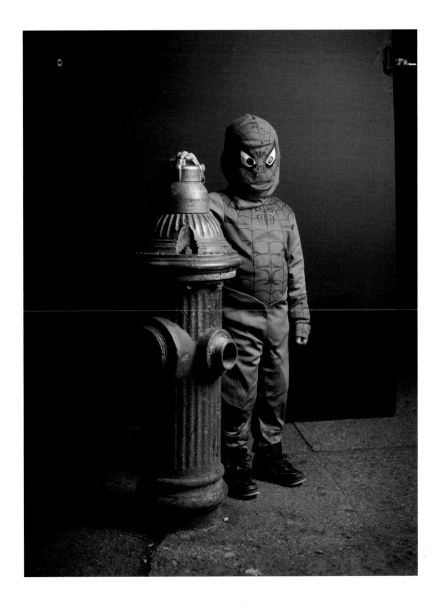

RIGHT While this photo may seem current because of the pop icon represented by the child's costume, years from now it will become a nostalgic, historical image as our superheroes change and people's costumes evolve. That's why I did the series in black and white; these images are pieces of a changing history.

1/125 sec. at f/4, ISO 50

OPPOSITE This image shows two typical kids in Bushwick. One has a mask and the other doesn't, so his hood serves as his Halloween outfit. I chose to compose this image with the park showing on either side of the background. By underexposing the background with the same technique I used in the Ethiopia series, the scenery in the background appears dark and ominous, fitting for Halloween.

1/125 sec. at f/5, ISO 50

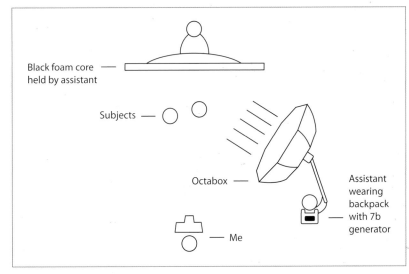

Black foam core held by assistant

Subjects

Octabox

Assistant wearing backpack with 7b generator

Me

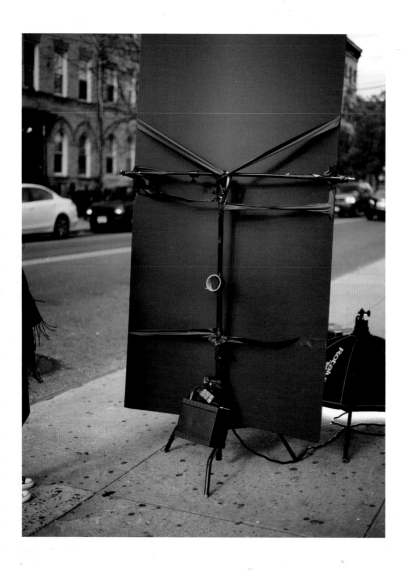

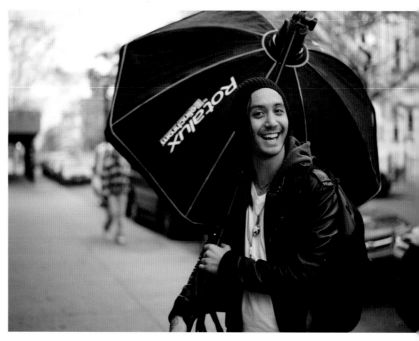

ABOVE My portable studio, complete with mobile backdrop and voice-activated light stand.

OPPOSITE I took two photographs of this child. In the first (not pictured), he's just standing there with his hands down. When he saw the flash go off in the big Rotalux Octa, he must have realized that it was a legit photo shoot, so he decided to get in character for the second shot. He slowly raised his hand in the air like Batman, and I captured this image.

1/125 sec. at f/3.5, ISO 50

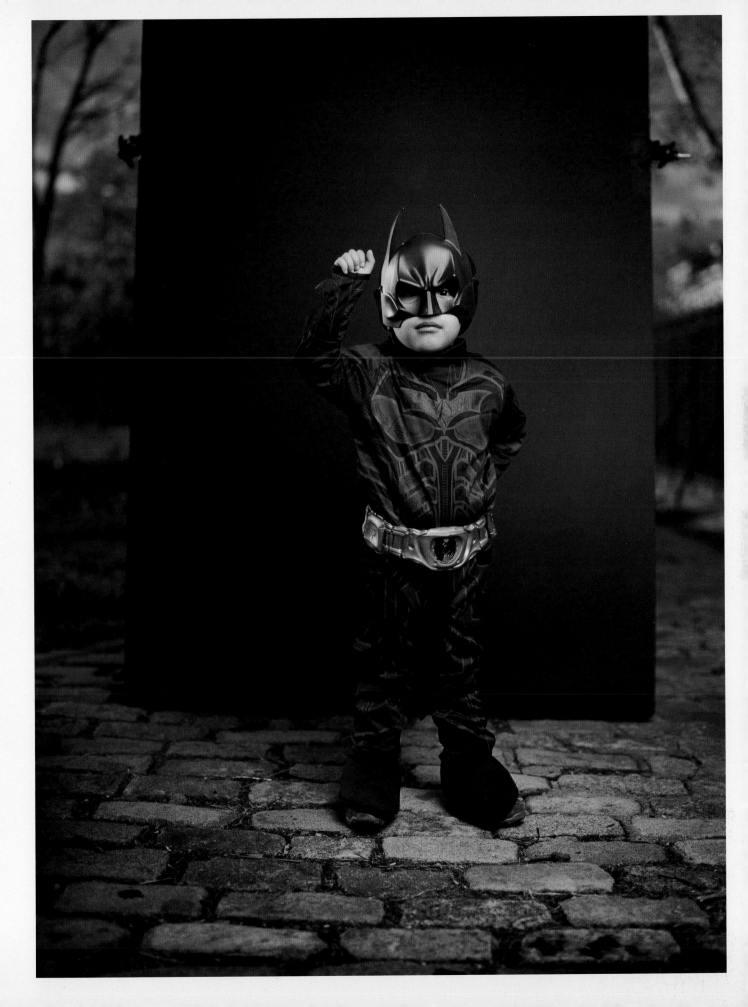

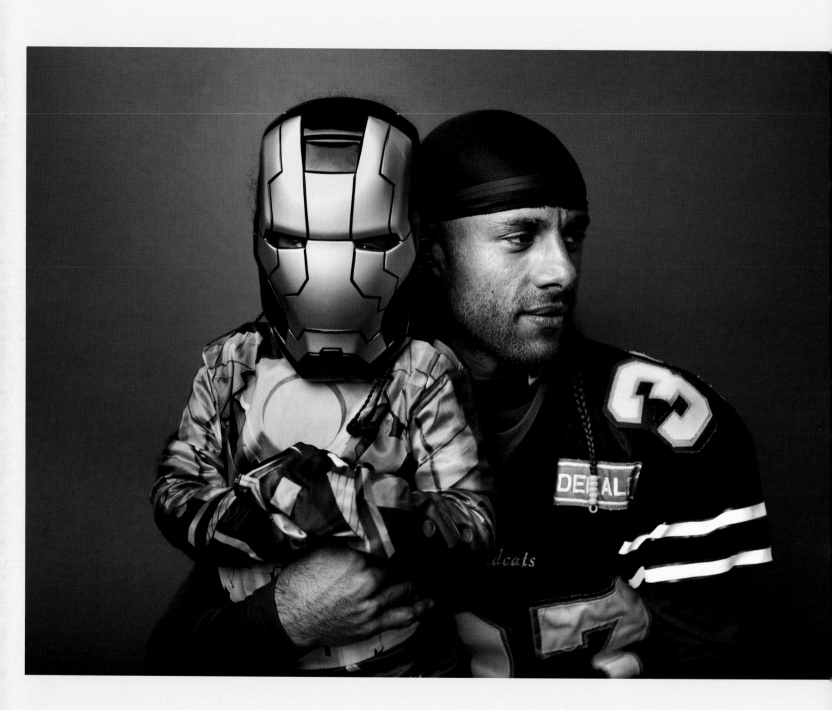

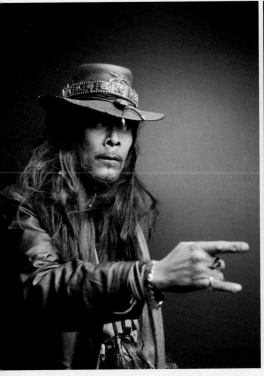
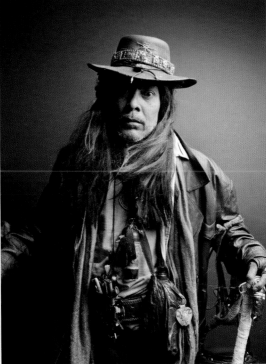

OPPOSITE I love this image because the dad is a big, tough guy, but he's sharing this tender moment with his son. The contrast between the tough guy and loving dad helps make it a touching portrait. The posing is reminiscent of portrait painting from the Dutch Golden Age, when the old masters often posed subjects so that one person makes eye contact with the viewer while the other looks away, off frame somewhere. When done in a landscape orientation, this type of pose can be powerful, giving both a connection to the viewer and a sense of realism to the subjects in the scene.

1/125 sec. at f/5, ISO 50

ABOVE This guy is a neighborhood clown. He's always intoxicated in one way or another. This outfit is his normal attire, with the addition of a wig that he donned for Halloween. This triptych is meant as an interesting commentary on the "characters" that live among us every day.

1/100 sec. at f/4.5, ISO 200

RIGHT With my light shining from high and to camera right, aimed down at this little girl at about a 45-degree angle, I produced strong shadows on the far side of her face. I prefer a higher-contrast look in black-and-white images, hence the more pronounced shadows here. The effect also matches the dark atmosphere of the series as a whole.

1/125 sec. at f/3.5, ISO 50

OPPOSITE To pose this Brooklyn boy in his homemade costume, I turned him to his left and asked him to focus on a point of reference off camera. My light was above him and held to camera right, so it illuminated the far side and part of the front of his face. As is typical in my portrait work, the shadow side of his face is turned toward the camera, displaying moody shadows that match the dark costume.

1/125 sec. at f/5, ISO 100

This series was more rushed than many of my other personal projects, since I set up and conducted all of the portraits in one day. Fortunately, people in Brooklyn are accustomed to photography, so I didn't need to familiarize them with the process. I just explained the purpose of the project and how the images would be used. Also, my neighbors are used to seeing me working around the neighborhood, and when they saw the lights and backdrop, many came over to ask how much it would cost to get a portrait. When I told them it was free, and I would mail them a photograph later, most were excited to participate.

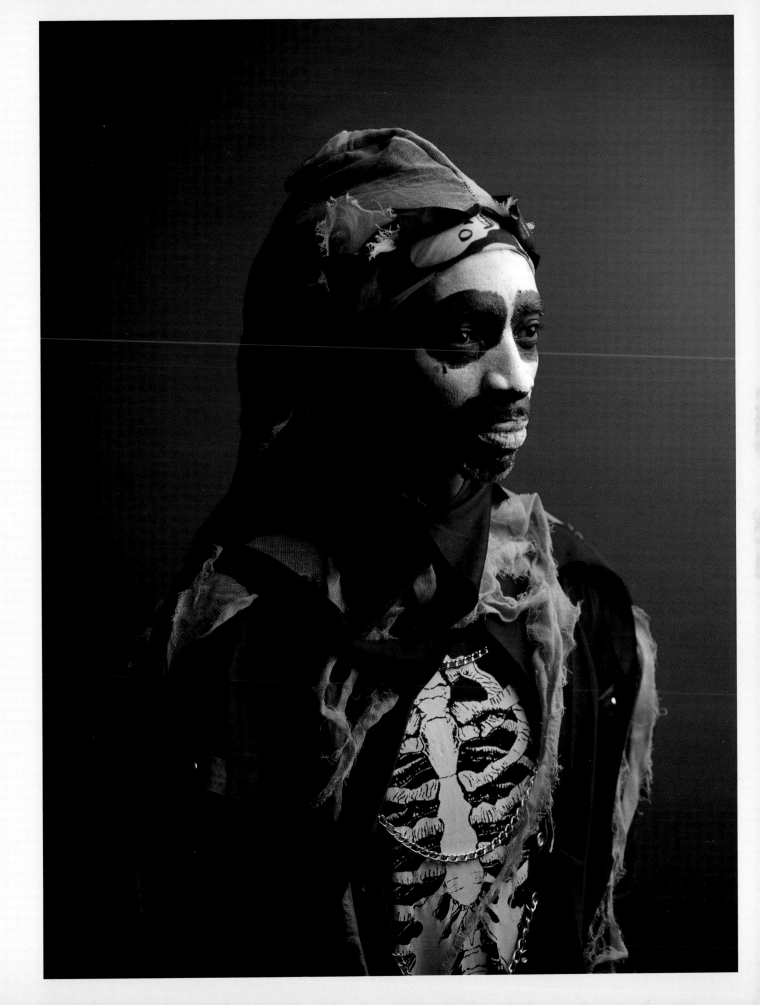

THE HOLY MEN OF VARANASI

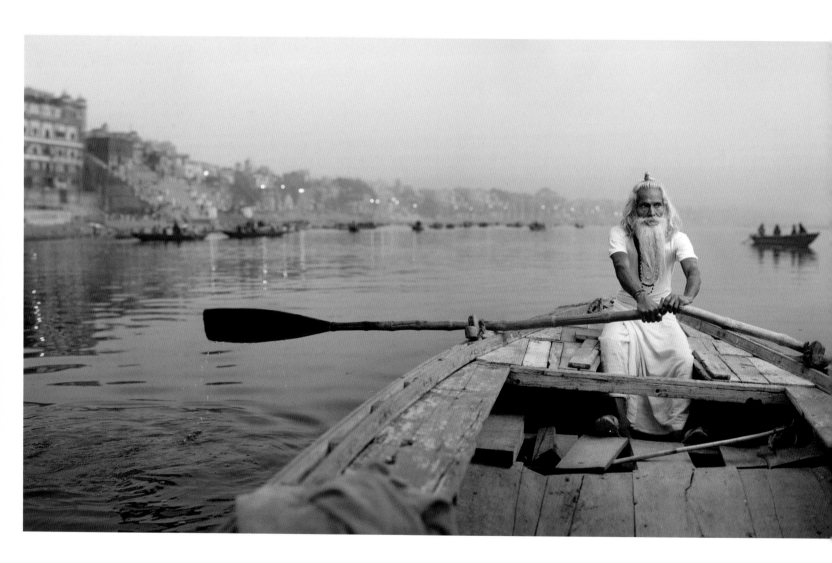

I first photographed this sadhu, Baba Vijay Nund, when I was sixteen. At the time, I thought his portrait was the best picture I'd ever taken. When I returned home, I sent a 4 x 6 print of the image to his ashram. During my third trip, I was walking down the street, and we ran into each other. He asked me to follow him to his tent by the river, where he took out a ziplock bag and pulled out the photo I had sent him years before. He had virtually no possessions, but he had my photo carefully preserved in a plastic bag. I was extremely flattered that he'd kept the photo, and absolutely humbled by the respect he expressed toward my work. Also, he was showing me that he trusted me and respected what I was trying to accomplish with my

photography. So I started working with him on more involved portraits, including this image of him rowing down the Ganges River. For this portrait, Vijay sat on one side of the rowboat and my assistant and I sat on the other. While my assistant held the Elinchrom Rotalux Softbox Octa aloft and aimed it down at Vijay, I photographed with the atmospheric lighting of dawn illuminating the river and city behind him. The rising sun lit a layer of fog that was blanketing the river, providing a soft haze in the background.

1/100 sec. at f/4, ISO 100

FOR THE PAST FIVE YEARS, I'VE BEEN WORKING ON A SERIES OF
portraits of the sadhus, or Hindu holy men, who reside in Varanasi, India.
I went there for the first time when I was sixteen, after saving up some cash from
my first few professional photo shoots of rock bands. The Varanasi project offered
an opportunity to photograph the diverse religious cultures of Varanasi, which is a
holy site for Hinduism, Buddhism, and Jainism. Built on the banks of the Ganges
River more than three thousand years ago, Varanasi is one of the oldest continually
inhabited cities in the world. The sadhus are a type of ascetic, wandering monks
who have renounced earthly possessions in their pursuit of *moksha*, or spiritual
liberation.

Over the course of three trips, my images of sadhus have evolved stylistically.
As my relationships with these men have grown more substantial, I've tried to
create increasingly insightful portraits that not only demonstrate the sadhus' deep
spirituality but also their individual personalities. The images in this chapter are
from my third visit, in March 2011.

Afterward, I imported the images into Adobe Photoshop and added a black-
and-white layer, which I turned down to low opacity so the colors underneath
were desaturated but still visible. Then I ran them through the blue channel in the
Channel Mixer. This technique is similar to the days of film when labs would put a
blue filter over the camera lens when shooting black-and-white film, pulling certain
qualities from the light to get a unique contrast effect. I prefer this type of contrast
and high texture in my black-and-white images, and the digital version of the blue
filter technique provided this look perfectly.

MY VARANASI CAMERA BAG

- **Camera:** Phase One 645 camera body and Phase One P 45+ and P 65+ backs
- **Lens:** 80mm F2.8 lens
- **Lights:** Two Profoto Pro flash heads (one for backup)
- **Light modifier:** Elinchrom Rotalux Softbox Octa
- **Accessories:** Two PocketWizards (one for the camera and one for the battery pack); set of Lee neutral density filters at 0.3, 0.6, and 0.9 increments
- **Power source:** Profoto Pro-7b battery pack

MAKING IT HAPPEN

Photographically, I started with many of the same basics that I discuss in "The Cradle of Mankind" chapter. I worked with one light, a Profoto Pro flash head in a 69-inch Elinchrom Rotalux Softbox Octa, and carried a portable power source to run my mobile studio lighting system. I positioned the light above the subject, to one side of the camera, and aimed it down at about a 45-degree angle, working with the feathered light to create atmospheric lighting on the subject. I also used neutral density filters and underexposed the background in the same basic manner that I describe on pages 57–58.

However, the way I applied light and exposure was much different than in the Ethiopia series. With these images I wanted a softer look, something more blended into the natural light, as opposed to the intentionally dramatic lighting I applied to the Ethiopia portraits. Here I underexposed less and brought in more of the ambient light. With more natural light, I needed less flash power to illuminate the scene. The more flash power you use, the more you're dependent on the artificial light source as the defining light in your image. I wanted the ambient light to be my defining light and the flash to just complement that natural light, not dominate it. Because I was working so intimately with the natural light, I had to be more conscious of that light—where it was shining, how it was affecting the subject, the colors it produced in the background. Then I adjusted my flash accordingly.

Because these sadhus are hermits and tend to keep to themselves, I almost always photographed them alone to portray that sense of intentional, spiritual isolation. With this sadhu, who was in his eighties and had about fifteen feet of dreadlocks wound up in his turban, I wanted an image that was intimate and secluded. I took him across the Ganges to the unpopulated side of the river. Varanasi is a city on one side and a big desert on the other. People don't live on the desert side because of monsoon floods, so it has an open, beachlike atmosphere, particularly early in the morning when it is empty. While we were photographing, a group of birds landed nearby and the noise startled my subject. As he turned to look at them with this curious expression, he was still perfectly aligned in my lighting setup, with the Rotalux Octa shining from above and to camera left, so I captured the image.

In some of my other fine art series, like the Ethiopia project, I would have completely underexposed that sun to make it look very dramatic. However, in this image I wanted a more subtle feel, so I didn't underexpose as much, turning the just-risen sun into a soft orange flare rather than a dark, moody orb. The exposure also brings in more natural light so you don't notice an obvious artificial light from the flash.

1/100 sec. at f/3.5, ISO 50

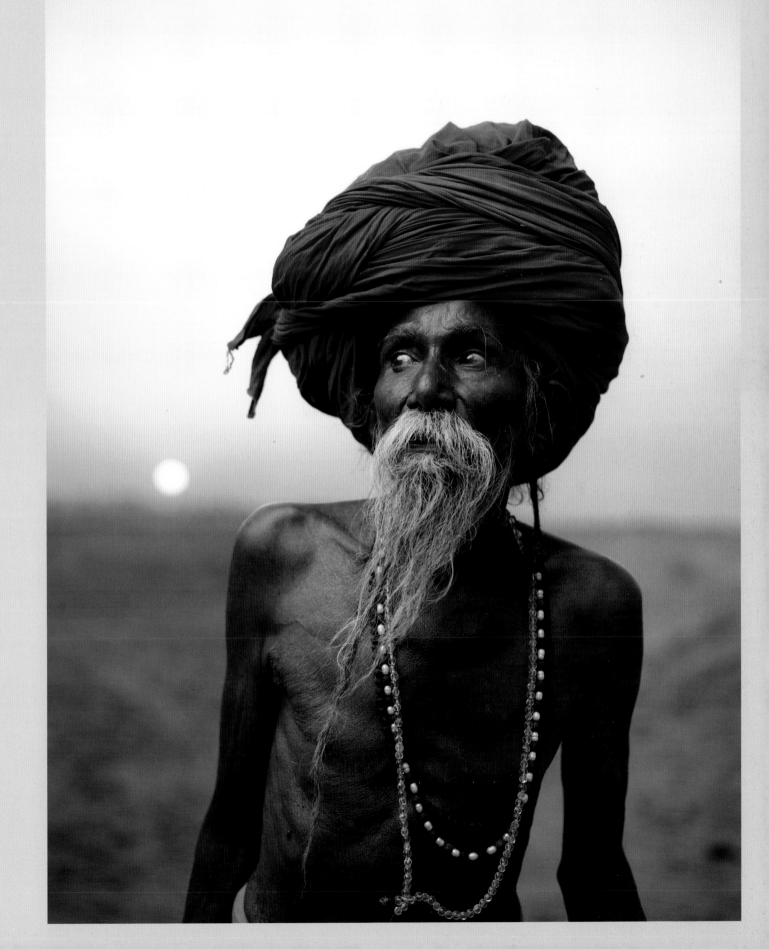

The Varanasi series is all about the sadhus' connection to this spiritual place. Over the course of several visits, I got to know these holy men, build a sense of trust, and gain a better appreciation for their bond with the holy city. To illustrate their bond to this unique place, I wanted my subjects to be part of their environment, which meant the colors and light of the background were more important to the compositions than in some of my previous fine art portraits. I started each portrait by photographing my subject with nothing but natural light. Then I would review the image and think about how I could add some light very subtly, very naturally, and unobtrusively—just a little fill, a little enhancement that would show an artistic hand without overpowering the composition.

I shot most of these images with the flash on reduced power and used less direct angles for the light. When using a light source like the Rotalux Octa, which produces a dappled pattern of highlight and shadow, very subtle changes in angle and power can make a tremendous difference in the style of the light. An inch to one side might be more dramatic and full of contrast. An inch to the other side might be softer, more seamless, more integrated with the ambient light. When I talk about the difference of mere inches, this is what I mean.

Of course, the time of day has a profound impact on the quality of light. In Ethiopia, I was an opportunistic shooter. I tried to work primarily at sunrise and sunset, but I always had my camera with me, and if I came across something interesting in the middle of the day, I'd photograph it. Shooting at midday necessitated a stronger flash to counteract the harsh daylight, which meant a more overt light. During my last trip to India, I shot all of my portraits before 8:00 a.m. I restricted my photography to the couple of hours at the beginning of the day, and then I spent the remainder of the day planning my next shoot and spending time with the people of the city. It was a much better way to work, and the benefits of the soft morning light are evident in the images.

I consider these images a big step forward in terms of my fine art portrait style, an evolution from more bold, noticeable lighting to a subtler approach that cooperates more with the ambient light. The fundamentals are the same, to maintain a critical sense of cohesiveness across my different fine art projects. However, these images show a more delicate hand applying the light, one that just touches up the image to augment what nature provided, rather than overpowering it. In these images, my added light is my own little twist on the composition, just a bit of stylization to take the photograph beyond pure reality and make it a work of art.

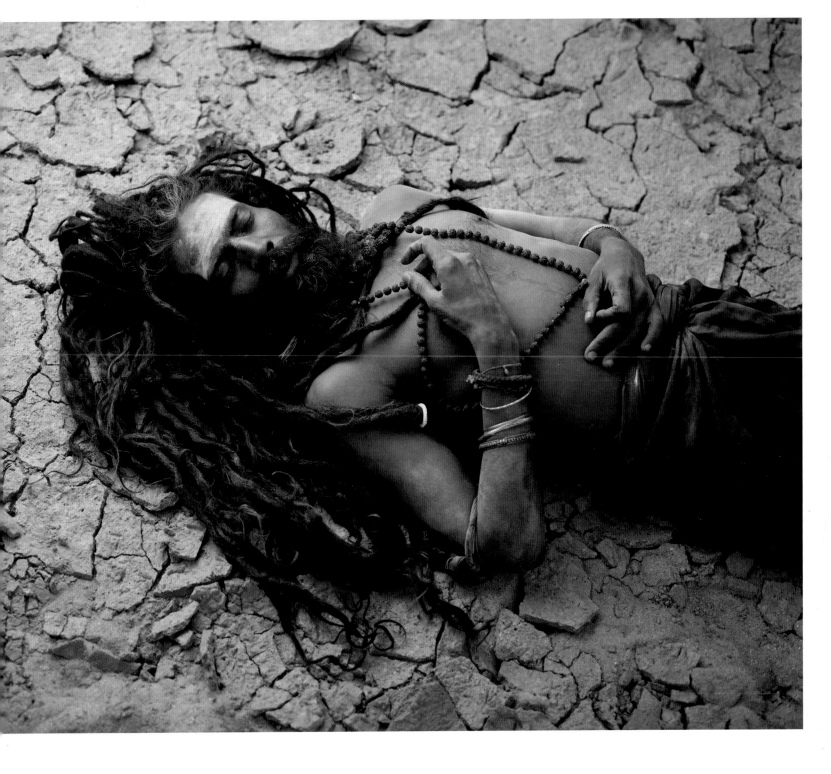

This sadhu is Aghori—a sect that believes in a very strong connection with the dead. These holy men will meditate on the dead and put human ash on their own bodies before doing rituals. Because of this, they view the world as a type of illusion and do not find death a fearsome concept. After staying up all night and watching this sadhu conduct his religious ritual, I asked him to lie down on the dirt in the predawn light. The idea was to illustrate his connection with the afterlife by positioning him on the parched, cracked, dead-looking earth in a pose reminiscent of death.

The colors in this image are the true hues from the early morning light, just before the sun rises, when a deep blue-purple sky lights the landscape. The only thing I did with the flash was light him very slightly from above and to camera right, just to add a light wash and bring out some detail. The flash power was not high enough to change the colors or have a profound impact on the image. This type of pose can look staged, but because of the subtle combination of natural and artificial light, it works.

1/125 sec. at f/4, ISO 50

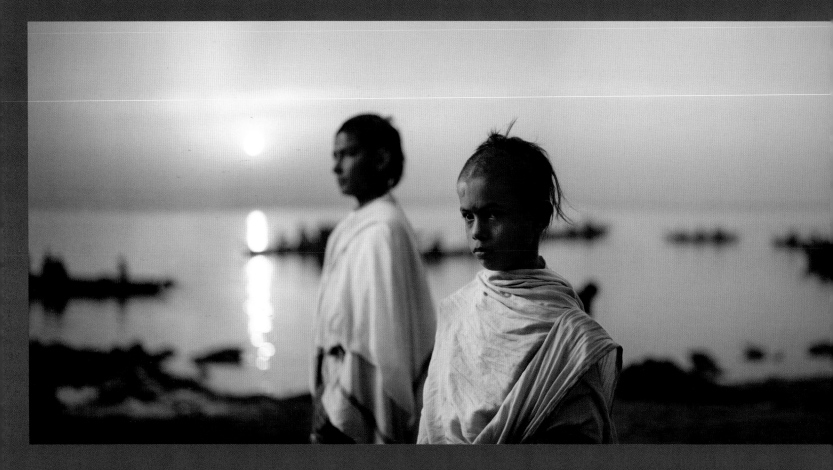

ABOVE This image is one of the few from this series with multiple subjects. These boys are not sadhus; they are Batuk students in a religious school studying to be Brahmin priests. They are in a community at this point in their lives, so I made their portrait together.

The image is actually three panels stitched together in Photoshop. Hand-holding the camera and carefully adjusting its orientation, I made three exposures: one of the kids, then one to the left, and one to the right. I centered my subjects in the final composition, which breaks the rule of thirds, but the image is so long on both sides that it provides balance, preventing it from being overwhelmed by the nearest subject's head in the center of the frame.

My assistant held the Rotalux Octa high and to camera left, aiming down at the boys at a roughly 45-degree angle. As in many of my portraits, the shaded sides of the subjects' faces are closest to the camera.

1/100 sec. at f/2.8, ISO 50

OPPOSITE While deeply committed and serious about his rituals, this sadhu, Magesh, is a bright and cheery guy, very happy, so I wanted to create a brighter portrait that fit his personality without relying on a cheesy smile. I captured this image about thirty minutes after sunrise, when the blue and purple hues had been replaced by the whites and yellows of morning. I put the sun right behind him so it flared out a bit. My assistant held the Rotalux Octa directly above the subject's head so that his entire face is in the light. The flash power is low, though, just a pop to match those whites and yellows in the background. This direct approach to the flash brightens up the image and gives the subject a holy presence. I also let more of the ambient light into the picture so the background turned into a creamy, soft glow that complements the fully illuminated face.

1/125 sec. at f/4, ISO 50

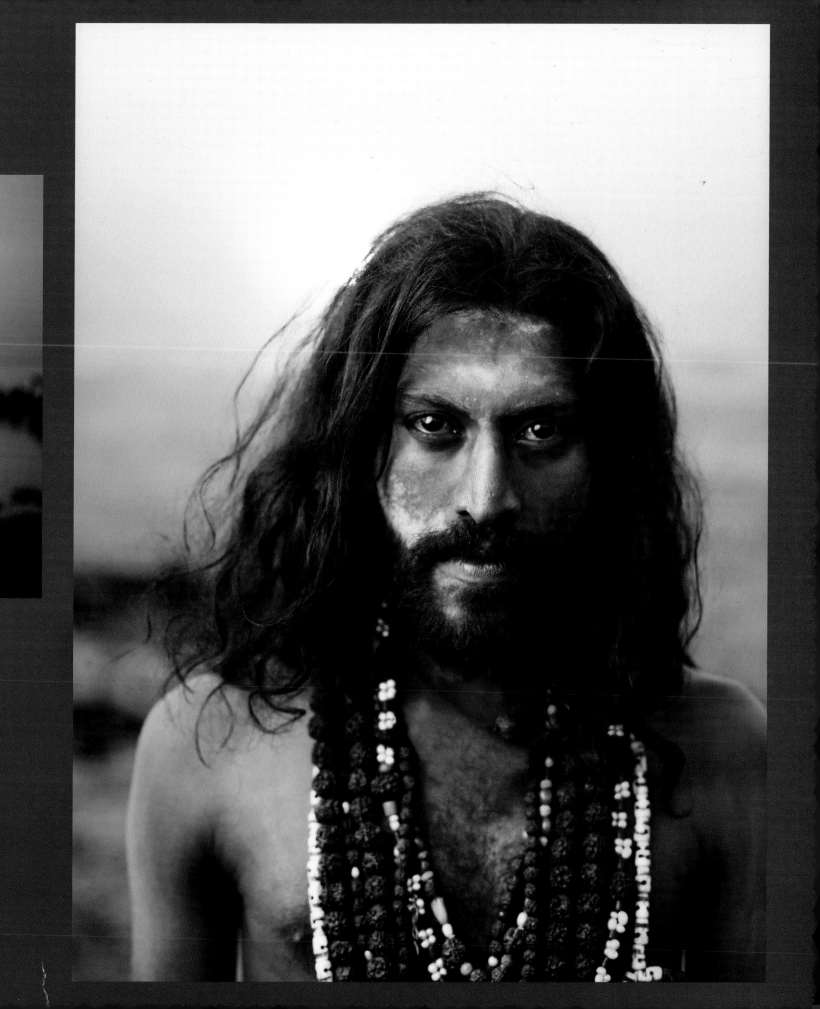

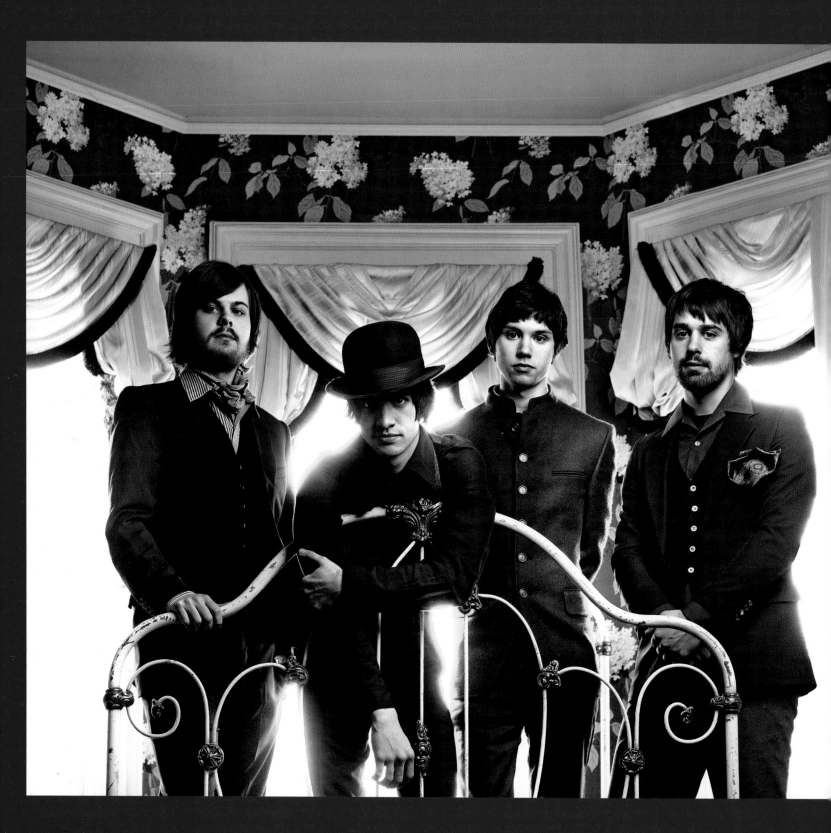

MUSIC PORTRAITS

My professional career got its first toehold through the world of music photography. After shooting several local bands around my hometown, my work caught the eye of a couple rock band managers, who hired me to photograph their clients. From those first few assignments, I started traveling around with bands, creating images for press kits, album packaging, and promotional campaigns. Many of these shoots took place on the road or with limited resources.

Music industry shoots are often fast-paced and low-budget, but there is a degree of creative freedom that can be beneficial to developing a signature style and personal vision. I often used the same additive lighting style described earlier, starting with a basic foundation and then adding lights as needed for a more polished appearance. This process works well in these types of multisubject shoots, where the client wants several different looks produced in a short period of time. I later found that this overall working style transferred well to bigger-budget, higher-profile commercial advertising jobs.

Working with the music industry also helped me learn to work under pressure and produce professional imagery quickly using the materials around me. For some of my first shoots, I employed a variety of homespun methods to get the job done, such as making scrims out of bedsheets and reflectors out of aluminum foil. Since I was often balancing the demands of high school, I didn't have a lot of time for Photoshop enhancements. This situation forced me to get my images right in camera and produce a nearly final image on set.

PROTEST
THE HERO

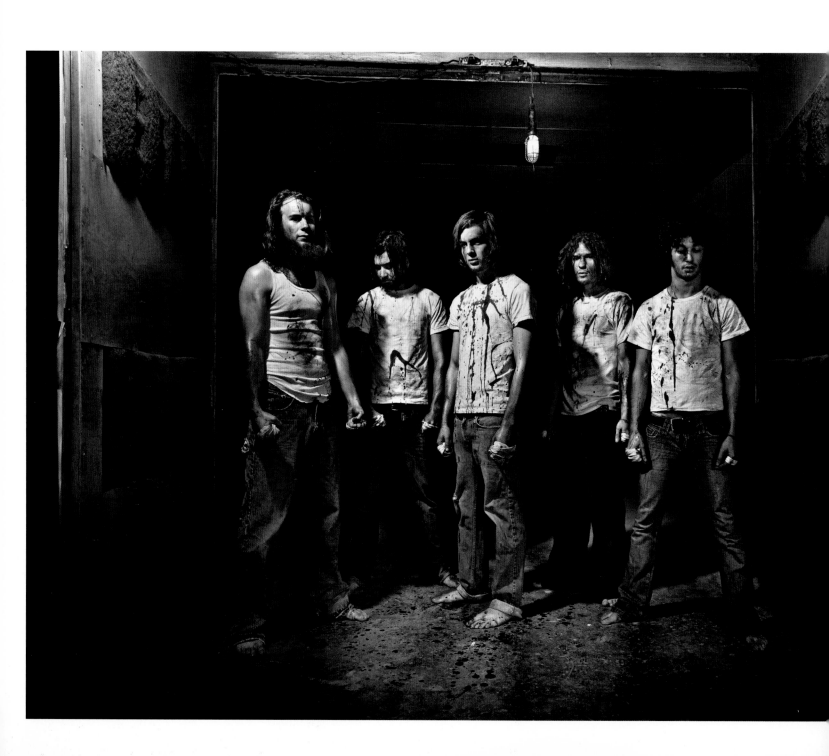

For this group portrait, I used the same one-light setup as for the group fight shot on page 90, but I held a longer exposure to soak up more ambient light. That gave the image a slightly brighter appearance, though still dark and moody overall. I asked the guys to stand in front of me in a group formation, and then turned the outside guys' shoulders slightly inward to draw the viewer's eye toward the center of the composition.

1/200 sec. at f/9, ISO 200

THIS WAS ONE OF MY FIRST REAL PROFESSIONAL JOBS WITH A BAND, WHICH

I did when I was sixteen. I'd been photographing some local bands in Lindsay, Ontario, and building an online portfolio of images. Protest the Hero's manager found me and hit me up to do this shoot. They were going on tour in Japan and needed images to promote that tour. We produced photographs for a full press kit, which included pieces for editorial submissions, posters, promos, and social network updates.

We staged the shoot in my dad's paint shop in Lindsay, and the band traveled to me to conduct the project. Back then I did it all—makeup, setup, cleanup, and everything in between. It was a very, very different situation from my current working methodology, which typically involves hopping all over the planet to shoot on location per my clients' requests.

After I did this shoot, Protest the Hero's manager took me on as a client and served as my first photo agent. He sent me all over North America photographing metal bands. I worked with him for about a year and then signed on with an agent who works full time with photographers. I mention this because I felt it was a highly productive experience for my career. I like the idea of working with people who can push you toward interesting clients, maybe in nontraditional ways. Whether or not they are proper photo agents doesn't always matter. Yes, it helps to know the ins and outs of the photography industry, and a good photo agent is a valuable asset. But the most important thing is the collaborative spirit involved when you work with someone who believes in your work.

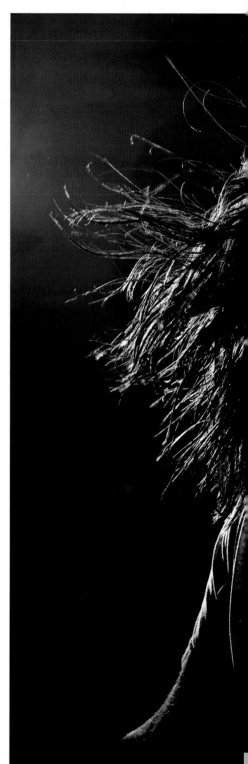

- **Camera:** Canon EOS 5D
- **Lenses:** 85mm F1.8 lens and 28-135mm F3.5-5.6 lens
- **Lights:** Two Speedotron flash heads
- **Light modifiers:** Softbox and Speedotron zoom reflector
- **Power source:** Speedotron generator plugged into a wall outlet

MAKING IT HAPPEN

This was a concept I'd wanted to do for a long time—several guys beating the hell out of each other in a dark, moody setting. Protest the Hero's music is aggressive, a thrash metal style, so the theme fit well.

The subjects needed to have a sweaty, greasy look, so I applied sunflower oil to their skin and had them rub it in lightly. When you sprinkle a little water on top of the sunflower-oiled skin, it beads up like raindrops on the hood of a freshly waxed car. This method works great for creating the look of sweaty skin. It also adds shine and allure to nude models or swimsuit models posing in beach or pool scenes.

To re-create the look of blood, I made a concoction out of food coloring, water, glucose syrup, and sugar. When you mix this solution to a thicker consistency, it works well on people's skin, since it won't run as much. A thinner consistency works better when spattering it on walls or other objects. As an added bonus, it doesn't taste half bad.

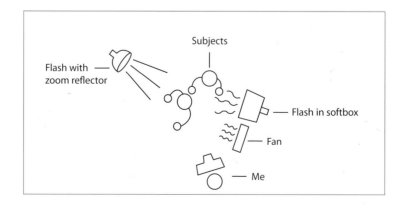

In this staged action shot, the guy getting punched leaned back while a fan (set up just out of frame to camera right) blew in his face to flutter his hair and accentuate the sense that he's in motion. We staged a slow-motion swing like in the group fight shot on page 90, cueing the puncher to swing and then the punch recipient to spit out a mouthful of fake blood. The combination of these movements, careful posing, and the fan provide the illusion of impact from the punch.

To light the scene, I placed a studio flash in a softbox to camera right. The shadow sides of their faces are toward the camera. Another flash with a zoom reflector shines from behind and above to illuminate their hair.

1/200 sec. at f/11, ISO 200

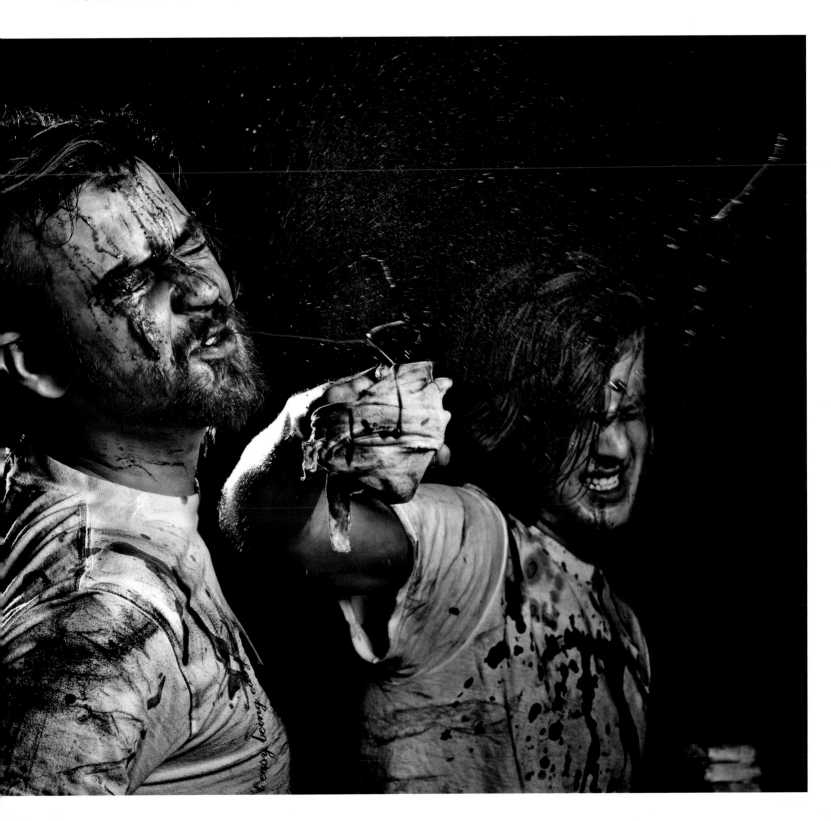

RIGHT I created this image to run on the cover packaging for a single called "Blood Meat." I lit the scene by placing a flash head modified by a zoom reflector high and to camera left, pointing down toward the band to produce harsh shadows. The single bulb that's visible in the picture only provides ambience; there's no noticeable light that significantly impacts the image. To produce the look of a fight, I asked one guy to swing slowly above the other's face, and at the right moment, the guy on the ground would spit out a mouthful of fake blood. I cued my subjects in this action, instructing one to start swinging slowly and then telling the other to spit as I hit the shutter button.

1/200 sec. at f/9, ISO 200

OPPOSITE After the group and staged action shots, I made individual portraits of all the band members. This is my favorite of the bunch. I lit the scene with one studio flash in a softbox, positioned high and to camera left, aimed down at the subject at roughly a 45-degree angle. After applying makeup and fake blood, I posed him to look serious.

1/200 sec. at f/11, ISO 50

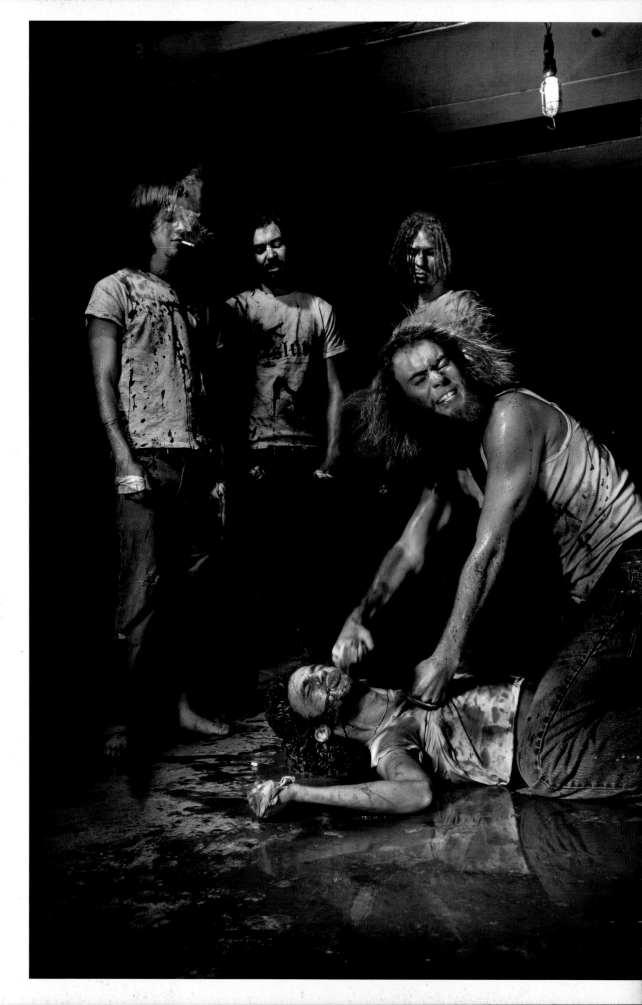

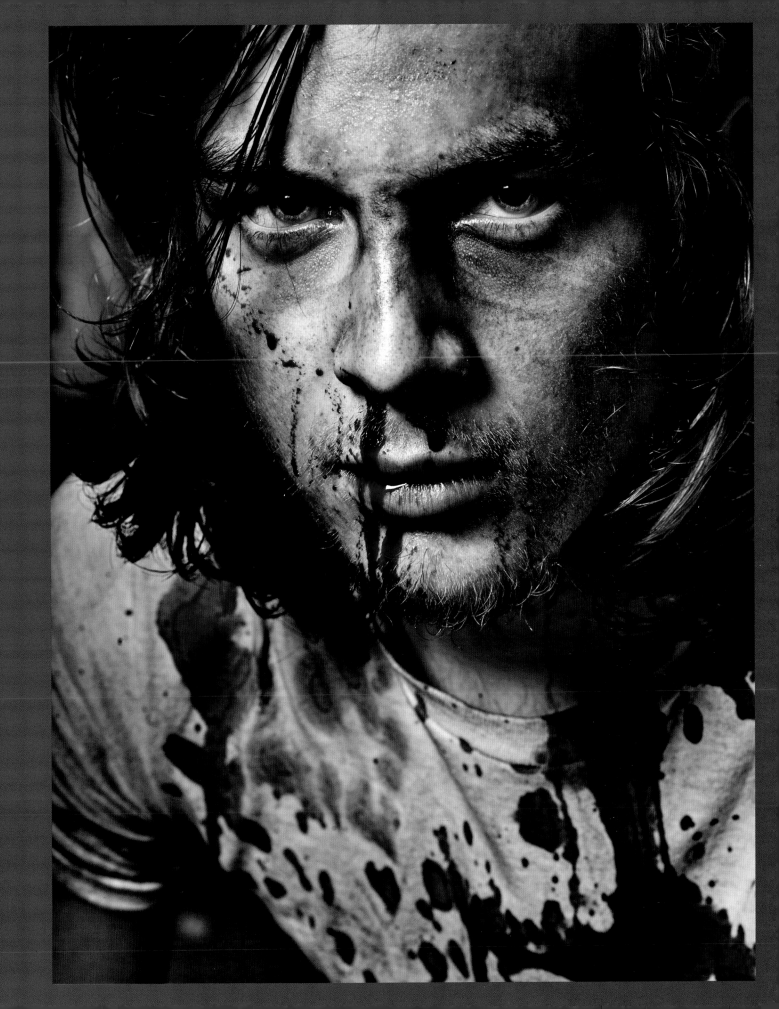

DAVID DRAIMAN
OF DISTURBED

THE SHOOT WITH DISTURBED FOR THE PACKAGING OF THEIR *INDESTRUCTIBLE* **ALBUM** was one of the highest-profile jobs I landed early on. As such, I wanted to impress people right off the bat. I was committed to offering something unique.

My concept, which played into the "indestructible" theme, involved things breaking all around the band while they remained unaffected. I did a variety of shots with the band and the individual members, but the portrait of lead singer David Draiman was by far my favorite.

The guys from Disturbed were incredibly nice and a real pleasure to work with. A lot of things went wrong on this shoot, including the power going out in the building, but they were very patient as we worked through the issues. There weren't even any complaints when we had to rewire all of the lighting setups to get them to work with the fickle electrical system. Sometimes things happen out of the blue, and you need to keep a cool head or everyone else starts to worry.

To create the dark and grungy mood of this image, I used a corrective color balance to make the blues more pronounced and give the portrait a colder color temperature. To accomplish this, I opened my camera menu, went to Picture Style, and then selected White Balance. Then I set a custom white balance function of "K" for Kelvin and adjusted the temperature manually to my choice. For this image, I selected 5,000 Kelvin. This creates a cooler look with more blue hues. You can produce the opposite effect, warming up your image with more reds and oranges, by reversing the above process and reaching into higher numbers, such as 7,000 Kelvin (normal daylight is usually rated around 5,400–5,500 Kelvin). If you shoot in raw format, you can tweak and redo these same functions later in a raw conversion program such as Adobe Photoshop Lightroom or Phase One's Capture One. For this shoot, it was better to do it in camera so my clients could see the results instantly.

1/125 sec. at f/22, ISO 800

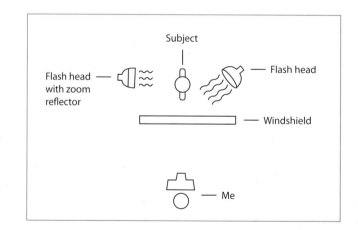

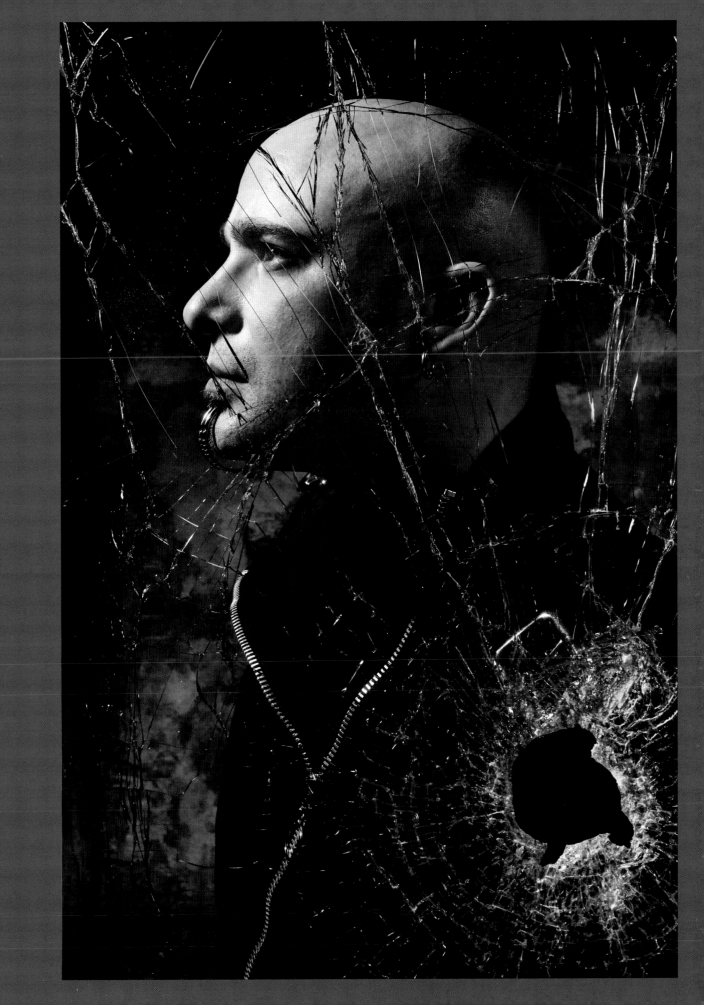

MAKING
IT HAPPEN

I wanted to overlay broken glass in front of David's face to create the look of a shattered window in front of the subject. Some photographers would have captured the portrait and then added the broken glass effect later in Photoshop. However, as I already mentioned, I was out to impress, and I knew they'd want to see the images on my camera's LCD screen during the shoot. As a very young photographer at the time, I felt it was important to produce interesting images on set that I could show the band and art director to quickly gain their respect. When you show people a knockout image while you're still on set, it instantly earns their respect because they see that you can deliver. It also helps them understand exactly what you're going for with the shoot, which leads to better collaboration for the remainder of the session. It's much more difficult to express your concept by asking people to imagine what the final image will look like with all the Photoshop effects applied.

To make the portrait of David Draiman, as well as some similar images of the band, I bought three broken windshields at an auto body shop and smashed them up with a crowbar. From these three smashing attempts, I chose the destroyed windshield variation I liked best. I set up that battered windshield in front of the subject, posed him on the opposite side of the hole in the glass, and photographed through the windshield. To light this scene, I used two flash heads. I modified the first light with a zoom reflector and set it up to camera left, on the far side of the windshield, a bit above the subject and pointed down toward his face. I set up the second light to camera right, angled similarly but pointed just a touch more toward the camera, so the light skims across the windshield and brightens up the cracks in the glass without causing any reflections. You can see a little hint of the light on the back of David's head. Background illumination came from ambient light. It came out dark and grungy, but that was the intentional mood of the image.

Matt Varnish, the well-known art director who was working with Warner Brothers on this shoot, provided some guidance, mainly to ensure that I was capturing the material he needed to create a successful package for the album.

After David's portrait was complete, I used the same lighting setup to photograph each of the other band members in front of the broken windshield. This portrait is of drummer Mike Wengren. Mike's hand rests against the glass, drawing our attention to it. The effect would have been very hard to make believable if the glass had been a texture added in Photoshop.

1/125 sec. at f/22, ISO 800

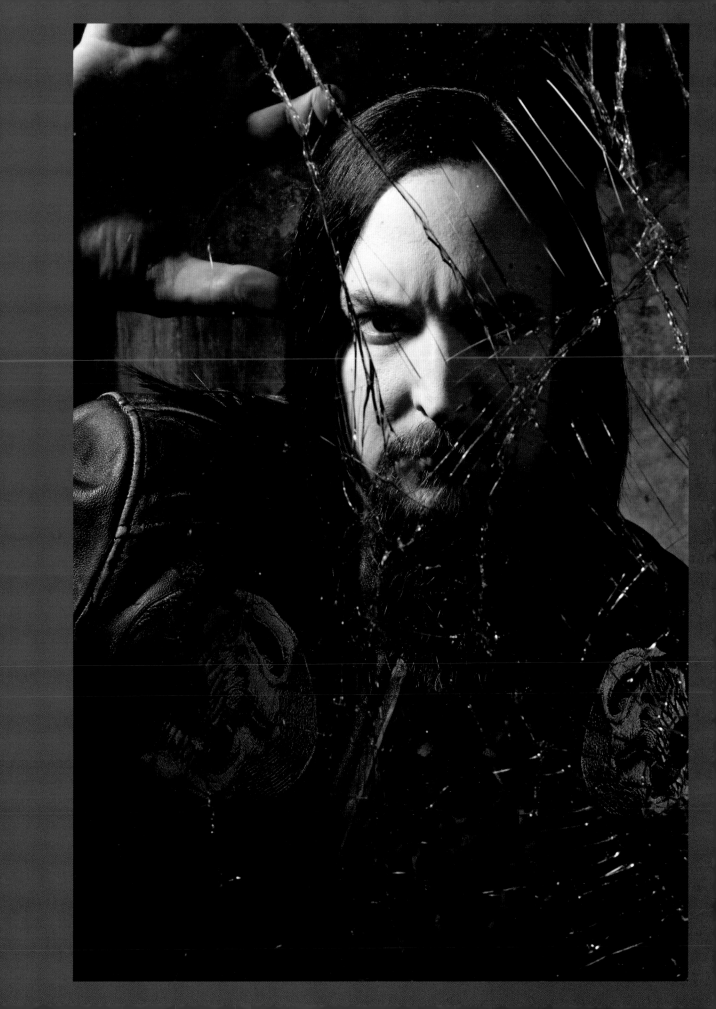

ERIC NALLY OF FOXY SHAZAM

ERIC NALLY OF THE BAND FOXY SHAZAM HAS BEEN A FRIEND OF MINE FOR years. I've known the band since I first started photographing musicians. When I wanted to stage a shoot to showcase some techniques for my instructional DVD series, Eric was the perfect subject. He's a very theatrical front man who dances with his microphone stand, kicks it around, throws it in the air, and does all kinds of other moves. I thought it would be interesting to capture his stage presence and energy in a shoot, but when I spoke to Eric by phone prior to the shoot, he suggested taking it a step further.

Eric came up with the idea of lighting the microphone stand on fire to add an element of danger and drama. Since I was conducting this shoot on my own, I had full creative control. So I said, "Let's do it!" The flaming mic stand was a good way to show color—the warm tones of the flame against the cool hues of the sky. Illustrating that interplay of color became the main objective of this image.

We did this portrait after finishing the shoot with the flaming microphone (see page 99). Working with my Phase One camera and an 80mm lens, I set up a similar lighting structure, placing my main light with the modified lamp globe and CTO gel to camera left, just off frame and slightly above the subject's face. However, I took a lot of the CTO gel off the light and pushed the light closer to the subject. When a light is close to a subject's face, it takes on a softer quality, more like a flattering beauty light. In a setup similar to the one for the fire image, I put another Profoto flash head with a zoom reflector behind the subject, just off frame to camera right. The light separates him from the background and provides some edge brightening along his left side.

I wanted the smoke to be subtler here, so instead of blowing it across the frame, my assistant moved it up and down to waft across the entire frame for a lighter, less prominent appearance.

In postproduction, I tweaked Eric's bangs a bit in Photoshop because they were blowing in the wind during the capture. Everything else in the image looked great, so I fixed the hair and kept the rest.

1/125 sec. at f/5.6, ISO 50

- **Cameras:** Canon EOS-1Ds Mark III and Phase One 645 camera body with Phase One P 65+ back
- **Lenses:** 16-35mm F2.8 lens and 80mm F2.8 lens
- **Lights:** Two Profoto Pro flash heads
- **Light modifiers:** Homemade globe modifier, CTO warming gel, zoom reflector
- **Power source:** Profoto Pro-7b battery pack

MAKING IT HAPPEN

We set up the shoot on a large, open rooftop. After establishing my lighting setup, we created the fire by inserting a lighter-fluid-soaked rag inside a hollowed-out mic. To do this, we just unscrewed the top of the mic, emptied out the electronics, and then stuffed the soaked rag inside. When we lit it on fire, it actually burned for about ten minutes, which was great. (Yes, we had a fire extinguisher on hand!)

It was a stormy day, so there was a layer of clouds behind him that gave a moody, swirling texture to the sky. To play up this look even further, I blasted a stream of smoke in front of Eric with a fog machine.

I started my lighting setup by considering the existing light source, which was flat, diffused light from the stormy sky. The light from the burning mic wouldn't be enough to illuminate Eric's face, so I wanted to re-create the look of fire with artificial light. To accomplish this, I used a Profoto Pro flash head modified with a big bulb—the type you'd use in a ceiling fan. This is my inexpensive, homemade version of the Profoto ProGlobe, a bulblike light modifier that produces a soft, 360-degree wraparound light when placed over a bare flashbulb. I purchased my bulb from a website that sells acrylic globe lamp covers, paying a fraction of the price of a ProGlobe, which is a fantastic but pricey item. My bulb didn't mount perfectly onto the studio flash, but I rigged it up with some duct tape and it worked well. I then covered the bulb with some color temperature orange (CTO) warming gel to give the light a warm look, similar to the fire. By placing this light source just off frame, near the flaming microphone, I was able to re-create the light of the fire and better illuminate my subject.

To separate the subject from the background and help him stand out among the smoke and clouds, I placed another Profoto flash head with a zoom reflector behind him, off frame to camera right. This not only provided an edge separation light on Eric's pants and torso, but also enhanced the natural sunlight coming through the clouds. The shiny quality of his leather jacket created a bit of reflection for a nice highlight effect.

From the same basic location as the main light, my assistant held a smoke machine. It was a windy day, which was helpful, because the smoke blew across the bottom of the frame for a windswept look without floating up to obscure the subject's face.

After creating the portraits with Eric, I made a few exposures of the scene without him, just capturing the smoke blowing across the set as well as close-ups of the flaming microphone. Later, in postproduction, these images were useful because I needed to enhance

I wanted the color tones to pan across this image, with orange on the left and blue on the right. The orange appears to be emanating from the fire and the cold blue from the sky. I adjusted the white balance in the camera to play up the cooler colors, which offset some of the orange color from the CTO gel and brought a bluer hue to the natural daylight. This produced an interesting color temperature throughout the image that starts orange in the bottom left and fades into a cooler, bluer appearance in the top right corner.

1/200 sec. at f/9, ISO 50

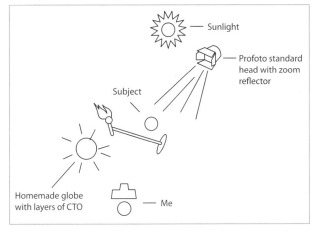

the fire in Photoshop so that it would stand out more against the background and in the midst of my high-powered studio lights. The actual flaming microphone didn't come out too well in the original version before compositing in the flame from another picture. However, using the flaming prop helped engage Eric and encourage the dramatic look on his face.

Since this image involved a lot of quick movements, I used a Canon camera because of its faster speed and quick frame recycle time. As is typical in my work, I underexposed the background for a dark, stormy look.

By the way, if you want to see more behind-the-scenes footage on this shoot and others, visit learnfromjoey.com.

G-UNIT

WHEN THE CALL CAME FOR THIS *VIBE* MAGAZINE SHOOT, I WAS SITTING IN AN airport in New York waiting for a flight back to Canada, where I was still living at the time. The opportunity to shoot G-Unit was a good enough reason to skip that flight, so I rescheduled my return home and booked it to the shoot.

G-Unit is a hip-hop group originally founded by rapper 50 Cent, along with his longtime friends Lloyd Banks and Tony Yayo. The group has a rough, gangsta rapper persona, but behind that facade they are all excellent businessmen. In fact, their business savvy has helped them become very wealthy in spite of the financial difficulties in today's recording industry. The story in *Vibe* was about their business success, about how they make music and simultaneously manage other ventures, like the G-Unit clothing line and record label, and 50 Cent's endorsements of Vitamin Water in exchange for company stock.

With this theme in mind, the magazine wanted to style them in suits, like sophisticated businessmen, instead of the typical baggy clothing you often see hip-hop artists wearing. *Vibe* also wanted to put them in a classy setting. The magazine chose a caviar restaurant covered with mirrors, which was atmospheric but a complete nightmare to light because of the abundance of reflective surfaces. In a space like this, you run the risk of inserting yourself in the image through a mirror reflection, and there's also the problem of the mirrors bouncing your light all around the room in ways you don't want.

The individual portraits of 50 Cent (see also page 104) involved a similar lighting setup as the group shot on page 103, with the main light coming from a Profoto flash head, modified by a beauty dish and focused with a 20-degree grid. Since the main light was above the subject, aimed down at a 45-degree angle, the brim of 50 Cent's hat obscured the light on the upper part of his face. In this straight-on portrait, I left the area around his eyes dark for a sense of drama and mystery.

1/200 sec. at f/16, ISO 200

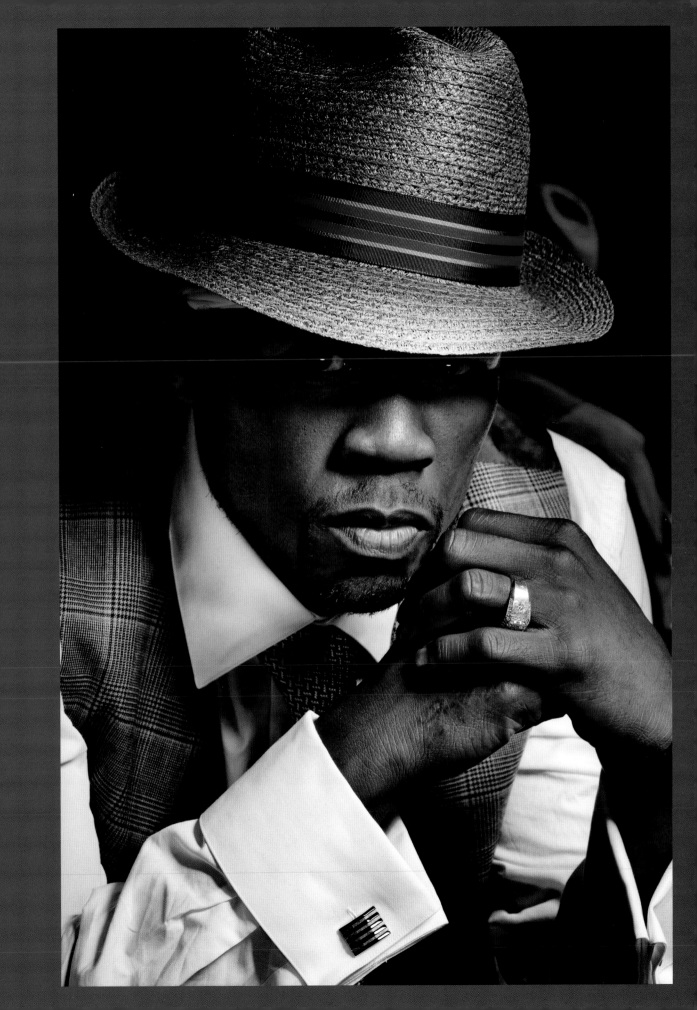

- **Camera:** Canon EOS-1Ds Mark III
- **Lens:** 24-70mm F2.8 lens
- **Lights:** Five Profoto Pro flash heads
- **Light modifiers:** Silver beauty dish, strip softbox, 20-degree grid, snoot
- **Power source:** AC outlet

MAKING IT HAPPEN

When I arrived on set, 50 Cent was initially a bit dismissive. He didn't seem to trust me, probably because I looked like a dumb kid in skinny jeans. But when I started working and he realized that I knew what I was doing, and that this shoot was the real deal, he responded very professionally. This is a situation I've dealt with from time to time, being young and working at a high level with established personalities. Whenever people doubt me, I just have to show them that I know my craft. You can't tell people. You can't insist that they respect you. You simply have to get down to business and demonstrate your skills and professionalism.

On the set that day, part of those skills and professionalism involved working out a solution for all the mirrors in the chosen shooting area. They were everywhere, and one of my normal lighting setups would have been plagued by weird reflections and light rays bouncing all over the place. Since I'm very particular about the directionality of my lighting and the dramatic impact that lighting style produces, I needed to figure out a work-around. In this case, the solution was a combination of careful posing and narrowly focusing all the lights using grids.

For the group shot, I arranged the G-Unit members around a table with a nonmirrored wall as the background. There were mirrors on the walls on either side of the group, just out of frame. I posed the guys very close together for a couple reasons: one, the mirrors on either side of the frame demanded it; and two, my use of a focused light source required them to

This *Last Supper*-style composition allowed me to keep problematic mirrors on either side of the group just out of frame as well as get all three members in the lighting sweet spot.

1/200 sec. at f/13, ISO 200

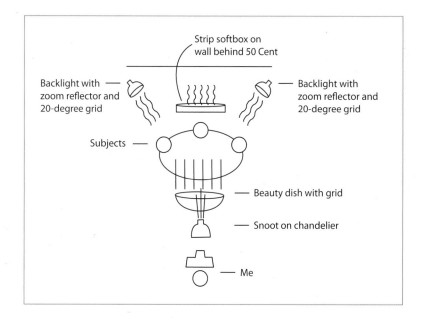

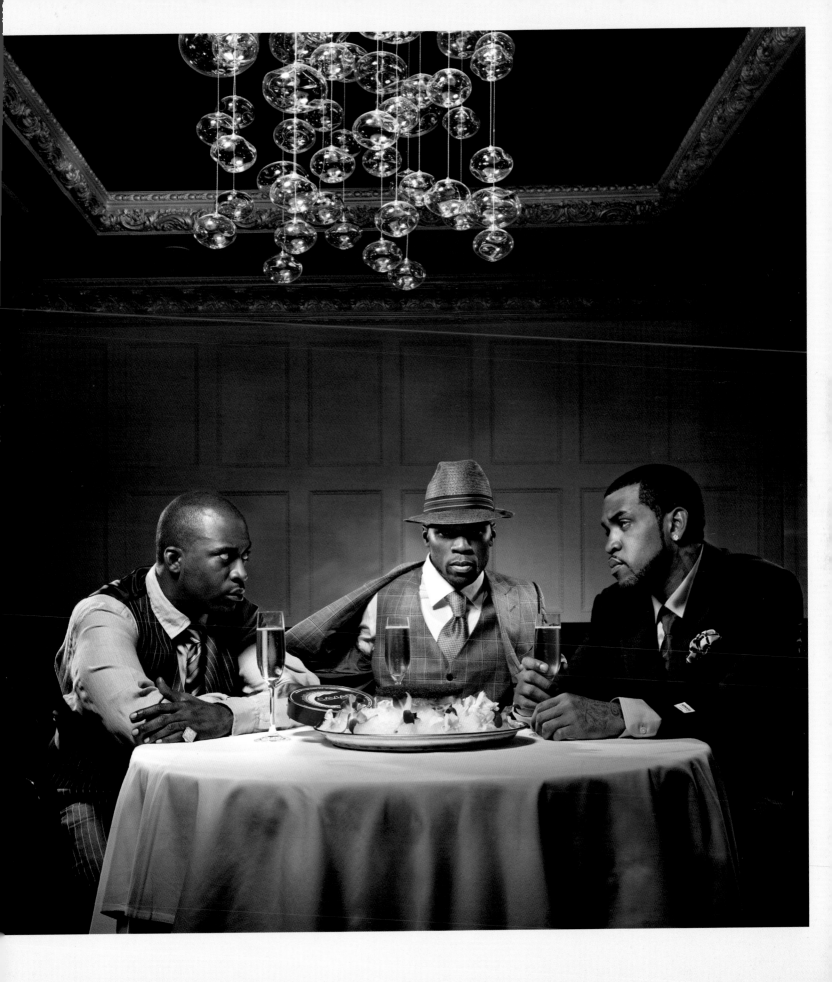

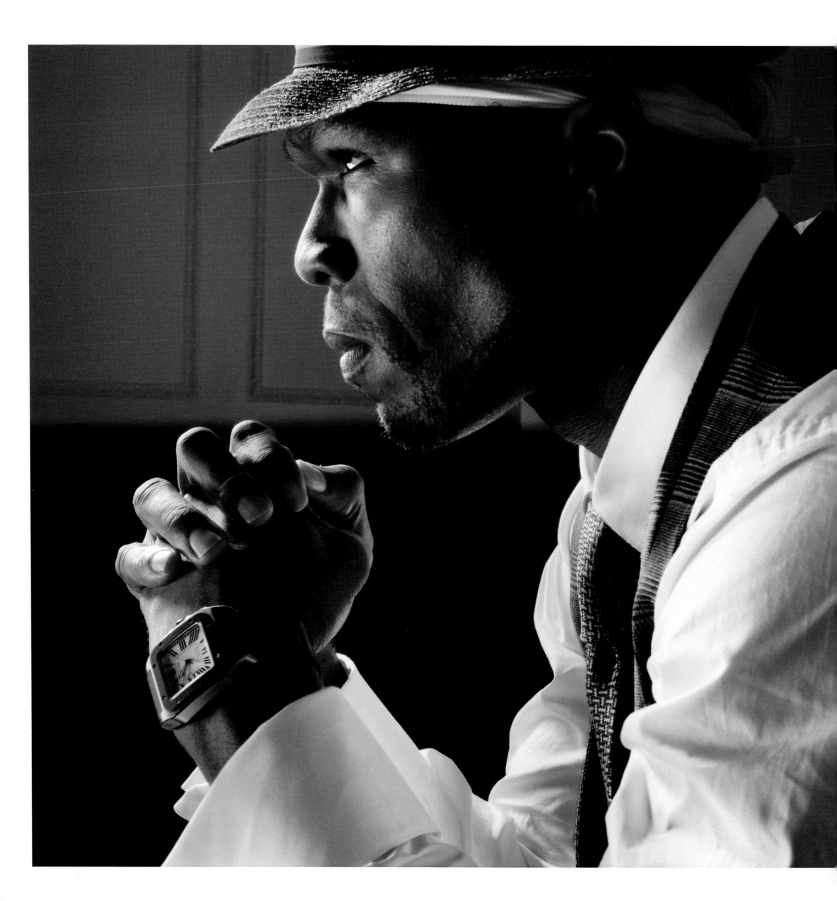

COMMERCIAL PORTRAITS

My commercial work is the most complex from a lighting and logistical standpoint. The images in this section are largely multilight setups with more elaborate scenes. The basics of the style remain the same: I piece things together one step at a time, starting with a simple foundation and adding elements to punch up different parts of the image for a dramatic final composition.

There's almost always a primary light source placed high and to one side of the subject, aimed down at roughly a 45-degree angle. As with my fine art portraits and band photography, I try to use the variable qualities of light emitted from modifiers like the Elinchrom Rotalux Softbox Octa and Indirect Lightbank. However, with the exception of the fast-moving, on-location project for History's *IRT: Deadliest Roads*, there are always other lights used to create a brighter, more commercially appealing look. This is what I mean by additive lighting. For my commercial assignments, I always start with the ambient light, then add my main light, and then additional lights one by one, until the image looks perfect.

IRT: DEADLIEST ROADS

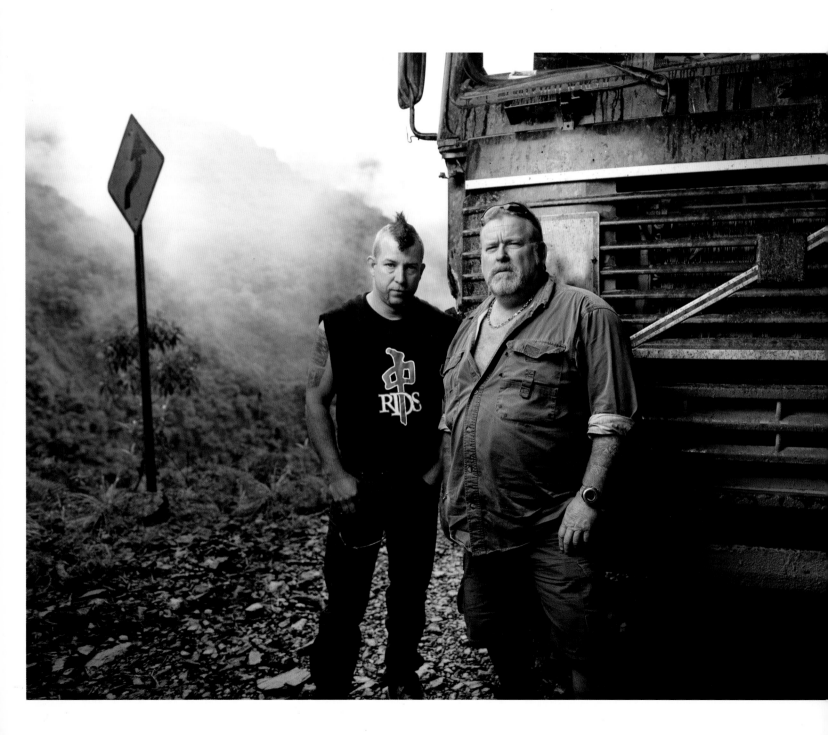

ICE ROAD TRUCKERS IS A POPULAR DOCUMENTARY/REALITY SERIES ON THE History channel. The show features a group of intrepid truckers driving harrowing routes on some of the world's deadliest roads. The show started out following these truckers on runs across frozen landscapes up in the Arctic Circle; then History decided to challenge them with routes through Bolivia (and later Peru) on treacherous roads through the Andes Mountains. This new series in South America took on the name *IRT: Deadliest Roads*.

Ice Luce, a creative director at History, is a fan of my fine art portraits and knows that I travel fast and light with a portable lighting setup. When History started putting together the Bolivia episodes for *IRT: Deadliest Roads*, he gave me a call to see if I could produce some promotional imagery for those segments. I was actually in Dubai, in the middle of a desert, doing cinematography on a horror movie when the call came in. I remember running up to the top of a sand dune to get reception so we could talk about the project. He wanted the same look and feel that I capture in my fine art portraits—almost as if I was photographing the tribal people in Ethiopia, only I'd be photographing truckers in Bolivia.

The project seemed like an ideal opportunity to apply my fine art portrait style to a commercial job and I was excited and honored to take on the project. I had to fly almost straight to Bolivia from Dubai, only managing a brief stopover in New York to do laundry and grab some supplies. I brought along my longtime friend and assistant Jesse as he'd worked with me on other projects and knew my system.

All told, we would spend ten days in Bolivia. This was a lot shorter than my usual trips, but we were working on a tight schedule. With the invaluable aid of our guide and translator, Fernando, we would follow different truckers for a day or two, then stop in a town in the middle of nowhere and wait for the next team of drivers to arrive. Fernando was critical not only to the photographic process but also to keeping us alive as we wound our way through these mountain roads at elevations sometimes exceeding 16,000 feet above sea level.

Conducting this project was a lot like working on a movie set. There would be days of

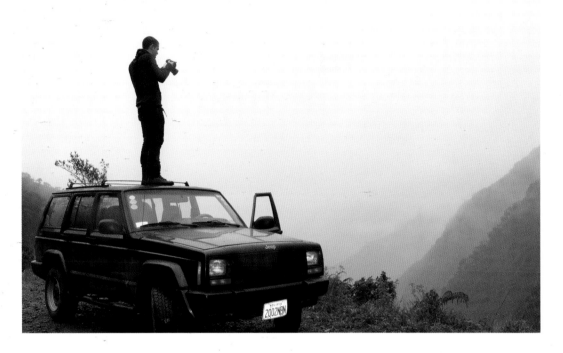

intense action and fast-paced shooting followed by extended downtime, sometimes two or three days, while we waited to link up with our next subject. When the next driver arrived, I needed to be ready to move quickly. These truckers were working real assignments on real deadlines; their runs weren't just invented for the show. So they were on the move and there was very little time to stop and capture photographs. The whole project worked on the truckers' schedules and the show's production schedule, not my timeline.

Often, we'd race ahead in our Jeep, find a good spot to pause for a quick shoot, and then radio back to the truckers to let them know where to pull off the road. They'd jump out, run to the spot I'd set up, work through a few photographs, and then run back to their trucks to get on the road. We'd race ahead again, trying to gain at least a few minutes of lead time so I could do some quick setup and testing before the truck arrived at the next photo spot.

If you think these roads are dangerous, try navigating them at accelerated speeds as you to try to race ahead of your subjects while scouting good photo opportunities. When I think back on it now, it was crazy, definitely the most dangerous project I've ever done. There were days when things were moving so fast, and the roads were so treacherous, that it would be too risky for us to race ahead

LEFT This behind-the-scenes shot shows me on top of our Jeep, paused along the cliff side to capture the image shown opposite. We had raced ahead of the truck to scout a place for a quick portrait. When I saw the truck rumbling toward us along the road, I jumped up on the Jeep and photographed the scene to show the dramatic landscape and the steep falloff at the edge of the road.

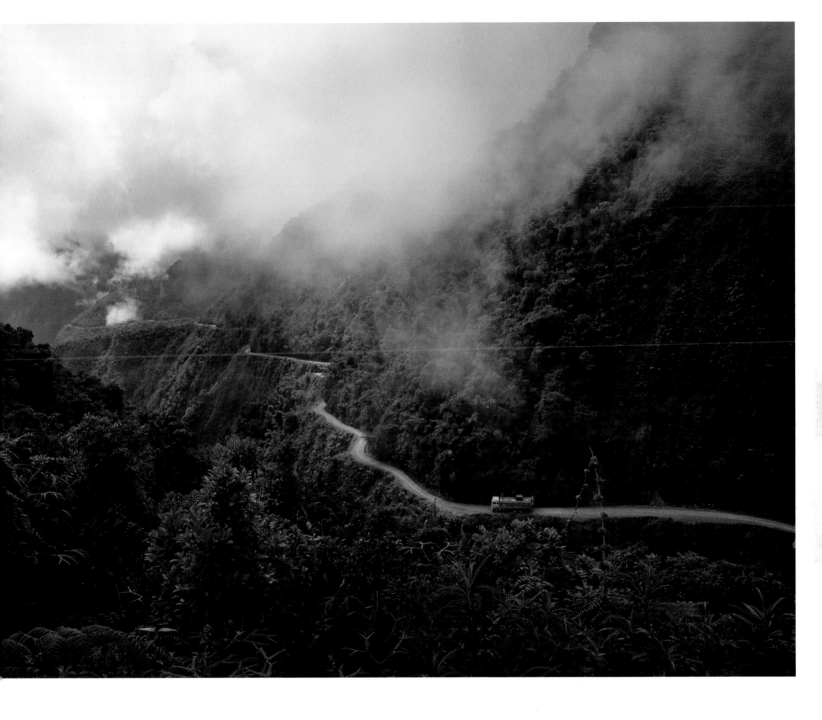

and set up photographs. On those days, I just told the production company, "Sorry. No images today. It's too dangerous." At some point, you've got to temper your enthusiasm for photography with your responsibility to keep yourself and your crew in one piece.

Riding with the truckers wasn't much more relaxing. Being in big rigs on those tiny roads with blind curves and thousand-foot drops was disconcerting, to say the least. The trucks barely fit on the pathway, and I could see right over the edge into the abyss. Still, the shoot was a lot of fun, and true adventure—probably the most enjoyable commercial job I've ever done.

ABOVE Captured in pure ambient light, this image gives a sense of scale and perspective to the project, showing the truck almost swallowed up by the landscape and the winding road.
1/200 sec. at f/11, ISO 200

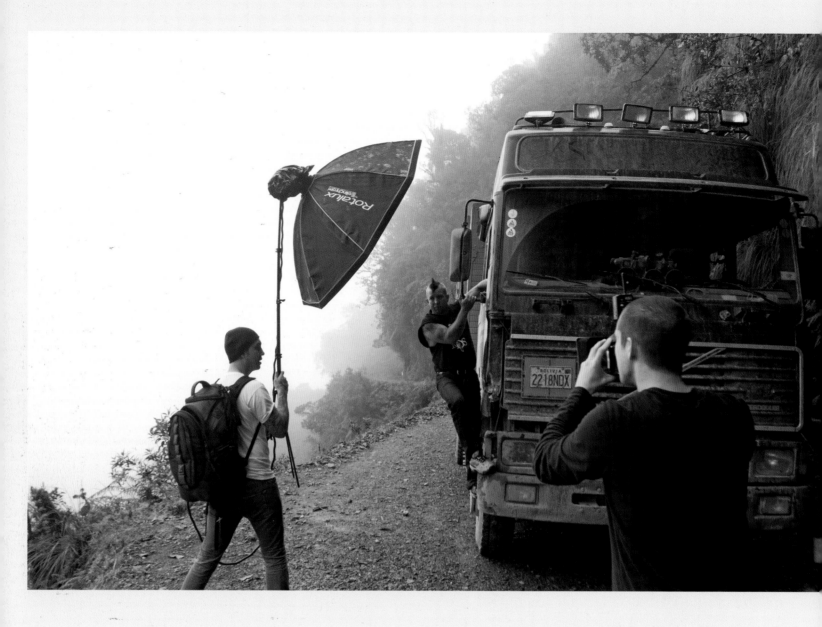

ABOVE This behind-the-scenes image shows how close to the subject Jesse held the Rotalux Octa. The light mimics the hazy white light coming through the fog, illuminating Rick perfectly.

OPPOSITE This is Rick, a hardheaded trucker who doesn't usually smile on command. I wanted to get a little bit of his lighter side, so I asked Hugh, his trucking partner, to stand down on the road at eye level. Then I told Rick to start cursing at Hugh, to really unload, to call him names and tell him what he really thinks. I figured this was one of the only ways to get a trucker to smile, and I was right. After each string of profanity, he would laugh, and I would capture him smiling or laughing. By having Hugh standing in front of him, I gave Rick a focus, instead of just asking him to scream obscenities into the sky.

To light these images, my assistant held the Rotalux Octa very close to Rick's face, just off frame to camera right. By positioning the light so close, I got a nice catchlight in his eyes, and good lighting along his right side.

1/100 sec. at f/4, ISO 50

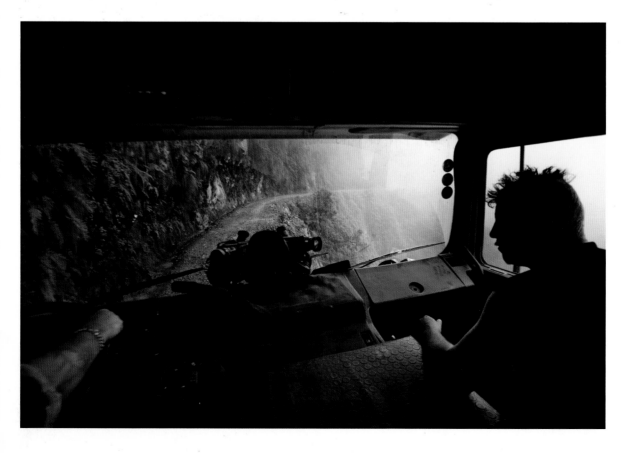

MY IRT: DEADLIEST ROADS CAMERA BAG

- **Camera:** Phase One 645 camera body and Phase One P 45+ and P 65+ backs

- **Lens:** 80mm F2.8 lens

- **Lights:** Two Profoto Pro flash heads (one for backup)

- **Light modifier:** Elinchrom Rotalux Softbox Octa

- **Accessories:** Two PocketWizards (one for the camera and one for the battery pack); set of Lee neutral density filters at 0.3, 0.6, and 0.9 increments

- **Power source:** Profoto Pro-7b battery pack

MAKING IT HAPPEN

I used the same setup for this project that I employ in all of my fine art portrait series: a Profoto Pro flash head in an Elinchrom Rotalux Softbox Octa, powered by a Profoto Pro-7b battery pack, held aloft by my assistant while I photographed with my Phase One 645. I also posed the truckers the same way I pose subjects in my fine art series. As with the portraits of the sadhus of Varanasi, I wanted a soft, painterly look to the backdrops, but it was also important to show a sense of place, and to demonstrate the extreme nature of the landscape these truckers had to navigate. So I worked to blend the artificial and ambient light and show more of the background scenery, as in the India series.

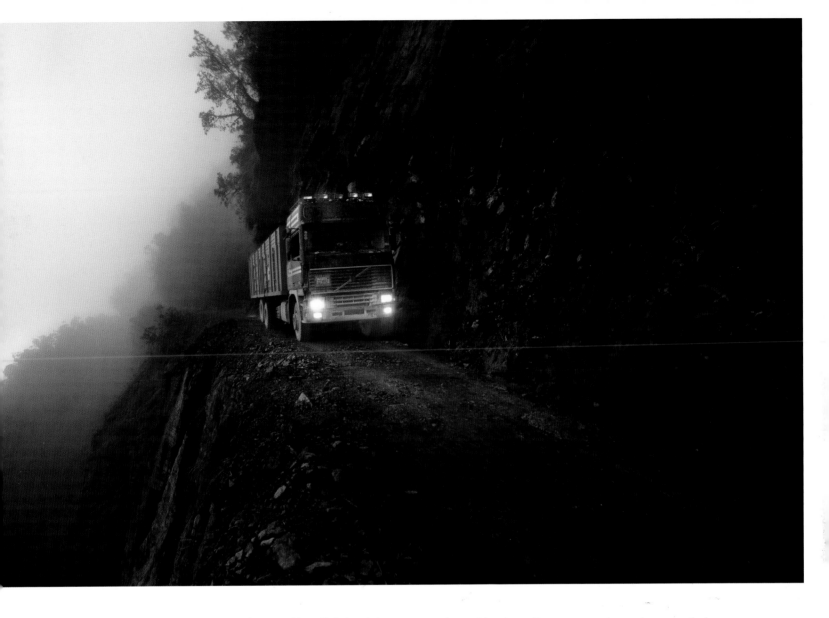

OPPOSITE This is another image created without any additional light. I made this photograph to portray the feeling of danger and to show how small the roads look when you're up in the cab of one of these trucks. The image presents the truckers' view, so I exposed for the outside and let the inside of the cab remain dark and underexposed. I used the windshield to frame the main focal point of the image, so the subject becomes the road itself, not the people.

1/160 sec. at f/5, ISO 400

ABOVE I created this image with a panoramic stitch, using the same method I've used for other images described in this book, such as the portrait of the two Batuk students in India (on page 82). There was no additional lighting other than the truck's headlights. I asked the driver to turn these on full power as he approached so they would light up the fog and provide some dramatic effect.

While the light was simple for this image, the capture was not. To illustrate the dramatic look of this big truck on this narrow road, I held on to my assistant's arm as I leaned out over the edge and captured this photograph. From that perspective, you can see more of the drop-off and gain a better idea of the slim paths these drivers had to cross.

1/125 sec. at f/11, ISO 800

History asked me to get images of the truckers with local people. You can tell they aren't super happy about wearing the hats, which makes the image all the more appropriate because the tough-guy American truckers are so out of place in this foreign land. The hats are a long-standing tradition among the people of Bolivia, particularly women, who wear taller, more rounded versions of the hat. We scouted out this spot the day before making this image, and had already asked the vendor to appear in the portrait. In exchange for her participation, we bought the hats. Then, when the truckers arrived, we just asked them to pull over and sit with this woman.

I lit the scene with a single light from the Rotalux Octa, held high and to camera right, aimed down at the subjects.

1/125 sec. at f/10, ISO 200

This portrait of a Bolivian hat vendor is reminiscent of my fine art portraits. It also fulfilled the request by the production company to photograph local people. When combined, the images for this project form a visual narrative. The photographs have an intentional sequence that tells the story of these truckers working in this distant place. For viewers not familiar with the area, it helps build a sense of the setting so they can better understand the context of the television episodes. I lit this scene from high and to camera right, using a single light modified by a Rotalux Octa. The shadow side of the subject's face is turned toward the camera to show the dramatic yet natural-looking lighting.

1/125 sec. at f/3.2, ISO 50

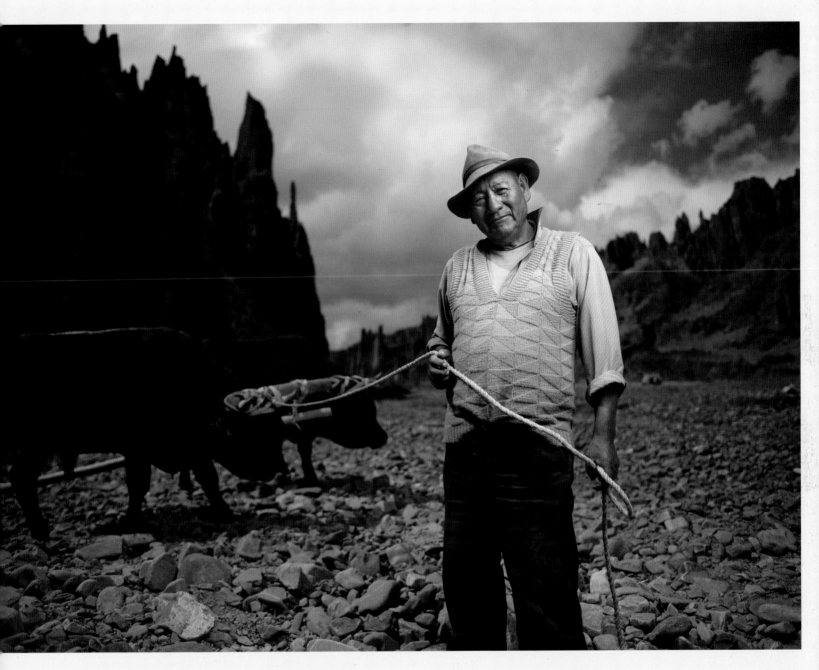

During one of the down periods when we waited for the next group to arrive at our out-of-the-way location, I used our spare time to make portraits of local Bolivians. We approached this man in the rock field working with his cattle. The locals in this area were a little standoffish at first. They like to test foreigners to see if they have a good demeanor before cooperating with any undertakings. When we approached the man, he hurled some good-natured insults at us through our interpreter for a few minutes. After he saw that we took his commentary in stride and had good senses of humor, he agreed to pose for some portraits.

With the single light in the Rotalux Octa held high and to camera right, aimed down at the subject at about a 45-degree angle, I underexposed the background slightly and made the portrait. The soft focus and underexposure of the background gives it a smoother, darker, more atmospheric appearance than it was in real life (it was a fairly bright scene). However, I let enough of the ambient light into the picture to bring out the colors of the landscape, which played well with the subject in the foreground.

1/80 sec. at f/3.5, ISO 50

This photograph shows us setting up for the portrait of the two truckers with the tires at 16,000 feet. You can see the Rotalux Octa and the heavy battery pack on the ground. The strain of carrying this gear around at high altitude ultimately caused Jesse to black out.

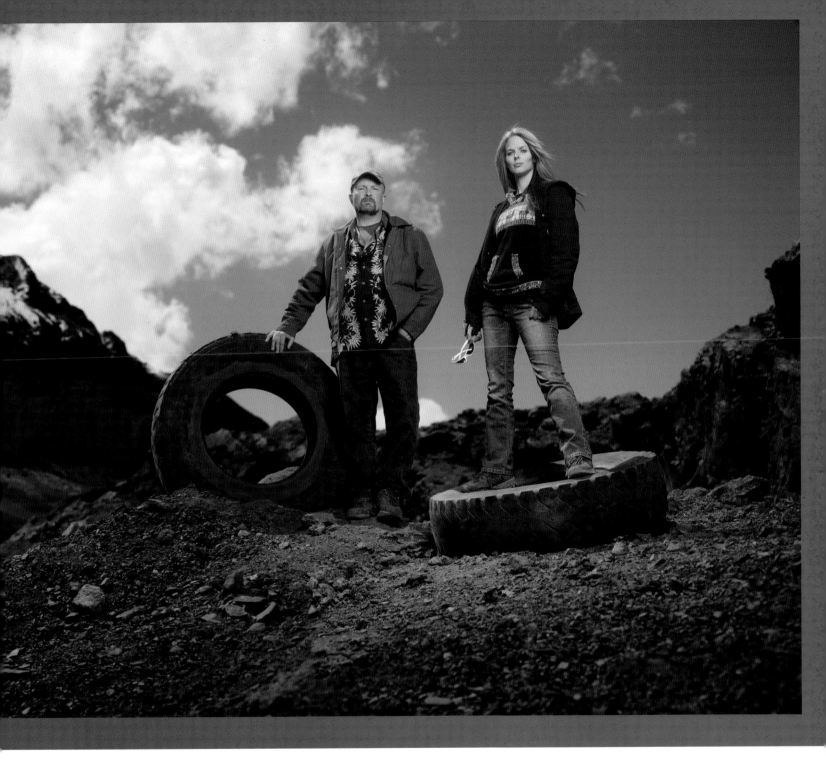

This team's truck had broken down the day before. It would have thrown off the entire production schedule if we'd waited for their truck to be repaired to make the image. So I thought, how do we show that they're truckers without showing the truck? My assistant and I went to a mechanic shop and bought two large truck tires. We tossed them on top of the Jeep, drove up to high altitude for a scenic panorama, and set up this shot. At more than 16,000 feet, the air was extremely thin and it was hard to breathe. Rolling those tires was more than a little difficult. Once we got them in place, we threw dirt on them to make the scene look more realistic. Then I posed the truckers the way you see here, lit the scene with a single light in a Rotalux Octa, high and to camera left, and made the exposure. I did a panoramic stitch with three exposures that I handheld and then later assembled in Photoshop. The background is all real. Stunning and real.

On this shot, my assistant Jesse not only helped me lug the heavy truck tires but also carried the Profoto Pro-7b battery pack while we photographed. He blacked out due to exertion and lack of oxygen. One minute he was standing there, and then he said he felt dizzy, and then he sat down and just passed out. We had oxygen tanks there, provided by the production company for just such an emergency, but they were defective and produced no oxygen. This was an extremely dangerous situation because the brain can only function without adequate oxygen for so long. So one of the truckers drove him back to a lower altitude as fast as possible. Jesse had to go to the hospital, where they administered oxygen until he recovered.

1/125 sec. at f/5, ISO 50

MUDCATS

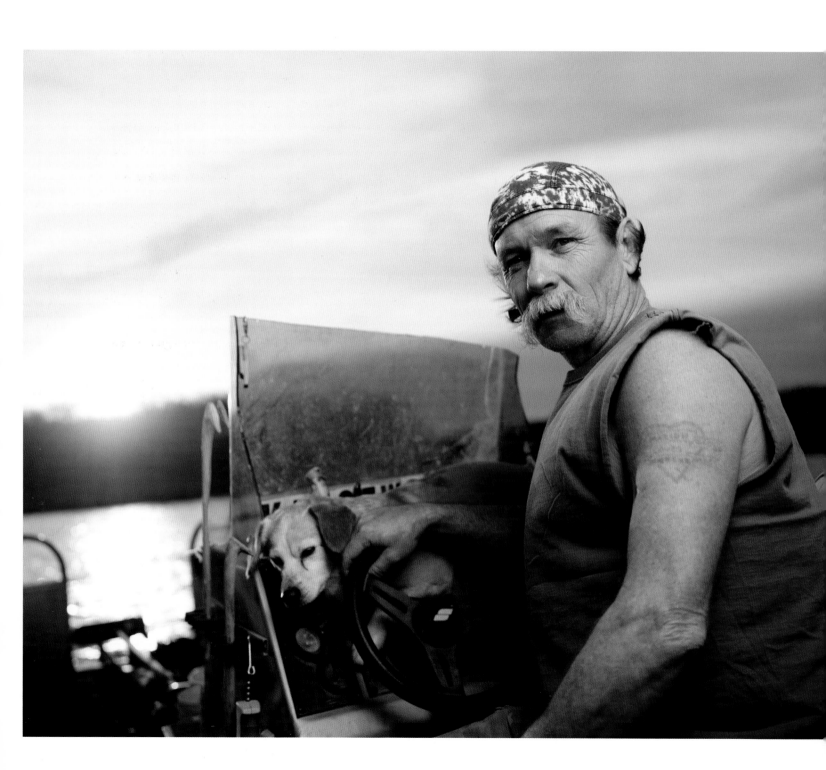

THIS SHOOT CAME ABOUT IN A HECTIC MANNER. HISTORY IS ONE OF MY
favorite clients because they always have interesting jobs and fascinating subjects. When
they contacted me about doing this shoot, I was already in Los Angeles on a job, with one
day off between that shoot and a presentation I was giving at the Professional Photographers
of America's Imaging USA convention in New Orleans. After I heard the details of this shoot,
that one day off quickly morphed into a workday as I traveled to Oklahoma to photograph
some of the stars of this unique reality show.

Mudcats are fishermen who use their hands to hunt large catfish on the bottoms of
lakes, rivers, and swamps. No lures. No rod and reel. Just their bare hands. They feel around
in the mud, wiggling their fingers as if they're worms. Catfish sense that movement and bite
the fishermen's hands. When the fish make this contact, the fishermen grab them and wrestle
them out of the water. It's pretty wild stuff.

History wanted individual portraits of the mudcat fishermen for a motion graphics intro
to the TV show, as well as some action shots of the guys hunting fish.

I went out with Marion Kincaid at sunrise to capture his portrait. Similar
to a few of my images from the Varanasi series, we were in a boat with
the sun coming up behind him. My single light came from a Profoto flash
head modified by an Elinchrom Rotalux Softbox Octa, held high and
aimed down at my subject at a 45-degree angle. I dragged the shutter a
little to let the background blow out just a touch. This technique flared the
sun and produced a creamy, milky-white backdrop from the light of the
early-morning sun. The result is a clean canvas that directs your focus to
the subject.

1/350 sec. at f/3.5, ISO 50

- **Camera:** Phase One 645 camera body and Phase One P 65+ backs (for portraits), Canon EOS 5D Mark II

- **Lens:** Phase One 80mm F2.8 and Canon 16-35mm F2.8 lenses

- **Lights:** Profoto Pro flash head and 69-inch Elinchrom Rotalux Softbox Octa

- **Accessories:** Two PocketWizards (one for camera and one for power pack)

- **Power Source:** Profoto 7b power pack

MAKING IT HAPPEN

The portraits were relatively straightforward. I set them up like some of the single-light images in my fine art portrait series; specifically, the overall lighting and compositional techniques were similar to those used for "The Holy Men of Varanasi" (pages 76–83). That meant a single light source positioned high and to one side, aimed down at the subject at a 45-degree angle. As in the images from India, my exposures emphasized the ambient light and the colors of the surrounding sky, with a less prominent impact from the flash. The portraits are about these men in their environment, so I wanted the feel of that environment to come through in the photographs.

Capturing the action shots was a trickier task. One problem was that our shoot took place outside of prime hunting season. It was the middle of winter, the water was freezing, and still we had to throw these guys in frigid water with no shirts. I crouched down in the muddy lake in waterproof waders, shooting with a Canon EOS 5D Mark II camera in a waterproof housing. I held the camera just under the surface of the water, aimed up, and shot from the perspective of a fish being pulled from the lake. I had my subject pull out the fish and shake it back and forth to create a sense of movement and some splashing. Then I fired several exposures, checked my results in the viewfinder, made some adjustments, and repeated. No additional light for the action shot—just a fun, muddy, wet take on a fish out of water.

When working with a camera in an underwater housing, you really need to understand the focal length you're using and how that focal length relates to your exposure. You typically set your focal length before putting the camera and lens in the housing. Once it's set and you're in the water, you can't make any adjustments, so you need to be sure your settings give you not only a well-exposed image but also the right depth of field for your scene.

For the type of image I wanted, the most dynamic shots come from putting the lens half-in, half-out of the water so the camera body was underwater and the lens partially submerged, right around the water line. This way you could see just a little bit of water splashing and also capture a good exposure of the action above the water.

It's also important to consider the type of water you're shooting in. If it's murky and muddy, the water will filter out some light and impact your exposure. Perfectly clear water will be brighter, and you will have more leeway in terms of how far you can submerge your lens. For this shoot, we were in a fairly muddy lake, so I put the lens just barely underwater. Anything deeper and the water would have obscured the image too much.

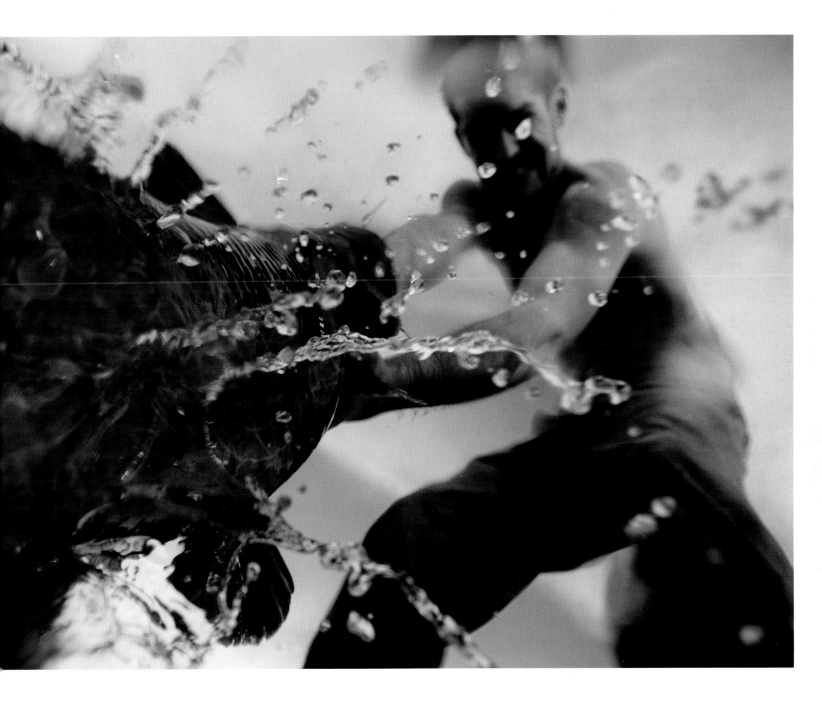

To get this action shot, I had to hold the camera just slightly underwater in a shallow part of the lake, which meant that I couldn't get behind the viewfinder to see my image before clicking the shutter. Instead, I positioned my camera so it was aiming at my subject and then I cued the action. On my signal, my subject pulled up the fish and moved it back and forth in a realistic motion. I made several exposures with autofocus on. This image is a departure from most of my work because I couldn't fine-tune everything and had to simply hope for some luck in my captures.

That luck arrived when the camera's autofocus zeroed in on the water droplets in the foreground. The water, which is in sharp focus, became the focal point of the image instead of the man, who is in softer focus in the background. This was a very happy accident, as the point of view came out great—more of a water's-edge view of the action.

To make the fish look bigger and more imposing, I used a 24mm focal length on a 16-35mm lens for a distorted, wide-angle look.

1/100 sec. at f/5.6, ISO 200

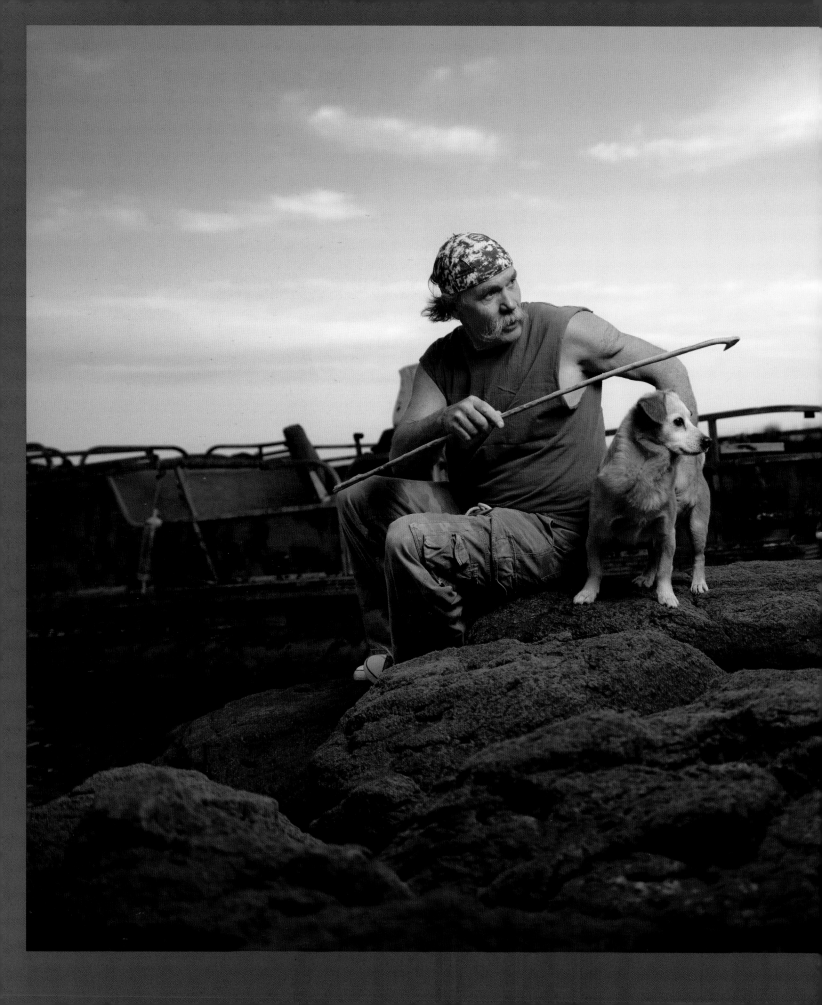

For this wide shot of Marion Kincaid, I placed my single light source (a Profoto flash head modified by an Elinchrom Rotalux Softbox Octa) so it hit the subject from the same direction as the rising sun. The idea was to augment the sunlight and provide a little more illumination on my subject. I underexposed the background a bit to bring in more of the colors of the morning sky. As opposed to the image on page 126, in which I wanted a clean, milky-white background to emphasize the subject, this image has more of an emphasis on the surrounding scenery, hence the longer exposure for more ambient light and deeper colors.

1/180 sec. at f/3.5, ISO 100

THE JONAS BROTHERS

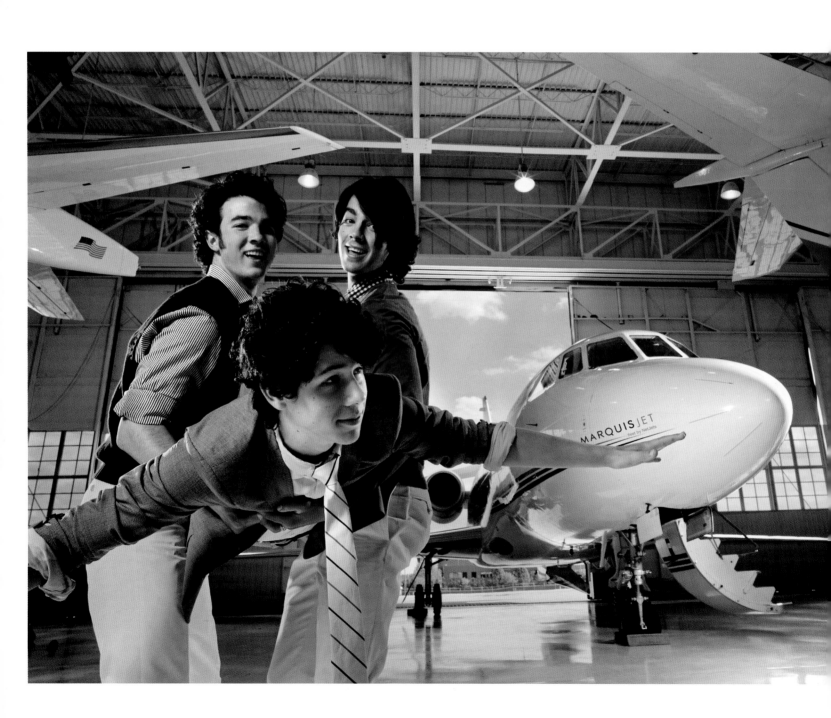

A FEW YEARS AGO, *FORBES* **MAGAZINE ASKED ME TO DO A SHOOT WITH THE**
Jonas Brothers to illustrate a story on their financial success and media empire. We staged the shoot in the hangar of a private airport in New Jersey and had a plane brought in for the shoot.

Initially, I captured a standard shot of them standing casually in front of the plane, looking relaxed and comfortable. This is the shot everyone expected. I wanted to play it safe before experimenting. After capturing that image, I tried something different. I didn't have time to do a completely new lighting setup, so using the same setup I tried something with more energy. I came up with the idea of making a human airplane out of Nick Jonas. The Jonas Brothers are usually portrayed more seriously; the styling and posing in most of their commercial images makes them look older than they are. Even though the article was all about the Jonas Brothers as successful, wealthy businessmen, really, they're child pop stars underneath it all, so I went for something that would capture their fun, childish side juxtaposed with the more grown-up scene and clothing choices. Their manager and publicist didn't seem to mind, so we did a few shots with this general pose until Nick's brothers dropped him a couple of times and their manager stepped in to stop all the fooling around. *Forbes* ultimately chose the human airplane image for the story.

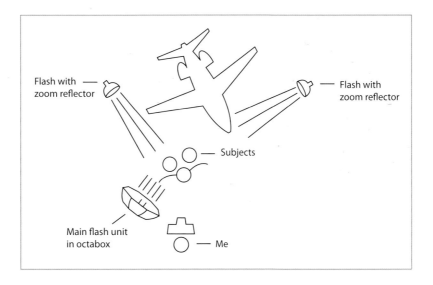

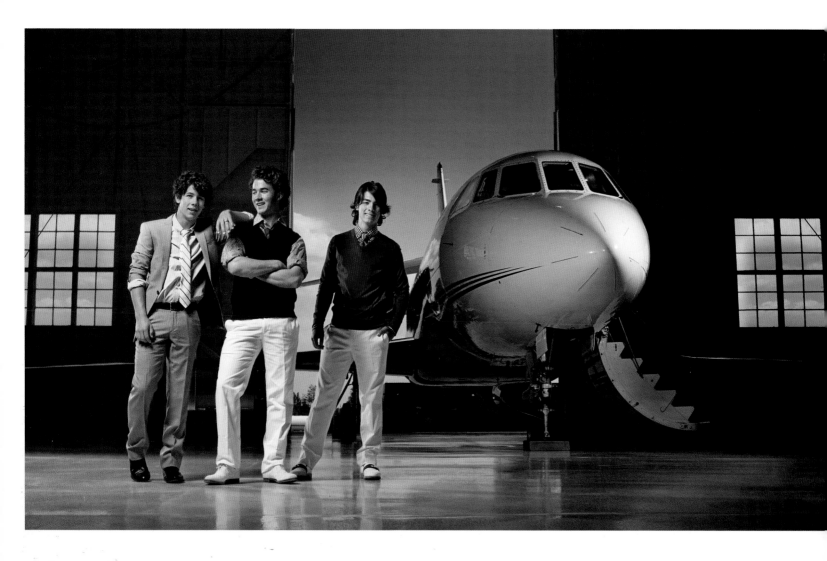

PAGE 132 AND ABOVE On these celebrity editorial shoots, the trick is to create a lot of content in a short amount of time, so I always try to capture several different types of images with one setup. Once I did the standard group shot, my only change for the human airplane image was to lower the key light closer to the subjects because the guys were physically lower in the airplane pose.

My main light was an AlienBees B1600 flash head modified by a Paul C. Buff octabox suspended high above the subjects and pointing down at a 45-degree angle. I then added two AlienBees B800 flash heads with zoom reflectors for background light. One to camera left lit up the plane and provided a little hair light on the brothers. One to camera right added just a touch of dimension to the plane, a little white highlight that you can see on the right side of the jet. I used AlienBees's lighting before I invested in the higher-end equipment I use today. The lower price tag can mean lower quality with inconsistent output of light and color temperature. However, for the price, the AlienBees lights are an incredible value for photographers just starting out.

PAGE 132 1/80 sec. at f/13, ISO 200; ABOVE 1/200 sec. at f/14, ISO 200

OPPOSITE With every editorial shoot, it's important to present a collection of images that the publication can use to help tell the story. They need to be cohesive and revolve around a central theme. This portrait of Joe Jonas follows the concept of the Jonas Brothers as successful businessmen.

Using the same plane, we rearranged our setup to shoot inside. I posed Joe by the window and aimed my two AlienBees B800 lights into the plane from outside. I arranged one of the lights directly outside the window, shining in on Joe's face. The light was a bare bulb with a zoom reflector, which produces a strong, direct light source reminiscent of the sun shining through the window of a plane in flight. I modified the other B800 with a 10-degree grid, and aimed it at an angle to create a little separation between the subject and the seat.

In postproduction, I pulled the image into Photoshop and added the flare to enhance the sense of the jet being in flight with the sun shining in the window, not sitting in a hangar. I used a flare from another picture I'd captured to make it look more authentic; I did not create a graphic in Photoshop.

1/200 sec. at f/3.5, ISO 200

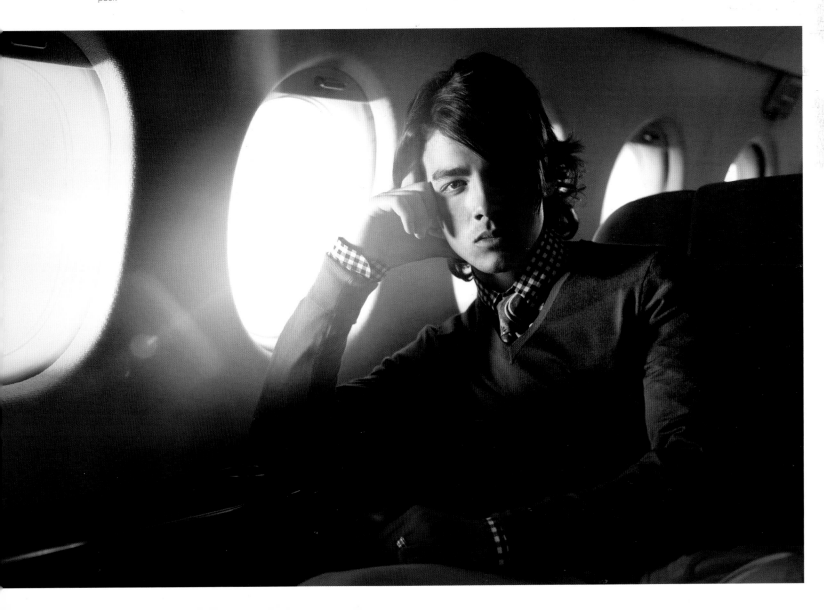

MY JONAS BROTHERS CAMERA BAG

- **Camera:** Canon EOS-1Ds Mark III

- **Lenses:** 17–40mm F4L lens and 24–70mm F2.8 lens

- **Lights:** One AlienBees B1600 flash head and two AlienBees B800 flash heads

- **Light modifiers:** Paul C. Buff octabox

- **Power source:** AlienBees Vagabond portable battery pack

MAKING IT HAPPEN

These types of shoots with celebrities are really fast. You've got only a few hours, at best, to set up the entire shoot, and you've often got mere minutes with the talent. So you need to light quickly, shoot quickly, and think quickly. These days, when I have a more relaxed time frame for a shoot, the client will sometimes ask me if I think I can get everything done by the deadline. I just smile and think to myself, *You have no idea!*

AMOUR.COM

PEOPLE OFTEN ASK HOW MUCH I AM INVOLVED IN THE CREATIVE conceptualization of my photo shoots. Which ideas come from me and which come from art directors or other creatives working for the client?

For my personal work, not surprisingly, everything is all mine. From concept to execution, I am in full control of and can art-direct the project based on how I see it evolving. For editorial photo shoots, the magazine usually gives some direction based on the theme of the story, but I remain very involved in developing the concepts behind the photography. For advertising campaigns, there is typically strong creative direction coming from the agency and more defined guidelines to follow. Creative teams at advertising agencies have pitched and sold their clients on something specific, and then they hire the photographer whose style best complements their creative vision. So that vision needs to be realized, but the agency has hired me to add something unique, to enhance the image and augment the creative process. The best images begin with a good creative brief and improve through collaboration between the art director and photographer.

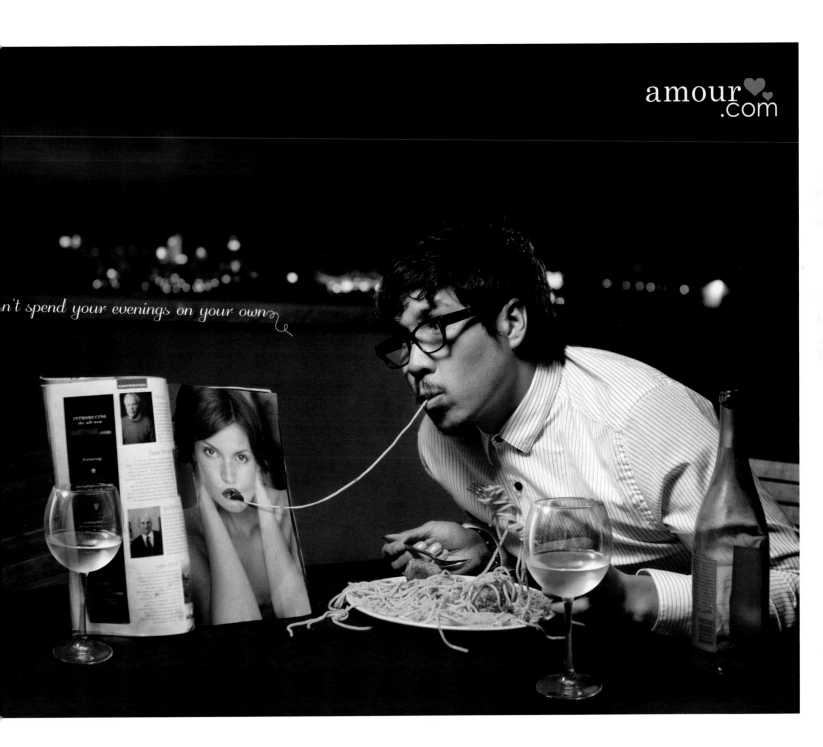

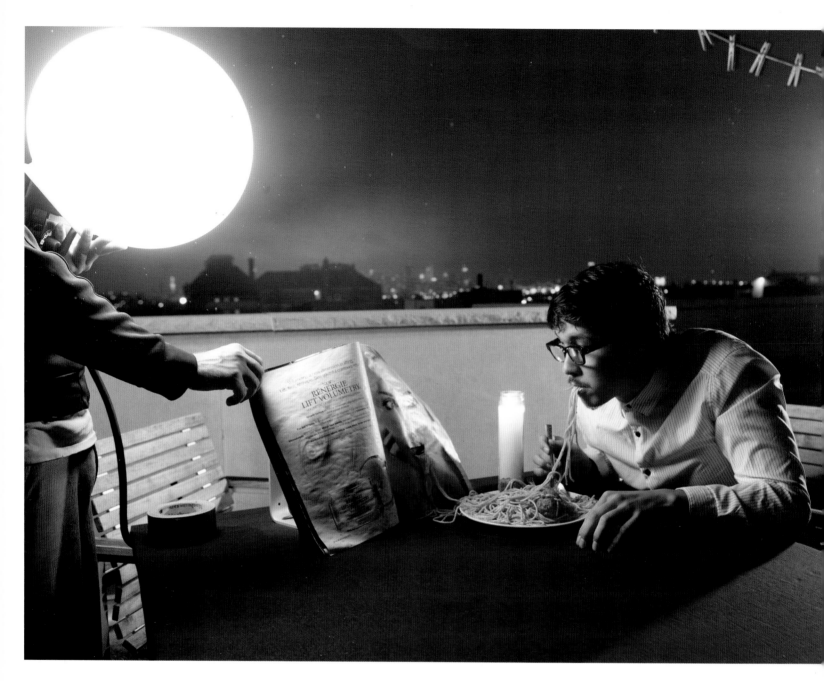

Here you can see the setup. Notice the placement of the homemade globe light, which enhances the light from the cityscape in the background while providing a nice main light on the subject. It's just close enough to add some catchlight in the subject's eyes. In the meantime, the backlight separates him from the background by lighting the edge of his backside.

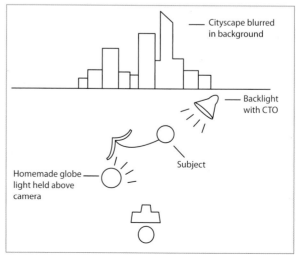

Cityscape blurred in background

Backlight with CTO

Subject

Homemade globe light held above camera

During an advertising shoot, it's important to pull off exactly what the client wants first; then you can spend some time playing around with the setup to produce some variations that might offer an interesting take on the initial creative brief. Sometimes the brief is extremely specific with diagrams or mock-ups to follow. In those cases, you need to bring all of your lighting, composition, and storytelling skills to the table to bring the sketch to life. Even if you're given very solid direction on an image, there are always subtle things you can do as a photographer to make the image yours. For every commercial photographer, those little tweaks and small photographic decisions are what define you. If you implement these subtleties well, you can bring a client's vision to life more effectively, while keeping the process true to your craft.

One great example of this is a shoot I did with art director Thomas Derouault at Euro RSCG in Paris for the matchmaking website Amour.com. Thomas and his copywriter, Peter Moyse, came up with an idea and scribbled some sketches in a notebook. The concept behind the campaign was to show lonely guys who need a date, and who are forced to create their own fake girlfriends. The implied conclusion is that they can visit Amour.com to find a real companion. After Thomas and Peter agreed that my photographic style matched what they were trying to pull off, they sent me the sketches.

MAKING IT HAPPEN

Once I stopped wondering how this weird project came to be, I started to figure out how to make it all come together. I had to think about how to dissect the diagrams and make them work in a real environment.

All of the locations in the sketches were very simple, so we staged them in my apartment. Casting from a model agency was out of the question as the concept called for a "street cast"—average-looking guys that everyday people could identify with. Since I thought it would be difficult to explain to a stranger, "You're going to play a guy who looks like he can't get laid," I decided to cast some of my friends, including photographer Nick Onken, whom I sort of tricked into being part of the shoot.

For the first shot, of a guy eating dinner by himself, I wanted the main light to be soft and wrap around the subject like candlelight. To achieve this effect, my first choice for a light modifier would have been a Profoto ProGlobe, a spherical, bulblike modifier that spreads the light around like a lamp. However, I don't own one of these expensive items, so I used my homemade version (see opposite). Once modified satisfactorily, I arranged the main light just above the subject's head, hovering over the middle of the frame.

I then placed a rim light to camera right so there was a bit of separation just touching the top of the subject's head, hair, and shoulder, helping him stand out from the background. I modified the rim light with a Profoto zoom reflector and warmed up the color temperature with some 1/2 color temperature orange (CTO) warming gel to replicate the ambient light from the city in the background. This effect unified the light sources (ambient city lights and rim light) so the scene appeared more natural and blended seamlessly with the surroundings. The modified rim light also helped separate the subject's dark hair from the dark background. I used the warming gel only on the rim light because I wanted to distinguish between the two light sources. If I'd used it on the main light as well, there would have been too much warm light in the image.

Finally, I brought in some ambient city light to add color and atmosphere to the picture. To do this, I dragged the shutter just long enough (1/8 sec.) for the city lights in the background to expose properly.

For the second shot, I felt the original sketch had a composition that didn't work as well. I felt it could be more dynamic if I took an over-the-shoulder viewpoint shot from right next to the subject's head. The art director made it clear that he didn't need the exact composition from the sketch and gave me free rein to do whatever I wanted. So I arranged the scene so I was shooting from behind the subject and getting a more up-close-and-personal perspective. After I captured the originally scripted shot, which didn't include the lipstick on the mirror, I drew some lips on the mirror with red lipstick for a few additional shots. The client ended up choosing one of the lipstick images.

The lighting for this shot was much simpler. I used the same Profoto Pro-7b battery pack with a single Profoto Pro flash head modified by an Elinchrom Rotalux Softbox Octa. I purposely "dirtied" up the light a bit by suspending it high above the subject to create some gritty shadows.

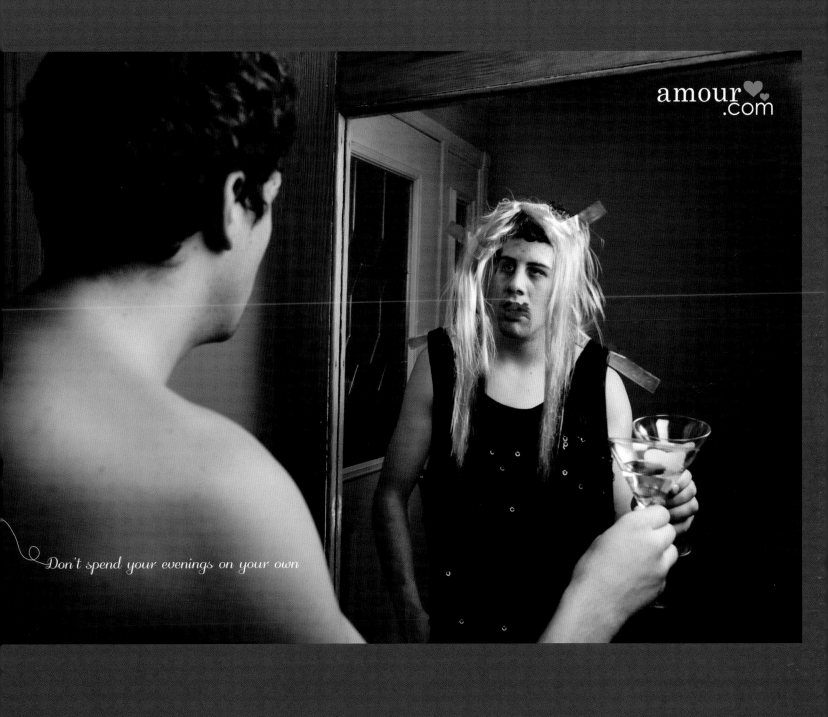

amour❤
.com

Don't spend your evenings on your own

PENNZOIL

Using a three-light setup, I created a bright, sunny scene during what was actually a dark, stormy day. My main light, a Profoto Pro flash head in an Elinchrom Indirect Lightbank Octa, became the "sun" while two additional lights to camera right provided accent lighting. I shot with a shallow depth of field to blur the somewhat cluttered background and emphasize the product. Since this technique also blurred the Pennzoil can in Helio Castroneves's hand, I added a sharp image of it back into the final composition in Photoshop.

1/60 sec. at f/5.6, ISO 100

MY WORK WITH PENNZOIL CAME ABOUT WHEN THE ART DIRECTOR ON THE project, Justin Smith at Doner, referred me after seeing my "Cradle of Mankind" series. Although Justin wanted a different look for Pennzoil's ad campaign, this is another example of fine art feeding commercial work. It supports my feeling that personal exploration is not only important for artistic growth but also as an ancillary route to professional success.

The idea behind this campaign was Pennzoil Pride, a concept based on passing down the value of Pennzoil products from professionals to everyday drivers, and from father to son. The first image (shown opposite) features Helio Castroneves, a celebrity IndyCar driver who has not only achieved great success on the track, but was also the winner of the fifth season of ABC's *Dancing with the Stars*. His name is associated with the Pennzoil brand, and so the image needed to showcase him as their recognizable front man.

The father-son images on pages 145–147 came from a different shoot for the same campaign. This duo was an actual father-son pair that we cast and photographed in Los Angeles. The client wanted a more authentic look to these images, so we did a mix of street casting and professional model casting until we located this pair.

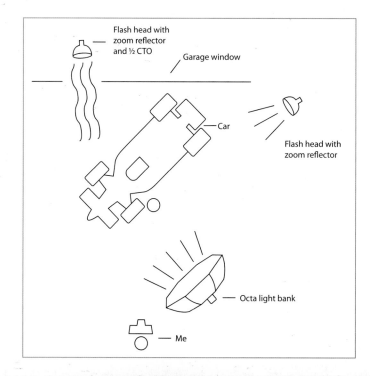

142

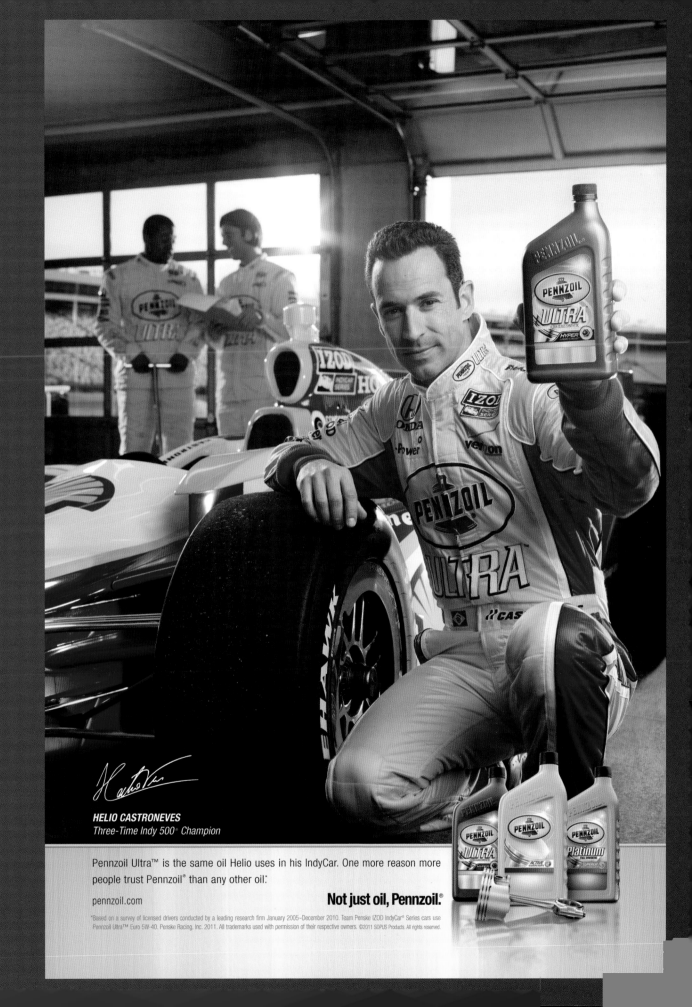

HELIO CASTRONEVES
Three-Time Indy 500® Champion

Pennzoil Ultra™ is the same oil Helio uses in his IndyCar. One more reason more people trust Pennzoil® than any other oil.

pennzoil.com

Not just oil, Pennzoil.®

- **Camera:** Phase One 645
 camera body with Phase One
 P 65+ back
- **Lens:** 80mm F2.8 lens
- **Lights:** Multiple Profoto Pro
 flash heads
- **Light modifiers:** Elinchrom
 Indirect Lightbank Octa, CTO
 warming gel, zoom reflectors,
 20-degree grid
- **Power source:** AC outlet

MAKING IT HAPPEN

I conducted the shoot with Helio Castroneves by a racetrack in North Carolina. The original television commercial for this campaign had a victory celebration going on in the background while Helio held aloft his can of Pennzoil. This didn't work as well in a still image because it seemed too staged to have this guy holding a can of oil while people were celebrating all around him. So I found some props around the garage, including a crank and a clipboard, and asked the models in the background to hold them and talk naturally. It's still an obviously staged commercial image, but it feels a little more realistic in this setting.

I wanted a shallow depth of field to keep the focus on the main subject, while the background elements went soft. This is particularly important in a commercial image that's showcasing a product and a recognizable spokesperson. You don't want a lot of confusing background features drawing your eye away from the main focus. The problem was that the shallow depth of field made it impossible to keep both Helio's face and the Pennzoil can in focus at the same time. To work around this issue, I made multiple captures and then used Photoshop to stitch in a sharp image of the can with a sharp image of Helio. His face is in focus and, magically, so is the bottle. There was no other way to accomplish that dual sharpness unless I stopped down to f/11 or f/16, and then I'd lose that nice, shallow depth of field that makes the image so effective.

We conducted this shoot on a dark and stormy day, but the client wanted a bright, sunny look to the image. So I added "sunlight" by arranging a strobe outside the garage window, aimed inward and modified by a $\frac{1}{2}$ color temperature orange (CTO) warming gel. The light stand was visible in the original shot, so I cloned it in Photoshop during postproduction. I also dragged the shutter and overexposed the image a bit to bring in more light and make the sky look lighter than it was in reality.

My main light came from a Profoto Pro flash head in an Elinchrom Indirect Lightbank Octa arranged to camera right, above the subject and aimed down at a 45-degree angle. Behind Helio, just out of the frame to camera right at the same distance from him as the two guys in the background, I placed another light to shine on the car and wash over the bottom of his right leg. I modified this flash with a zoom reflector. To add some shine to the hood of the car and some sparkle to the wheel, I placed another Profoto flash head just off frame to camera right, aimed at the car and focused with a zoom reflector and a 20-degree grid.

For the second image, we cast a real father and son to get more authentic expressions and interaction. We had a long day of shooting, so, understandably, the young boy was starting to get frustrated and the dad let him honk the horn to amuse himself. After honking the horn a few times, the boy looked back at his dad to see if it was okay to keep honking. At the moment he looked back and made eye contact with his father, I captured this image. Pennzoil loved this picture because of the tenderness of the moment and the look of trust in the boy's eyes.

I placed my main light on the car hood, braced it with a light stand, and modified it

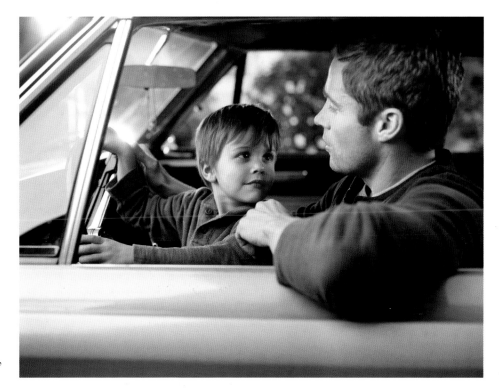

For this image, I worked with a real father-son duo to get a more authentic interaction.

1/50 sec. at f/4, ISO 50

with an Elinchrom Indirect Lightbank Octa. You can see this light on the dad's face and the left side of the boy's head. I set the light a little higher than the hood so it would fill up the entire windshield.

The little flare in the top left corner comes from a Profoto flash head modified by a ¼ CTO warming gel. This light drops a little orange on the back of the boy's head, as well as some light on the dad's lips and chin.

To light up the bushes behind the car, I placed a bare-bulb flash on the far side of the vehicle. The 360-degree light sprays around the background, brightening it up and also putting some light on the dad's hands. This light is a little cooler than the other flash because it doesn't have the orange gel.

Since the boy's head is turned away from the main light, I put another flash with a beauty dish on the back of the car, aimed through the rear window to fill in his face and provide some catchlight in his eyes. I turned down the power on this flash to half that of the main light on the hood so it would provide just a subtle pop of light to brighten up the boy's face.

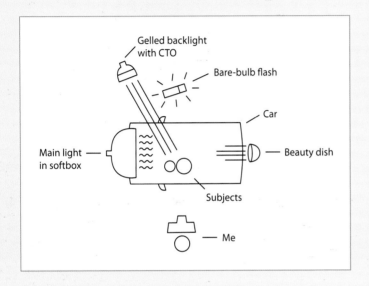

Gelled backlight
with CTO

Bare-bulb flash

Car

Main light
in softbox

Beauty dish

Subjects

Me

In this commercial image made for Pennzoil, I built a scene around this father and son sitting in a car. My main light sat on the hood of the car, filling up the windshield with light and shining on the dad's face and the right side of the boy's head. In the top left corner, I added another light with an orange gel to provide a little warm light on the back of the boy's head. To light up the bushes in the background, I positioned a bare flashbulb, which sent out 360-degree light to illuminate the bushes evenly. Since the boy's head was turned away from the main light, I put a another flash in a beauty dish on the back of the car, aimed through the rear window, to provide some catchlight in his eyes. With this scene created, I let my subjects interact naturally as I made several exposures.

1/50 sec. at f/4, ISO 50

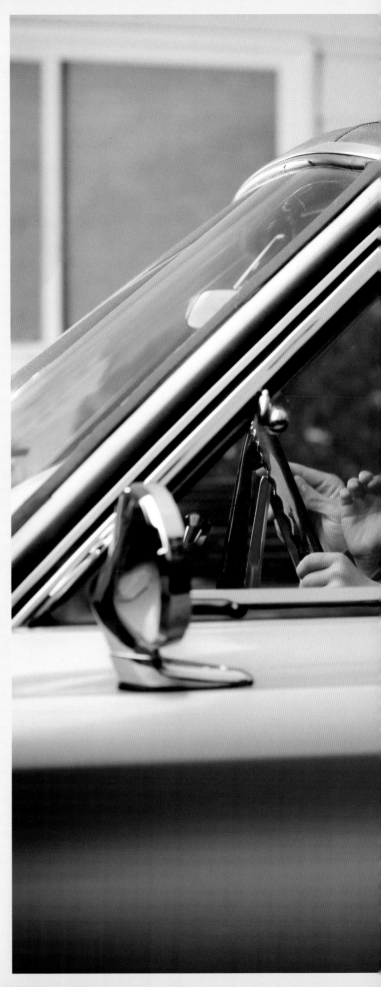

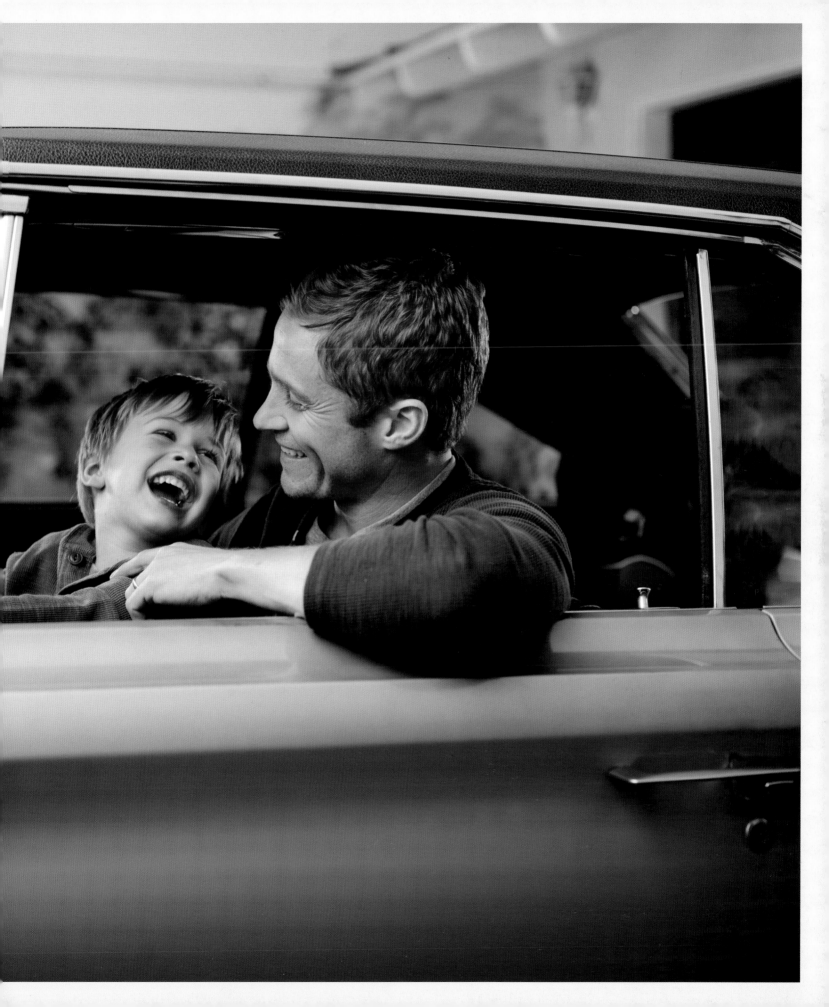

PAWN
STARS

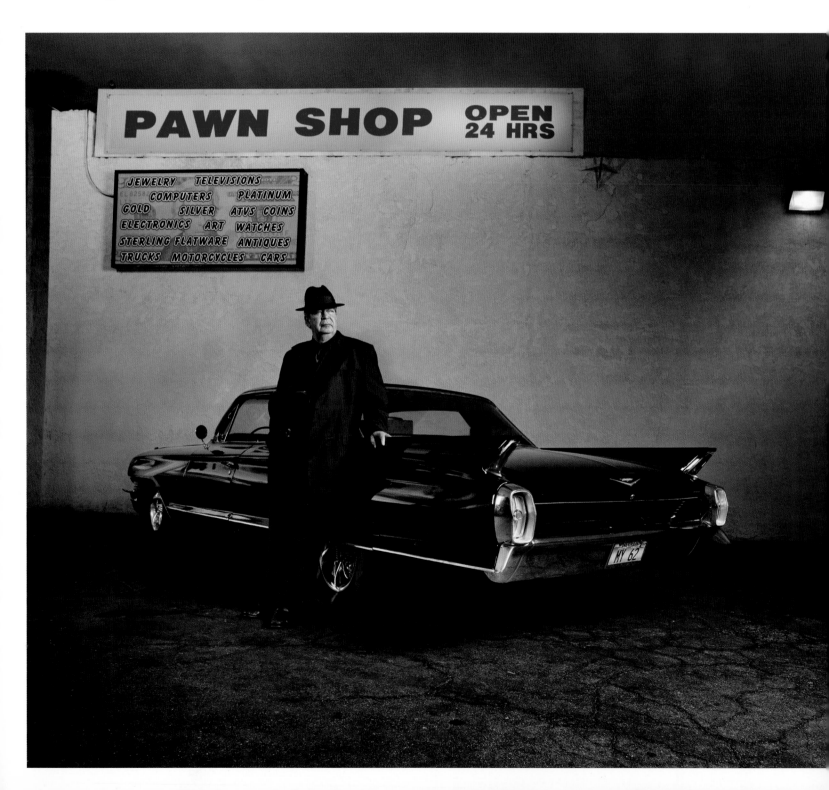

WHEN THE HISTORY CHANNEL APPROACHED ME ABOUT CREATING SOME
images for a new reality series called *Pawn Stars*, I jumped at the chance. They'd sent
me the show's pilot episode and I thought it had an interesting concept with some
intriguing characters. History wanted some images of the main people to help them
promote the show in other media. So I set up a trip to Las Vegas to meet the guys and
produce some promotional portraits.

During that first shoot, the show hadn't aired yet, and no one knew how
popular it would become. The now-famous pawn shop was empty and it was just like
photographing any other group of normal guys. I didn't have a strict set of directions
from the show's producers because they didn't know exactly where it would go. This
presented an exciting challenge because I had an opportunity to help craft the show's
look and branding through that initial set of images. Since the pawn shop featured
in the show is a Vegas landmark, I talked to the art direction team at History about
using a lot of Vegas themes, playing up the dark tones and neon colors that many
people associate with the city. I also photographed a lot inside the shop. Lighting
options were a bit limited, so I opted to add interest to the portraits by incorporating
antiques and other items from the store into the backgrounds. This would place my
subjects in the context of their work, surrounded by the artifacts that define the show.
We created so much content during this initial session that History was able to use
the images for the first two seasons of the show, pulling different setups and portraits
without repeating material.

Working at dusk, I set up a Profoto flash head in a Rotalux Octa as my main light. Positioning it to
camera right, I flagged the bottom of the softbox to obstruct the light and prevent it from hitting the
ground. The light just skims the top of the picture, right by the Old Man's upper body, and lets the
rest of the composition drop into atmospheric shadow.

To highlight the car bumper and chrome accents, I placed a Profoto flash head modified by a
zoom reflector and a grid just behind the car and out of frame. To add an extra little pop of light, I hid
a Canon Speedlite EX flash with a PocketWizard transceiver inside the light fixture on the wall.

Finally, by intentionally underexposing this image, I gave the sky a darker tone and made the scene
appear to be at night, when it was actually shot just after sunset while there was still a good bit of
residual light in the sky.

1/80 sec. at f/9, ISO 100

The primary illumination for this scene came from a Profoto flash head in an Elinchrom Rotalux Softbox Octa, placed to camera left in front of the subjects at about a 45-degree angle. However, the key to making this scene realistic was blending the photographic light with the ambient light from the casino. To do this, I added a second light to the back and right of the subjects and modified it with colored gels to re-create the yellow light from the casino. Deeper orange and red tones also come through from the casino, producing a reddish wash and helping everything blend together.

1/125 sec. at f/4, ISO 1000

After the third season of *Pawn Stars,* when the show had become an enormous hit, History hired me to do another shoot. Since the main guys had become celebrities, we didn't need to identify them as much with the pawn shop; they were recognizable characters who could stand on their own. Plus, the Gold & Silver Pawn Shop was no longer a quiet set. There was a line of tourists six blocks long waiting to get into the store! History's art direction came up with the idea of depicting a stronger Vegas theme, so we started planning some shots of the characters walking down Fremont Street in the old part of Vegas, as well as other images that exemplified the characters' connection to the city. One consistent element that we carried through both shoots was the Old Man's car, a vintage Cadillac that made the perfect prop.

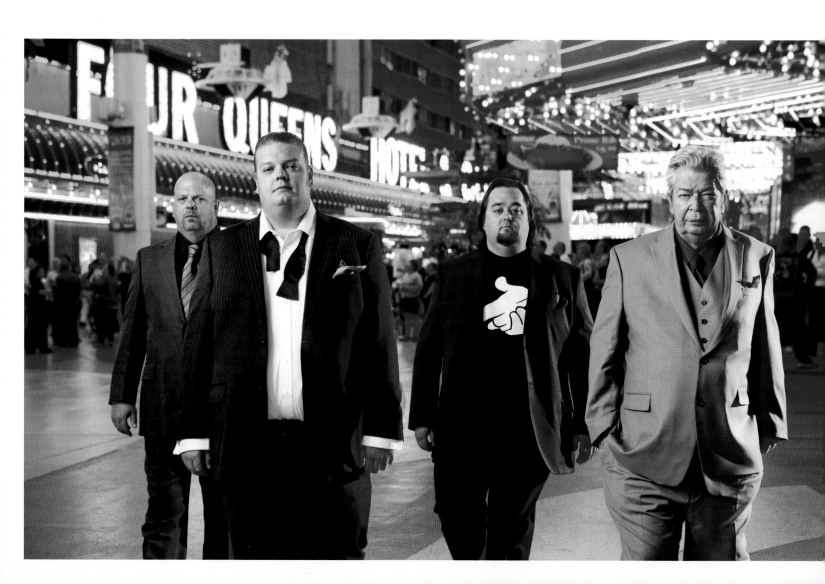

MAKING IT HAPPEN

I'm often hired for commercial jobs that involve noncelebrity, nonmodel clients because I have a lot of "ordinary" people in my portfolio. This means a lot of shoots with the casts of new reality television shows (who aren't famous yet) and advertising projects with street casting. Working with these types of subjects can be a little more difficult because they're not used to being in front of the camera. They might be uncomfortable, and they're often unsure of themselves. The key to managing one of these sessions successfully is building a rapport with the subjects and instilling confidence. I reassure them, try to help them relax, and explain that my job is to make them look good. In many cases, I'll start off by showing them my portfolio so they get a sense of my style and what, in general, I'm going for in the imagery.

Next, I work with my amateur subjects on posing and how to act in front of the camera. People who aren't used to being photographed often like more direction, so I'm fairly detailed in my coaching at this stage. Then I watch them when they're not on camera. I pay attention to how they cross their legs, how they stand, where they place their hands. When people relax and act naturally, that's usually the look I'm seeking. It's also the look that most clients want from these shoots featuring normal, everyday people—as opposed to a highly stylized commercial shoot with models or actors, where the posing fits into a specific, predetermined look. For "ordinary" people, natural usually works best, so I'm always watching the subjects in between shots and during breaks. When they relax, when they settle back and act like themselves, then I step in and ask them to hold their pose (or, more accurately, their lack of a pose).

My style of direction is more subtle with established celebrities, models, and actors, who have been photographed thousands of times. These people know what they're doing— usually—and I can work with them on a more advanced level, discussing things like mood and a more nuanced expression. With these high-profile subjects, I usually limit my direction to my lighting setup and how and where the subjects should position themselves within that setup. From there, my feedback revolves around the lighting and maximizing the impact of my light setup. For example, I might point out my main light source and ask a professional model to turn toward that light so that I can capture a reflection in her eye. Or I'll point out the source and directionality of the light, explain where the shadows will fall and then ask the subject to work with those shadows while producing a dark, thoughtful expression. By making it about the lighting, I'm bringing the subjects more into an artistic collaboration, helping them tweak their look so we can optimize the results. Typically, I'll deliver a lot of positive feedback in these situations; you have to let people know when they are doing something right so they can work off it.

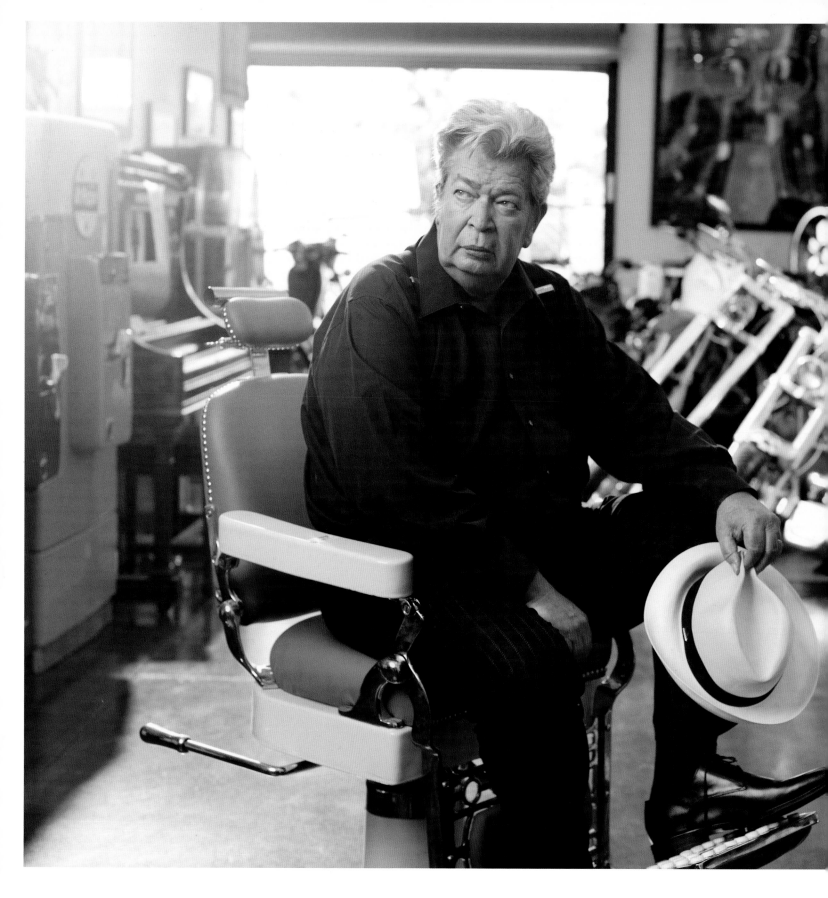

When creating the image shown at left, taken during my first shoot with the cast of *Pawn Stars,* the Old Man (that's his name on the show) was very standoffish. We needed more enthusiastic participation from him, so I had to find a way to connect. I noticed that he had some old Coke machines in the shop. It just so happens that my dad's job involves restoring vintage Coke machines, so I know a lot about them. I started talking to him about the machine and the history of Coca-Cola, and you could tell he was immediately impressed. He really opened up after that. He confided in me that he'd never had his photograph professionally taken in his entire life. Many times, when people are a little reserved on set, it may be because they feel awkward or unsure. I always try to find some common ground, to relate to them in a way that demonstrates my sincerity and interest in helping them look great in the photographs. In reality, the Old Man is one of the most photogenic people I've ever shot and he looks good in almost every frame.

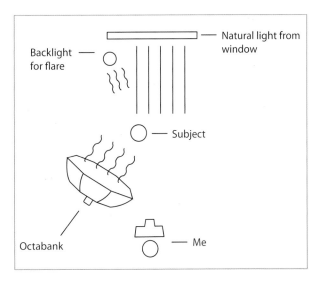

For this image of the Old Man, we rearranged several elements in the background to create a more intriguing composition. For example, we dragged the Coke machine and the sailboat into the scene, completely scratching up the floor in the process. The main light was an Elinchrom Rotalux Softbox Octa with a standard Profoto Pro flash head positioned to camera left, just far enough to the side to shine on the subject's profile. I angled the Old Man so he was backlit by the window light, and I made a test shot during which I dragged the shutter to produce some lens flare. I didn't see enough flare, so I added another light behind him that would flash into the lens and add additional flare. As with most of my portrait images, I oriented the shaded side of the subject's face closest to the camera.

1/60 sec. at f/5.6, ISO 200

For the group portrait shown on page 150, the art department at History wanted a Rat Pack style photograph, something that resonated with classic Vegas style. So we chose a location on Fremont Street in the older part of Vegas. This area has smaller buildings with lower lights, as opposed to the Strip, which has taller buildings and higher lighting arrangements. We wanted the bright lights in the background, so this setting was perfect.

By the time we did this shoot, the guys were famous, so we had to set up barricades and have police and security handle crowd control. People kept screaming the guys' names. After the shoot, I received several Google Alerts with people's pictures of me shooting this image. (I had set up a Google Alert on myself and the *Pawn Stars* crew, and the alerts flew in after the shoot.) It was a wild situation, and crazy to see the transformation of the guys' lives from the first shoot to this one.

My main light was a Profoto flash head in an Elinchrom Rotalux Softbox Octa. I positioned this light to camera left, in front of the subjects at about a 45-degree angle. Then I added one colored light to the back and right of the subjects. This light was another Profoto flash head with a zoom reflector, modified by a grid, as well as a sodium vapor gel and a yellow gel. The combination of these gels—the intense orange from the sodium vapor and the yellow—mimicked the yellow-orange lighting coming from the casino lights behind the guys. I didn't want to use a plain white flash here because the white light would have separated the subjects from the scene and made them look as if they were cut out from their surroundings. The idea with this colored light was to replicate the yellow light from the sign behind the subjects to create a yellow highlight on the guys' faces. However, the ambient yellow wasn't quite powerful enough to show up on the subjects because the ambient red light overpowered it. So I re-created the yellow color on the right side of my subjects with my gel-covered flash. It took a lot of trial and error to match the color exactly, but the result is a yellow highlight that looks like it's from the casino lights. At the same time, the deeper orange and red tones from the casino provide an overall reddish wash. (In postproduction, we changed the name of the casino to avoid copyright problems.)

I included the shot on page 148, taken at the end of my first photo session with the *Pawn Stars*, because I wanted a picture with the Old Man by his classic Cadillac. I'd been shooting the entire group in the same setup, and then I asked the rest of the guys to step aside and slipped in this shot quickly before we wrapped up. I needed to work fast because the client was paying everyone overtime at that point, so I posed him, tweaked the lighting slightly, and got the shot in three exposures.

We were working just after sunset with some residual light in the sky still illuminating the scene. I positioned my Rotalux Octa to camera right and covered the bottom of it to obstruct the light from that portion of the octabox and prevent it from shining on the ground. As a result, the light scrapes only the top of the picture by the Old Man's upper torso, leaving the rest in shadow. The interplay of light and shadow produces a dramatic, atmospheric feel. If the light hadn't been flagged on the ground, there would be a big, awkward splash of light right in the middle of the composition.

To camera right, behind the car and just out of frame, I placed a Profoto flash head with a zoom reflector and a grid. This flash provides just a little bit of light on the car bumper and chrome. It doesn't even hit the Old Man.

You'll notice a distinct shine coming from the wall light on the wall of the building. The actual light was too weak to produce this effect, and you would only notice these light trails if it was completely dark outside, so I enhanced the existing light by placing a little Canon Speedlite EX flash with a PocketWizard transceiver inside the light fixture. I love to add interest to my compositions by concealing flashes in existing lights—streetlights, lamps, car lights, and so on. It's a great way to add some extra punch. In this case, the flash produced the lighting effect I wanted, and then I added in the greenish tint in Photoshop.

I intentionally underexposed this image to give the sky a darker appearance, as if it were much later at night. Also, by letting in less ambient light, the flashlight appears more focused, with a spotlight effect coming from the existing light fixture, which works very well for this scene. Ambient light makes artificial light appear less pronounced because it mixes in and washes out the flash. When you underexpose an image, you get rid of much of that ambient light, leaving just the particular look of your artificial lights.

PROJECT RUNWAY ALL STARS

WHEN LIFETIME WANTED PROMOTIONAL IMAGERY FOR ITS LATEST PROJECT RUNWAY series, *Project Runway All Stars*, I got the call. The show featured fan favorites from various seasons of the hit reality show, which follows up-and-coming fashion designers.

The project involved coordinating separate shoots with individual designers, or pairs of designers, and each image had to be perfect so that art director Aaron Day and his team could produce composites and repurpose the photos into multiple formats. Aaron was familiar with my work, but wanted to be sure I could produce the clean, commercial, studio-style images needed for the project. Prior to landing the job, I had to send him a separate portfolio of studio work to demonstrate that I could produce flawless individual images.

Prominent considerations for this shoot were the style of the imagery and how the show's contestants wanted to be depicted. The designers were all fun and easy to work with—nothing like the cutthroat, moody personas they sometimes took on for the show— but they were also a very image-conscious bunch. They are, after all, fashion designers, so appearance was everything. Unlike some of my other commercial portrait shoots, in which I used prominent shadows to accentuate facial features and create a sense of depth, these pictures needed to be cleaner, brighter, and lit with a softer light that was more flattering to the subjects.

This composite comprises multiple images of individual subjects or pairs of subjects. Over the course of a single day of shooting, I conducted multiple shoots with the contestants on the show, matching the light, exposure, and point of view as much as possible. I shot all the images for this composite with a Mamiya RZ67 medium-format camera (with a Phase One P 65+ back) and a 110mm F2.8 lens. The reason for such a long lens in a studio setup was limited space. Working within the confines of the loft, we had to place the subjects relatively close to the background. An image from a shorter lens would have lacked depth. By using a long lens on a medium-format camera, I extended the background to create the illusion of extra room behind the subjects.

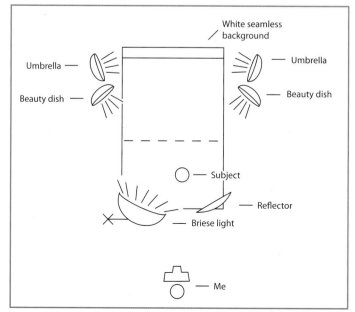

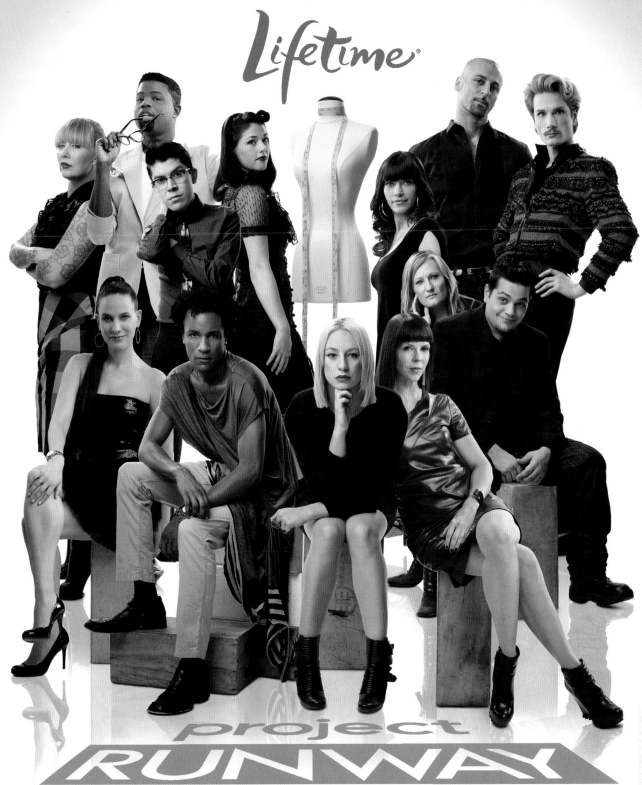

MAKING IT HAPPEN

I created all of the images for this project on a white seamless background that I set up in a loft space near where they were shooting the show in New York. We had one day for the shoot, but all of the designers wouldn't be available at the same time. My portable studio allowed the designers to come over during breaks in the filming for quick photo sessions. This was the best option, because I needed the results to be absolutely consistent, even though I was photographing people at different times during the day. A controlled, on-location studio with identical lighting against a uniform background was the way to go.

For my main light, I put a Briese flash head in a Briese 180 Focus umbrella on a boom arm positioned high above my subject and slightly to camera left. The boom arm allowed me to suspend the light over the camera, aimed down at my subject at about a 45-degree angle. I used the Briese instead of the Elinchrom Rotalux Softbox Octa, which I've employed on similar shoots, because of the Briese's distinct look with its more defined separation between highlight and shadow. The Octa is a more variable light source with hot and cool spots that I would position over my subjects to create moody shadows and add depth. It also produces softer light with less defined tonal differences between highlight and shadow. While extremely expensive, the Briese provides a flawless light from a perfectly engineered concave umbrella. The "punchy" light it produces has a very commercial studio look. By placing this light squarely on my subjects, I illuminated them with a uniform studio light that is generally considered more flattering.

On the other side of the frame from the Briese, to the right and a little forward from the camera position, I placed a piece of white foamcore to bounce some light onto the shadow sides of my subjects' faces. This evened out the lighting, removing any pronounced shadows and gave everything a clean, polished look.

Two Profoto flash heads in beauty dishes provided backlight on the subjects. I like beauty dishes for backlighting in these types of situations because the light is soft. Softer light tends to wrap around subjects for more of a flattering glow, as opposed to light sources with hard edges (more contrast between highlight and shadow), which produce a defined light on the edges of the subject. This bright edge lighting doesn't work well when shooting against a white seamless background for a composite. Overly defined edges on the subjects will make the composite look artificial, too obviously cut and pasted into a digital composition, as opposed to softer edges that blend and appear more natural.

To light the white background evenly and fill in shadows, I pointed two Profoto flashes modified by white umbrellas directly at the paper. Positioned high and on either side of the

backdrop, these lights provided a flat light that evened out any definition or folds in the paper background for a more consistent look across all the images.

When working with a seamless background for images that will later be composited, it's important to get a proper exposure of the background that remains consistent across all of the images. The more consistent the exposure and lighting, the easier the compositing job will be later on. That's why I like umbrellas for this type of shoot— they are a very consistent light source.

Even though a white seamless shoot is a simple, clean, studio lighting setup, there are so many ways that you can do it. One way to separate a good shoot from a lackluster one is to make sure the main light is at a proper height in relation to the subjects. You want the shadows and highlights to be consistent; shadows should be close in size and length, and highlights should fall on the same general places on your subjects. If they're off, your images won't match, and it will become very clear, very quickly, that your lighting was inconsistent. I maintain consistent lighting by suspending my main light high above the subjects and then pointing it down at a 45-degree angle to the subject's face. This technique involves adjusting the light up and down for the different height of each subject so it's always striking them at the same angle. This angle should provide a pleasing light while still sparking a little catchlight in the subject's eyes. You also have to make sure that the camera is in the same spot for each photo, and that it's at the same height relative to your subject. If your point of view changes from image to image, the subjects will look mismatched in the final composition.

I shot everyone with the same setup, so all the subjects are backlit with the same light. However, in the final composite, some of the designers appear in front of the others. In real life, if it was a group shot with everyone photographed together, that backlight would be blocked on some of the subjects by the people standing behind them. So there's a touch of unrealistic lighting there, if you really look close. However, you can't control this type of situation as a photographer. The final composite made by your client is often well beyond your control. It's best to just shoot everything perfectly if the exact composition hasn't been decided yet.

I had a digital tech working with me on this shoot. A digital tech sits at a computer during the shoot, monitoring the images as they are created and backing up the files right there on the spot. My digital back was tethered via FireWire to a laptop so the tech could check out the images as they came through. While some photographers may feel a little uneasy with someone looking over their shoulder at all times, I find digital techs to be extremely helpful. They are trained to look for specific things like subtle differences in lighting and color. It's great to have another set of eyes helping me keep things consistent and well exposed on such a long and fast-moving shoot.

HOUSE
OF ANUBIS

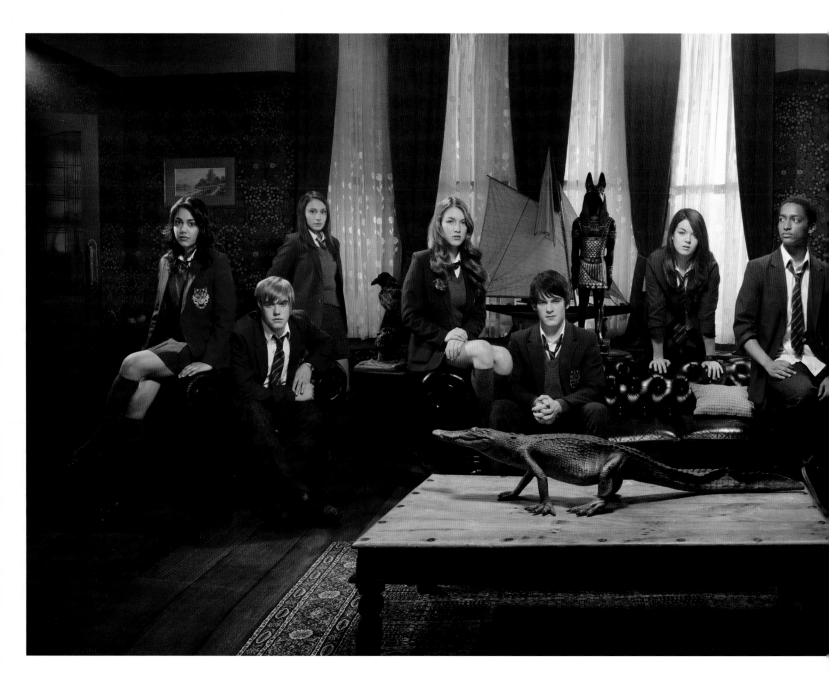

IN THE FALL OF 2010, I FLEW TO LIVERPOOL, ENGLAND, TO PHOTOGRAPH THE advertisements and press shots for Nickelodeon's new kids' show *House of Anubis*. I've always been impressed with David Hamed's art direction of Nickelodeon photo shoots. Even though the network focuses on younger audiences, its visual material always has a high production value. Working with this sort of client, and collaborating with its talented creative team, is a dream for any photographer.

Nickelodeon had a talented set builder create a set for filming the actual show, and I got to use it for my photo shoot. I love doing shoots on television and film sets because they are designed for productions. There are trusses to hang lights and plenty of space around the set to shine lights through windows, and everything is spacious and open-ended so you have plenty of room to maneuver your camera. It's an environment made for great images. For someone who is used to taping backgrounds to mud huts in Africa and rigging up quick, on-the-fly solutions during location shoots, working on a well-outfitted production set is a real treat. I even felt a bit spoiled. I just had to make sure I didn't get lost in the confusing labyrinth of different rooms and set features. Word of caution: When working on a television set, make sure you go to the bathroom in the real one, as the fake television bathroom can look pretty convincing!

With a total of six lights and some additional help from reflective white foamcore, I lit this large group as naturally as possible while providing some atmosphere to the image. Posing was simple, tweaked slightly to give the composition an interesting flow while representing each subject well within the lighting setup. The key to this image, from a lighting perspective, was illuminating the entire scene to look like a real room in a house, not a film set with 100 percent artificial light. At the same time, I needed to make sure each subject—including the crocodile—was well lit and clearly visible.

1/125 sec. at f/16, ISO 100

MAKING IT HAPPEN

For large commercial projects like this, there's usually some time allotted to prelight the scene on the day prior to the shoot, or maybe a few hours before the shoot. This is the time to figure out the lighting setup and work out any bugs. Once I've gotten all that sorted out, I start building my lighting scenario piece by piece, perfecting each stage before I move on to the next.

The prelight always takes place with test subjects, not the actual cast. Working with some assistants, I set up the shoot and light all the elements to my satisfaction. Next, it's time to pose the real subjects. In this instance, I had been working with the cast for three days on other shots, so we were all very comfortable working together and it was easy to move them around and see what group composition worked best.

Posing nine people anywhere can be tricky (well, ten if you count the crocodile). I wanted to vary the eye levels of the subjects and make sure no one was sitting exactly the same way. I posed some of the cast high on the couch, some lower, and some standing, and I kept tweaking until the composition had a nice flow—the eye moved from subject to subject fluidly, without getting stuck on a particular element or distracted by any inconsistencies. It was also important to leave spaces so the viewer could see some of the interesting props on the shelf and around the room, since these items contributed to the overall feel of the image and the branding of the show.

For my main light, I started out with a Profoto ProGlobe, a spherical, bulblike light modifier that spreads light around 360 degrees, almost like a bare lightbulb. In many shoots, I have used a similar modifier that I crafted out of a spherical glass lampshade, but since I was traveling abroad for this shoot, I just rented the real thing while on location.

When I did my first test shot, I didn't like the way the light draped over the walls. It was too bright and uniform; the scene didn't look cozy, warm, and moody as I wanted. So to get that look I taped some black paper to the areas of the ProGlobe from which the light was spraying onto the walls. By customizing my modifier, I focused the light only on the subjects without any falloff on the walls. Then I added a sheet of diffusion paper to the bulb to further soften the light that did hit the subjects.

I added two lights outside the set windows to replicate sunset light coming in from the outside. It appears to be one light source, much like the sun, but it's actually two separate lights with zoom reflectors. I used two lights because the windows are so far apart from each other that one light would not shine evenly through both windows with the same impact as the setting sun. Two lights with identical orientations accomplish this look beautifully. Also,

the light aimed through the window on camera right helps distinguish the actors on that side of the composition from the background by illuminating the wallpaper behind them.

Since we have the illusion of warm window light shining in from behind the group, I needed to add some additional interior lighting to enhance that effect. I also needed some rim light to separate the actors from the background. I positioned two Profoto Pro flash heads inside of beauty dishes and then added a grid to focus the light more acutely. Then I suspended the lights high above the subjects, aiming the beauty dishes down and slightly toward the camera. To warm up the color temperature, I placed a 1/2 CTO (color temperature orange) warming gel on each light. This orange gel created a warm glow from behind the actors, which wrapped around the edges of the subjects and separated them from the background.

Once we arranged everyone, it was clear that the actor on the far left, Tasie Dhanraj, needed an additional light to help her stand out better in that dark corner. I arranged a Profoto flash head with grid and a 1/2 CTO warming gel to camera left, just out of the frame, above her and pointed down at her at about a 45-angle. In the final photograph, you can see the flare from this light, but I decided to keep it because it looks interesting and works with the final composition. Besides, it appears natural, as if it were coming from an interior light in the room.

Even with this additional light on Tasie, the left side of the image was still a touch dark, and it wasn't lit evenly by the main light. So I placed a piece of white foamcore to camera left, just out of the frame, to reflect light back onto the two subjects in the chair.

The light from the modified ProGlobe looked great, but it caused some strong shadows on the actors' faces. To address this issue, I bounced some light up to the underside of their faces using a piece of white foamcore under the table. I positioned the foamcore out of sight and angled it to even out the facial shadows without affecting much else in the image.

To get a wide, panoramic look without any distortion, I shot the final image in two separate panels. For this kind of image, I usually don't like the look of super-wide-angle lenses; they distort the items in the frame. I want my images to have a similar perspective to a human eye's, so I merged two images taken with an 80mm lens. I used a panoramic adapter to rotate the camera on the correct axis, and then combined the two images later in Photoshop with a photo merge. I employ this technique quite a bit on panoramic-type images. All of the subjects remain in one place, but the camera moves back and forth between two positions.

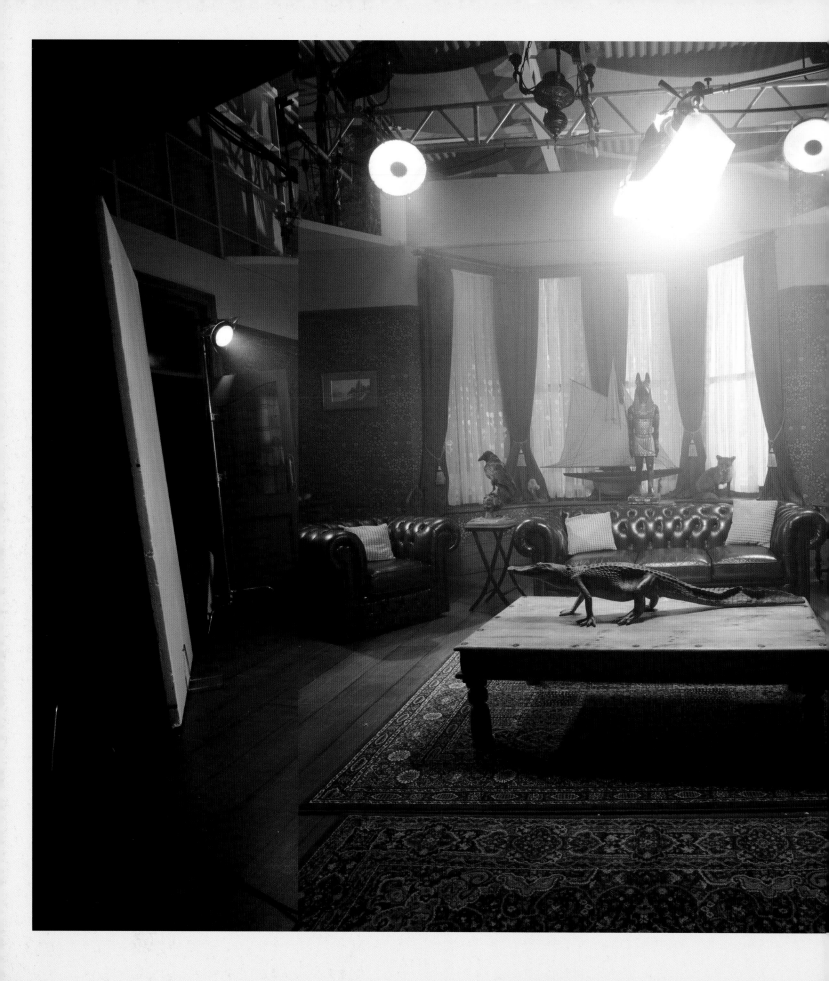

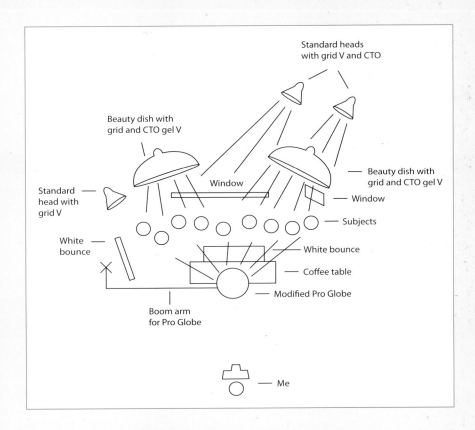

This setup shot shows the lighting arrangement I used for the *House of Anubis* group portrait, conducted on the set of the Nickelodeon television series. There wasn't enough time to switch to a wide-angle lens to show the entire scene in one shot, so I panned the camera roughly left to right to create this composite.

POSTPRODUCTION WORKFLOW

A LOT OF PEOPLE LOOK AT MY WORK AND THINK THAT IT'S BEEN HEAVILY PHOTO-shopped. Particularly in my commercial images, the way I apply multiple light sources may give this impression. However, I do most of my work on set and in camera. I do enhance the images in Photoshop, of course, but my techniques are subtle. They are designed to optimize what I've already captured.

I'm not implying that the digital processing and enhancements aren't an important part of image creation—not at all. A well-executed postproduction process can augment the look of your images and help them stand out. In today's photography marketplace, where success relies on a unique vision, developing a good digital workflow can help your images ascend to the next level. The specific tools and techniques you use will further define your photography. It's the final step in implementing your personal vision.

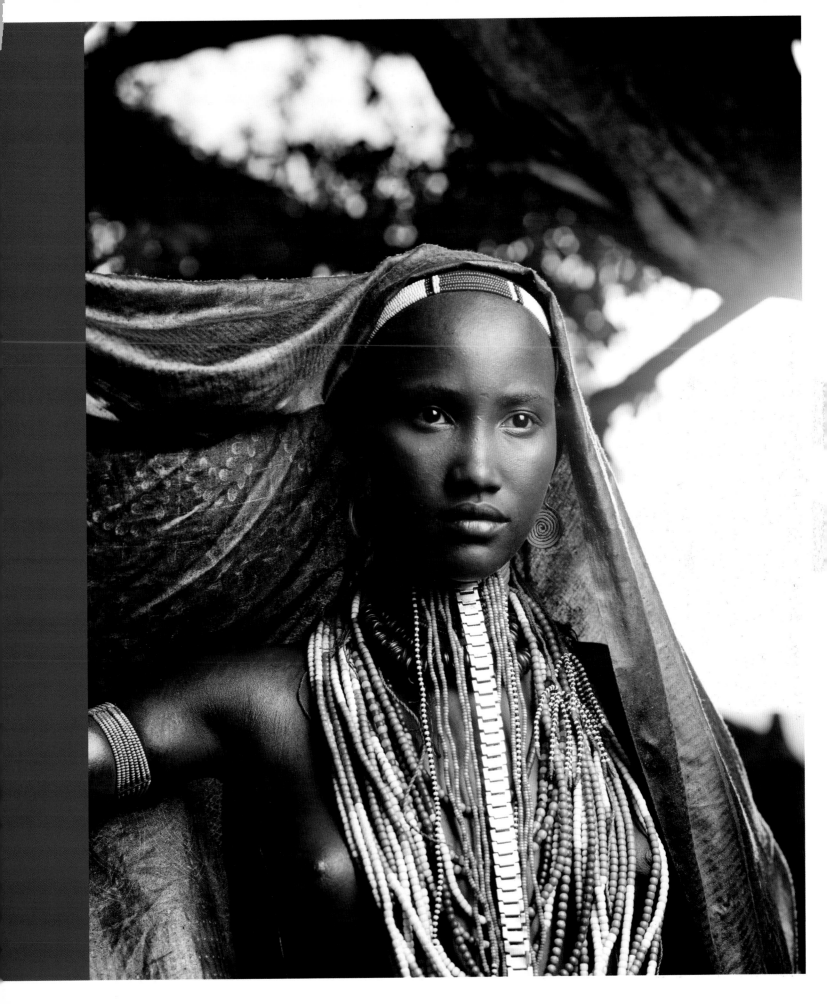

Also, digital enhancements offer another opportunity to shore up the cohesiveness of your work. If you can create a consistent postproduction workflow, it will go a long way toward building cohesiveness across all of your work. I'm not saying that every image needs to be processed identically, but a reasonably standardized set of methods should be in place. Then you can tweak, play, and make subtle variations to bring each picture to life.

To give an idea of my digital darkroom process, I've provided an inside look at my basic postproduction workflow. As with my capture techniques, I don't for a second suggest that you simply take my process and copy it. Instead, use this information as another tool in the construction of your personal vision.

1. I always shoot in raw with a color space of Adobe RGB 1998. I prefer this method because it gives me the most digital information with the widest tonal range. Since I don't capture thousands of images per shoot, the larger size of these files isn't a concern. Later, I can create new, smaller files as necessary for the final output method.

2. Using Phase One Capture Pro, I sharpen the image and then convert the raw file into a 16-bit TIFF file at 100 percent size. I always sharpen before converting the raw file to a TIFF because the raw file has the most digital information, so sharpening at this stage offers the most accurate method. I don't sharpen the base image in Photoshop. During this entire process, I leave the image in Adobe RGB 1998 because that's the native color space, and it's a larger color space than something like sRGB. It handles more detail in shadows and highlight, and it holds more information.

3. Using Curves, I tweak the color levels and tonal range of the image. I start by clicking Image > Adjustments > Curves. You can use the RGB channel to adjust the tonal range of the image. The area at the top right of the graph represents the highlights, and the bottom left, the shadows. You can pull the line one way or another in multiple places to adjust these highlights and shadows. Pulling the shadow portion of the line down and the highlight area up will increase your contrast.

 To adjust color in this box, click on Channels in the upper left and select red, blue, or green. Within each color channel, you can move the line up or down to adjust those color levels without affecting the tonal range. However, remember that the top right impacts the highlights and the bottom left affects the shadows, so by pulling your line one way or the other in those areas, you're changing the color levels in those tonal areas. For example, by pulling the blue line up in the upper right corner, you're increasing the blue color (and decreasing the opposite color, yellow) in the highlights of the image. Similarly, by pulling the green line down in the lower left corner, you're decreasing the green color (and increasing the opposite color, red) in the shadow areas. You can play around with all of the individual colors to achieve a look that you like. I do not have a set formula for this process; I adjust the levels until I achieve the look I want.

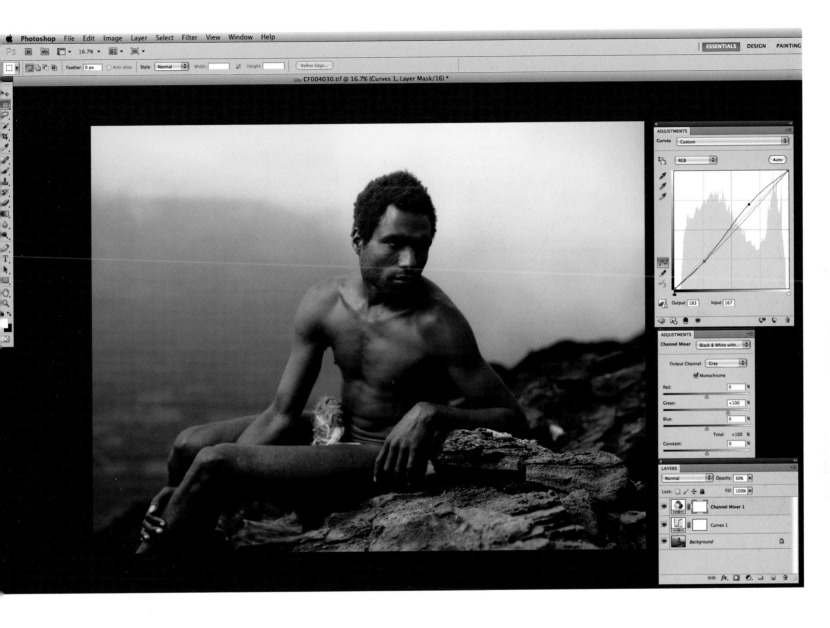

In Photoshop, I tweak color levels and tonal range using Curves, then adjust colors further and desaturate the image using the Channel Mixer (see Step 3, opposite, and Step 4, page 170).

This is the best method for colorizing an image because you can get any color combination you want by playing with these levels.

4. I use the Channel Mixer to desaturate the image. Go to Window > Layers (F7) > Adjustment Layer > Channel Mixer. You can also get to Channel Mixer by going to Image > Adjustments > Channel Mixer, but I like to work in layers so I can go back and change things easily later on. By accessing the Channel Mixer through Layers, it creates a new layer with a mask, and you can edit in a nondestructive way.

The Channel Mixer opens a box with red, green, and blue channels, which are the main colors affecting your photos. By moving the sliders, you can see how to adjust overall color levels in the photo.

This method is also how I do black-and-white conversions. Digital cameras offer great options for shooting in color and then converting to black and white with customized tonal ranges. By running the image through different color channels in Photoshop, you can create your own black-and-white effects, similar to colored filters and custom processing back in the days of film. To do this, while you've got the Channel Mixer box open, click the box for Monochrome. You can play with the red, blue, and green sliders some more and see how adjusting these colors completely changes the contrast range of the black-and-white image. The red channel tends to give a smooth, soft look to skin. The blue channel is the opposite, providing a harsher look to the skin. The green channel is in the middle. I like to use a mixture of green and blue channel adjustments to give my images an interesting look. I can achieve a more high-contrast, high-impact look to my black-and-white images by using this method, as opposed to just turning the image to black and white by clicking Desaturate. You can see this process and other Channel Mixer techniques in more detail on my instructional DVD, available at learnfromjoey.com.

5. Once I've achieved the look I want, I save the file as a high-resolution TIFF, and then make copies at different sizes, depending on the final use for the image. If necessary, I adjust the sharpness along the edges of my subjects in these smaller copies using the Unsharp Mask filter. I always do this additional sharpening adjustment after resizing the image because when you downsize an image, the process reduces the number of pixels in the image. You need to produce harder edges because there are now fewer pixels along those edges. I typically apply Unsharp Mask with a radius of 0.7 and an amount between 60 and 80 percent at a threshold of 3.

6. Finally, I back up my files. I never keep all my files in the same place. Photographers have many different options for saving files in different physical and virtual locations, including multiple hard drives, additional servers, Drobo-type storage devices, and cloud services. Choose what works for you—just make sure you back up your images. All hard drives fail eventually. If you spend your life creating images, it's a good idea to preserve and protect them.

Whenever necessary, I adjust an image's sharpness using the
Unsharp Mask filter (see Step 5, opposite).

Remember, your postprocessing and Photoshop techniques should be as uniquely yours
as your style of capturing the original image. The digital darkroom is your opportunity to
bring it all together, to turn your work in the field into a finished composition. If you hone
your skills, standardize your methods, and, most important, apply an overarching vision
to your digital enhancements, you will be well on your way to creating a cohesive, distinct
portfolio that defines you as an image maker.

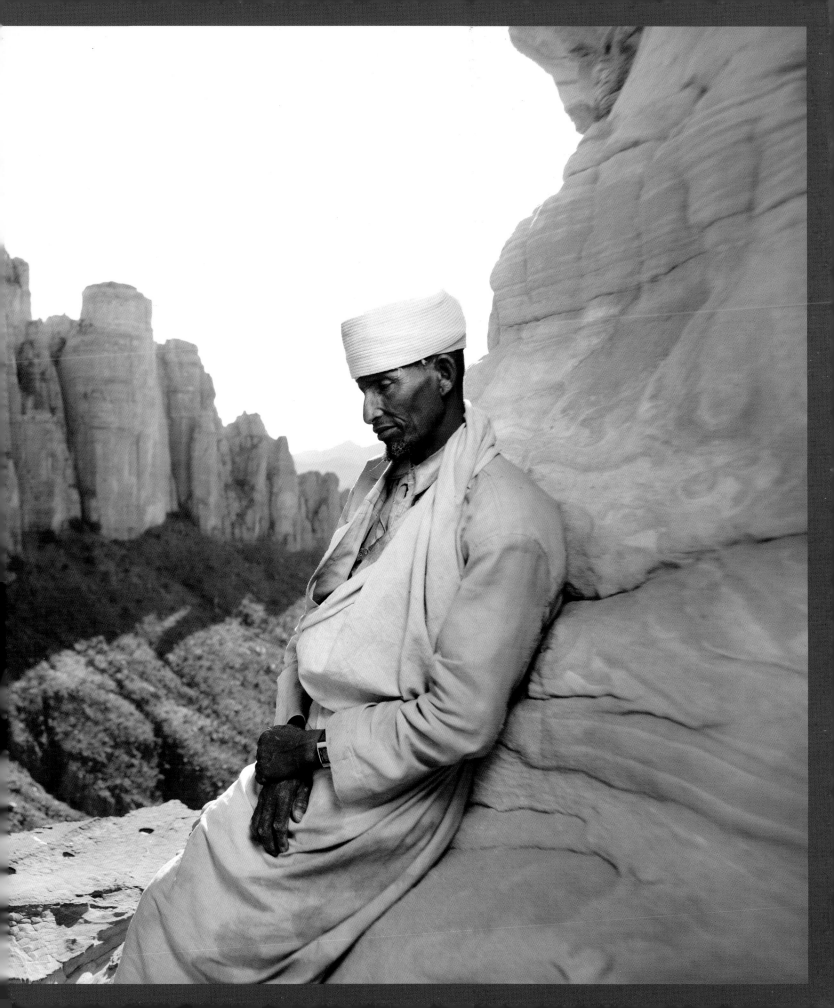

ACKNOWLEDGMENTS

I would like to thank the following people for their support of my career and their help with my various endeavors, including this book:

George, Kim, Shane, and Corey Lawrence, and the rest of my family.

Jeff Kent, Julie Mazur, Stephanie Leonard, James Hill, Shaneeza Aziz, Patricia Mcmahon, Jonboy and Gabi Simpson, Barbara Cox, Aunde Cornely, Anne Sheridan, Mary Charas Healy, and Donna Maxey.

Jesse Korman, Black Black, Tasie Dhanraj, Ryan McCarney, Cale Glendening, Willem Isbrucker, Sterling Healy, Justin Woodward, Jonathan Bregal, Khalid Mohtaseb, Tyler Ginter, Oscar Zabala, James Zanoni, Lara Jade, Chris Dowsett, James Douglas, Sarah Rigney, Sebastian Koever, Susie Hayasaka, Tom-Tom Leavy, Adam "PDA" Ross, Sam Spratt, Allora Visuals, Survival International, Eric Nally, Haakon, Benedict Evans, Ovation TV, Benjamin Bates, Jazmine Valencia, Todd Russell, Luke Fontana, Hector Aldid, Ashton Do, Dustin Snipes, Jed and Vicki Taufer, and Ross Tanner.

Ricky Putra Sinaro, Anteneh Endale Mamo, Raju Verma, Satish Kumar, David Hobby, Mohamed Somji, Hala Salhi, Kholloud AlMuraikhi, Mat Holloway, Hind Iskander, Tejinder Singh, Fernando Piaddio Politi, and Andy Redpath.

Ian Luce, Zach Dilgard, Aaron Day, David Hamed, Justin Smith, Angelo Patrona, Kevin Pesta, Sara Clark, Stefan Haverkamp, Thomas Derouault, Aurelie Bourdais, Stephen Aviano, Todd Heughens, Brandon Donahue, and Margy Dudley.

INDEX